AFTERWAR

VETERANS FROM A WORLD IN CONFLICT

PHOTOGRAPHS AND INTERVIEWS : **LORI GRINKER** de.MO

ERRATA

On page 19, lower right hand side,
under Casualties,
the figure 600,000
should read 60,000

IN MEMORY OF MY BROTHER, MARC

EDITED WITH **ROBERT PLEDGE** TEXT WITH **JACQUES MENASCHE**

AFTERWAR

VETERANS FROM A WORLD IN CONFLICT

HOTOGRAPHS AND INTERVIEWS : **LORI GRINKER**

de.MO

TABLE OF CONTENTS

LORI GRINKER

AFTERWAR is not about the heroics of war, although many of the individuals photographed and interviewed for this book have done heroic things. Covering the entire range of combatants of the past one hundred years, across boundaries of culture, geography and time, this project is meant as a polyphony of voices revealing how people find themselves in war, what happens to them there, and the marks that remain when the fighting is over.

If I discovered any single universal truth about war in the years of this book's gestation, it is that it is a deeply personal experience. This is reflected in the many roads that people take to get there. While generally young and disadvantaged, the men, women and children who fight on the frontlines hail from all walks of life: conscripts and volunteers, patriots and rebels, those lured by adventure, and those bound by a sense of duty.

What is common to all is the aftermath. Here, one culture mirrors another. It makes no difference if one has been in a "bad" war or a "good" war, justified or unjustified, on the winning or losing side. As Elvigio Pellitero, who fought in the Nationalist army under General Franco during the Spanish Civil War, said: "We were ignorant. We thought we would probably die, that's all. We fought, we won. If we had lost it would have been just the same."

During a visit to the Vietnam Veterans Memorial Wall in Washington D.C in 1991, I noticed children looking at the veterans there with an odd curiosity. Indeed, there was something inherently different about them. Civilian visitors are perhaps daunted by the number of names on the Wall and angered or saddened by what happened in Vietnam. But the veterans visiting the site are not removed from the experience. They carry war with them day to day. They've been responsible for death, and faced their own. There is an aura around them, an aura born of having witnessed something that should never be seen. It was this I wanted to capture. I wanted to get past the macabre curiosity, which I too had, and to move through the fear and horror of seeing them with a missing limb or a burnt face — to see veterans beyond their wounds, but to capture the war in their wounds and through their memories.

The question of which conflicts can truly be called a "war" came up numerous times during the course of this work. The Vietnam War was never declared a war, nor was the Korean War or the Algerian War of Independence. Officially, "the Troubles" in Northern Ireland are not a "war," and neither is the Palestinian Intifada. When asked about this, ex-combatants all responded the same way: "We bleed the same blood, we kill and die with the same bombs and bullets whether you call it a conflict or an insurrection, whether it's been officially declared war or not. What's the difference?"

Over the past fifteen years this project was supported through publication in magazines, several generous grants, and the guidance of my agency, Contact Press Images. When the time came to turn AFTERWAR into a book, Contact's director, Robert Pledge, who had been involved since the inception of the project, and I sat down and discussed the layout. Ultimately it was decided to organize the book in reverse chronological order, from the most recently ended conflicts, reaching back in history to the early part of the century. Reverse order is a way to peel back the layers of time, a way of tracing the mad route of the past century back towards its origins.

While working in some thirty countries during the course of this work, in addition to research and planning, I followed to some extent a more poetic impulse, trusting the accidents of fate that led me to my subjects. It was never my intention to create an encyclopedia of war.

Each chapter contains a small section of data, including numbers of casualties for each conflict in the book. Whenever possible, I listed both the number of killed and wounded. Where extreme discrepancies in the figures appeared in a variety of sources, I've included a range of numbers.

A final issue of historical authenticity inevitably came up in the matter of names used in this book, of both the wars and their combatants. Wars often have several names, depending on which country writes the history. "The Vietnam War" to Americans is "The American War" to the Vietnamese. To resolve this dilemma, in the book's timeline, wars are listed by the most commonly used name in addition to the name used by the participants themselves. If adults gave permission to use their full names, they have been included as such. In order to protect the children included in these pages only their first names have been used.

The past century was one of history's deadliest. More than one hundred million people died in over one hundred and fifty conflicts. Countless others were wounded as nationalism, competing ideologies and religions, and genocidal conflicts raged across Europe, through Asia, Africa and the Americas. There is no reason to believe it will end anytime soon. Those sent to war are cannon fodder, and we live vicariously through their violent experience. We watch the reports from the front on television as if it were a spectator sport. But they suffer for us. They are our sacrificial lambs. I hope their images and words will serve as a powerful reminder of the wastefulness of war.

Lori Grinker
New York City, April 2004

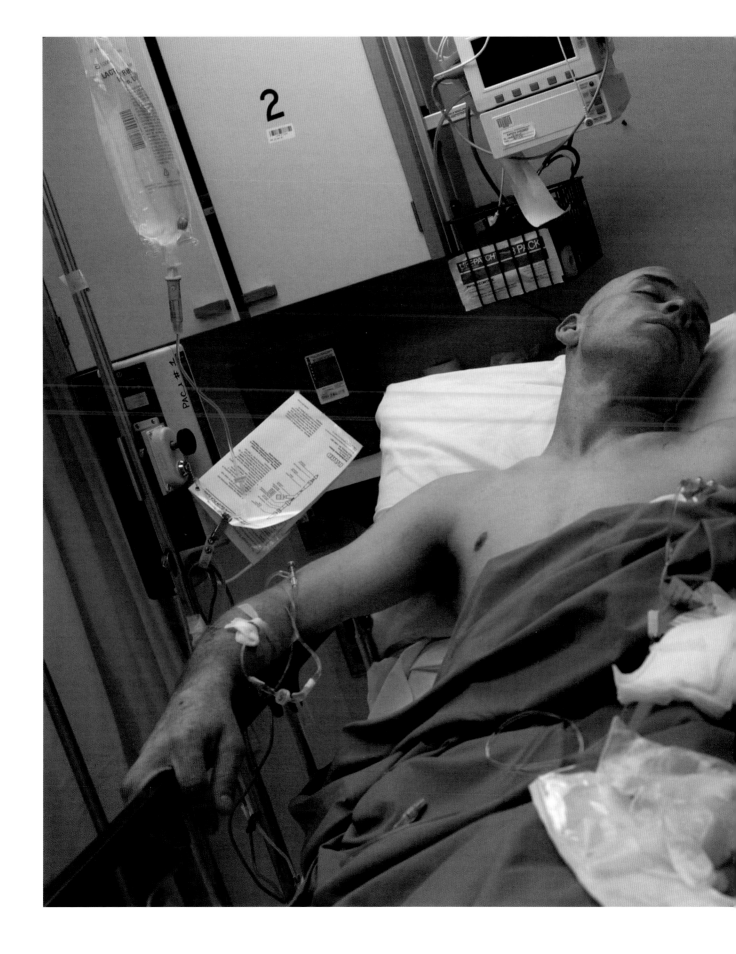

AFTERWAR : Lori Grinker IRAQ WAR : 2003 . 2004

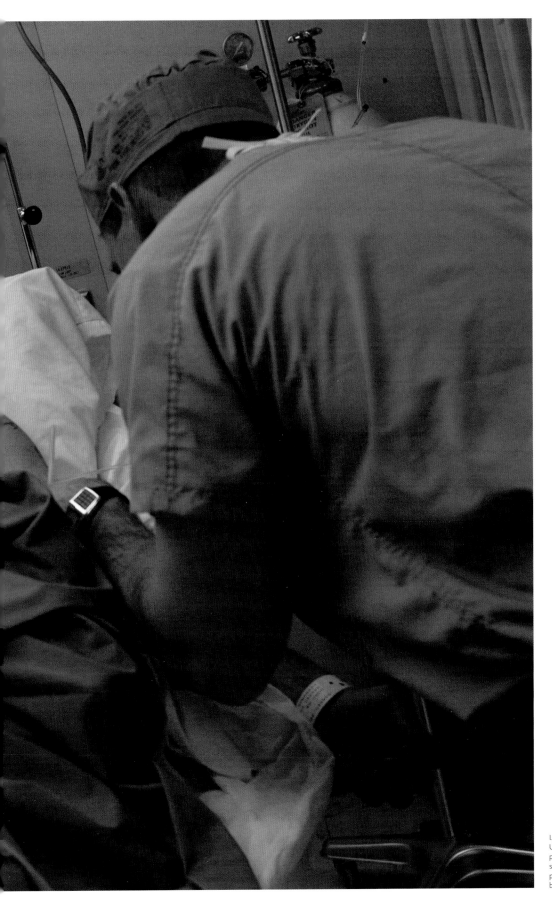

Lying on a gurney in the pre-op room aboard the USNS Comfort, US Marine Sgt. Jose Torres is prepped by an anesthesiologist before his ninth surgery. Torres was wounded when his armored personnel carrier was hit by friendly fire during the battle of An Nasiriyah. Persian Gulf, March 2003

CHRIS HEDGES

My father and three of my uncles fought in World War II. I grew up in the shadow of the war. But it was not the romantic war of movies and books, although this romance infected me, but the war of the emotionally and physically maimed. My father, who had been an army sergeant in North Africa, went to seminary after the war and became a Presbyterian minister. Years after the war he would speak about his rifle and you could almost see his fingers push the gun away. He loathed the military and the lie of war. When our family visited museums he steered us away from the ordered displays of weapons, the rows of muskets and artillery pieces, which gleamed from within cases or roped-off areas.

He was an early opponent of the Vietnam War. During a fourth of July parade in the small farm town where I grew up, he turned to me as the paunchy veterans walked past and said acidly, "Always remember most of those guys were fixing the trucks in the rear." He hated the VFW Hall where these men went mostly to drink. He found their periodic attempts to recreate the comradeship of war, something that of course could never be recreated, pathetic and sad. When I was about twelve he told me that if the Vietnam War was still being fought and I was drafted he would go to prison with me. To this day I have a vision of sitting in a jail cell with my dad.

But it was my Uncle Maurice who I thought most about as I leafed through the images in Lori Grinker's book AFTERWAR. He was in the regular army in 1939 in the South Pacific and fought there until he was wounded late in the war by a mortar blast. He did not return home with my father's resilience, although he shared my father's anger and sense of betrayal. His life was destroyed by the war. He refused to accept his medals, including his purple heart.

Maurice would sit around the stove in my grandmother's home and shake as he struggled to ward off the periodic bouts of malaria. He could not talk about the war. And so he drank. He became an acute embarrassment to our family who lived in a manse where there was no alcohol. He could not hold down a job. His marriage fell apart. Another uncle hired him to work in his lumber mill, but Maurice would show up late, often drunk, and then disappear on another binge. He drank himself to death in his trailer, but not

before borrowing and selling the hunting rifle my grandfather had promised me.

There was only one time he ever spoke to me about the war. It was at my grandmother's kitchen table. He spoke in a flat monotone. His eyes seemed to be looking far away, far across the field outside the house, across the snowy peaks of southern Maine, to a world that he could never hope to explain.

"We filled our canteens up in a stream once," he said. "When we went around the bend there were twenty-five dead Japanese in the water."

War is always about betrayal. It is about the betrayal of the young by the old, idealists by cynics and finally soldiers by politicians. Those who pay the price, those who are maimed forever by war, are shunted aside, crumbled up and thrown away. They are war's refuse. We do not see them. We do not hear them. They are doomed, like wandering spirits, to float around the edges of our consciousness, ignored, even reviled. The message they bring is too painful for us to hear. We prefer the myth of war, the myth of glory, honor, patriotism and heroism, words that in the terror and brutality of combat are empty and meaningless.

It is a measure of the power of this myth that despite the experience of my father and my uncles in war I was seduced by the siren call of war. I longed for adventure, for a life that would allow me to break free from the confines of a farming community. I read about the American Civil War, Spanish Civil War and World War II. I wanted an epic battle against evil to define my own life. Of course I would not return a shell of a man, like my uncle, for as I look back on it I blamed him for the wounds he received. Now I know better. I had to learn this myself, as each generation learns it anew.

I did go to war, not as a soldier, but as a war correspondent, and twenty years later I too battle the demons that defeated my uncle. Perhaps it is hopeless to expect anyone to listen. The myth has a powerful draw. It allows us to be noble, heroic, to rise above our small stations in life.

Most war images meant to denounce war fail. They still impart the thrill of violence and power. War images that show scenes of combat become, despite the intention of those who produce them, war porn. And this is why soldiers who have not been to combat buy cases of beer and sit in front of movies like *Platoon*, movies meant to condemn war, and yearn for it. It is almost impossible to produce anti-war films or movies or books that portray images of war. It is like trying to produce movies to denounce pornography and showing erotic love scenes. The prurient fascination with violent death overpowers the message.

The best record of war, of what war is and what war does to us, are those that eschew images of combat. This is the power of this book. Born of Lori Grinker's fifteen-year odyssey through more than thirty countries — some of them newly formed by violent conflict — it serves no ideology. Her subject is not the flag or the nation or even the victim. Instead, it is the real, unromantic life of the veteran whose body and mind are changed forever when they serve nations and movements that are all too ready to sacrifice them. It forces us to see what the state and the press, the handmaiden of the war makers, work so hard to keep from us. If we really knew war, what war does to young minds and bodies, it would be harder to wage war. This is why the essence of war, which is death, is so carefully hidden from public view. We are not allowed to see dead bodies, at least of our own soldiers, nor do we see the wounds that forever mark a life, the wounds that leave faces and bodies horribly disfigured by burns or shrapnel. War is made palatable. It is sanitized. We are allowed to taste war's perverse and dark thrill, but spared from ever seeing war's consequences. The wounded and the dead are swiftly carted off stage.

War, at least the mythic version, is wonderful entertainment. We saw this with the war in Iraq where the

press gave us a visceral thrill and hid from us the effects of bullets, roadside bombs and rocket propelled grenades. The war was carefully packaged, the way tobacco or liquor companies package their own poisons. We tasted a bit of war's exhilaration, but were safe, spared from seeing the awful affects of its machines.

Only those works, such as this one, which eschew the fascination with violence to give us a look at what weapons do to human bodies, begin to grapple with war's reality. We can only understand war when we turn our attention away from the weapons my father refused to let us see in museums and look at what those weapons do to those on the receiving end.

In the modern world, war is largely impersonal, mocking the image of individual heroics. Industrial warfare, waged since World War I, means that thousands of people, who never see their attackers, can die in an instant. The power of these industrial weapons is staggering. They can take down apartment blocks in seconds, burying everyone inside. They can demolish tanks and planes and ships in fiery blasts. The wounds, for those who survive them, are horrific, usually resulting in terrible burns, blindness and loss of limbs.

"There were three of us inside, and the jeep caught fire," the Israeli soldier Yossi Arditi says of a Molotov cocktail that exploded in his vehicle. "The fuel tank was full and it was about to explode, my skin was hanging from my arms and face, but I didn't lose my head. I knew nobody could get inside to help me, that my only way out was through the fire to the doors. I wanted to take my gun, but I couldn't touch it because my hands were burning."

He spent six months in the hospital. He had surgery every two or three months, about twenty operations, over the next three years.

"People who see me, see what war really does," he says.

It is this view of war that most cannot stomach, that sees even those who are close to us flee in horror. Saul Alfaro, who lost his leg in the war in El Salvador, speaks about the first and final visit from his girlfriend as he lay in an army hospital bed.

"She had been my girlfriend in the military and we had planned to be married," he says. "But when she saw me in the hospital, I don't know exactly what happened, but later they told me when she saw me she began to cry. Afterwards, she ran away and never came back."

Those left behind to carry the wounds of war feel, as my uncle did, a sense of abandonment, made all the more painful by the public manifestations of gratitude to veterans. But these are the veterans deemed palatable, those we can look at, those who are willing to go along with the lie that war is about glory and manhood and patriotism. They are trotted out not so much to be honored but to perpetuate the myth.

Gary Zuspann, who lives in a special enclosed environment in his parent's home in Waco, Texas, suffering from Gulf War Syndrome, speaks of feeling like "a prisoner of war" even after the war has ended.

"Basically they put me on the curb and said, okay, fend for yourself," he says. "I was living in a fantasy world where I thought our government cared about us and they take care of their own. I believed it was in my contract, that if you're maimed or wounded during your service in war, you should be taken care of. Now I'm angry."

My family was not unique. We carried the crucible of war. But there were tens of thousands, maybe hundreds

of thousands of families like ours, families that cared for the human refuse of war. The wounded after war are cloistered away, kept from public view, swept to the sides. I went back to Sarajevo after the war and found that hundreds, perhaps thousands of war wounded were trapped in rooms in apartment blocks with no elevators and no wheelchairs. Most were young men being cared for by their parents, the glorious heroes left to rot.

When the mask of war falls away, when the intoxication with the cause is spent, we fall into despair. This is why suicide so often plagues war veterans. Indeed, more Vietnam veterans may have committed suicide since the war than were killed during it. The very qualities drilled into soldiers in wartime defeat them in peacetime. This is what Homer taught us in *The Iliad*, the great book on war, and *The Odyssey*, the great book on the awful journey towards recovery from war.

"They program you to have no emotion, like if somebody sitting next to you gets killed you just have to carry on doing your job and shut off," Steve Annabell, a British veteran from the Falklands War, says. "When you leave the service, when you come back from a situation like that, there's no button they can press to switch your emotions back on. So you walk around like a zombie. They don't deprogram you. If you become a problem they just sweep you under the carpet."

"To get you to join up they do all these advertisements, they show people skiing down mountains and doing great things. but they don't show you getting shot at and people with their legs blown off or burning to death. They don't show you what really happens. It's just bullshit. And they never prepare you for it. They can give you all the training in the world, but it's never the same as the real thing."

Those you have most in common with when the war is over are those you fought.

"Nobody comes back from war the same," says Horacio Javier Benitez, who fought the British in the Falklands. "The person, Horacio, who went to war, doesn't exist anymore. It's hard to be enthusiastic about normal life; too much seems inconsequential. You contend with craziness and depression."

"Many who served in the Malvinas," he says, using the Argentine name of the islands, "committed suicide, many of my friends."

And this, finally, is the power of the book. It looks beyond the nationalist rants that are used to justify war; it looks beyond the seduction of the weapons and the pornography of violence. It focuses on the evil of war. War always begins by calling for the annihilation of the others but ends ultimately in self-annihilation. It corrupts our soul and deforms our bodies. It destroys homes and villages. It grinds into the dirt all that is tender and beautiful and sacred. It is a scourge. It is a plague. And before you agree to wage war, any war, look closely at this book.

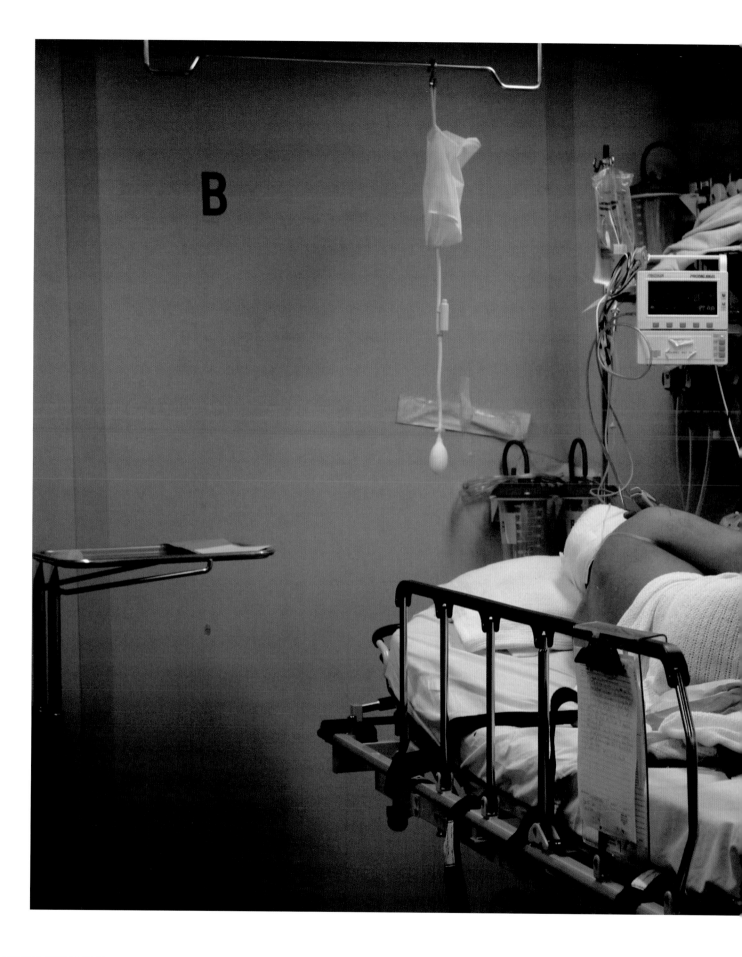

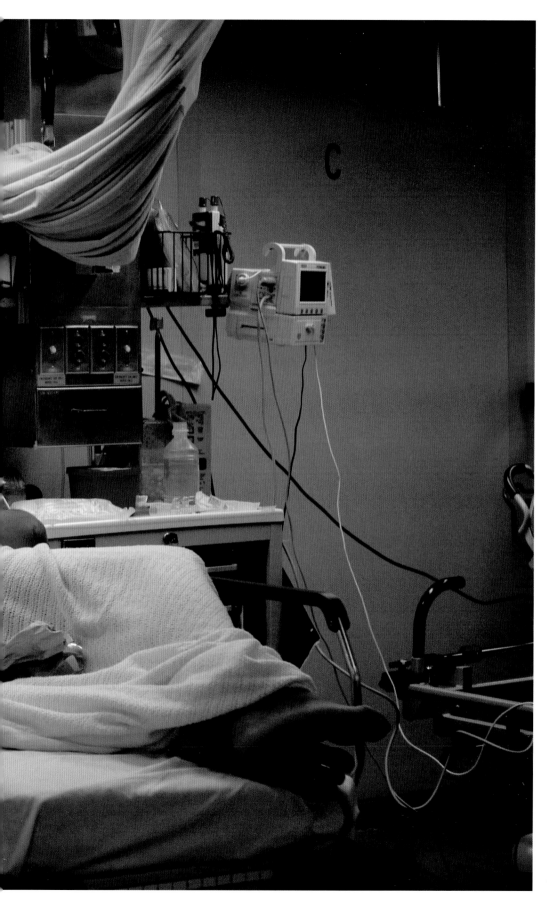

Lying on a gurney aboard the USNS Comfort, a naval hospital ship in the Persian Gulf, an un-identified Iraqi POW waits for medical treatment. March 2003

SRI LANKA $^{1983 \text{ to } 2003}$

1910 1920 1930 1940 1950

Formerly a British colony named Ceylon, Sri Lanka gained independence following World War II as a Buddhist Sinhalese-speaking state that included a Hindu Tamil-speaking separatist minority in the north and east. In 1983, after the killing of thirteen soldiers by Tamil guerrillas, and retaliatory attacks by the Sri Lankan military, large-scale violence erupted between the government and the Liberation Tigers of Tamil Eelam (LTTE), or "Tamil Tigers," which has continued, on and off, ever since. Funding their operations through bank robberies and drug smuggling, the Tamil Tigers have left behind a legacy of terrorist actions, including the pioneering use of suicide bombings such as the one that killed Indian prime minister Rajiv Gandhi on May 21, 1991.

NAME:
Tamil Insurgency, Sri Lanka Civil War
TYPE:
Ethnic/Religious
CASUALTIES:
600,000 killed

1960 1970 1980 1990 2000

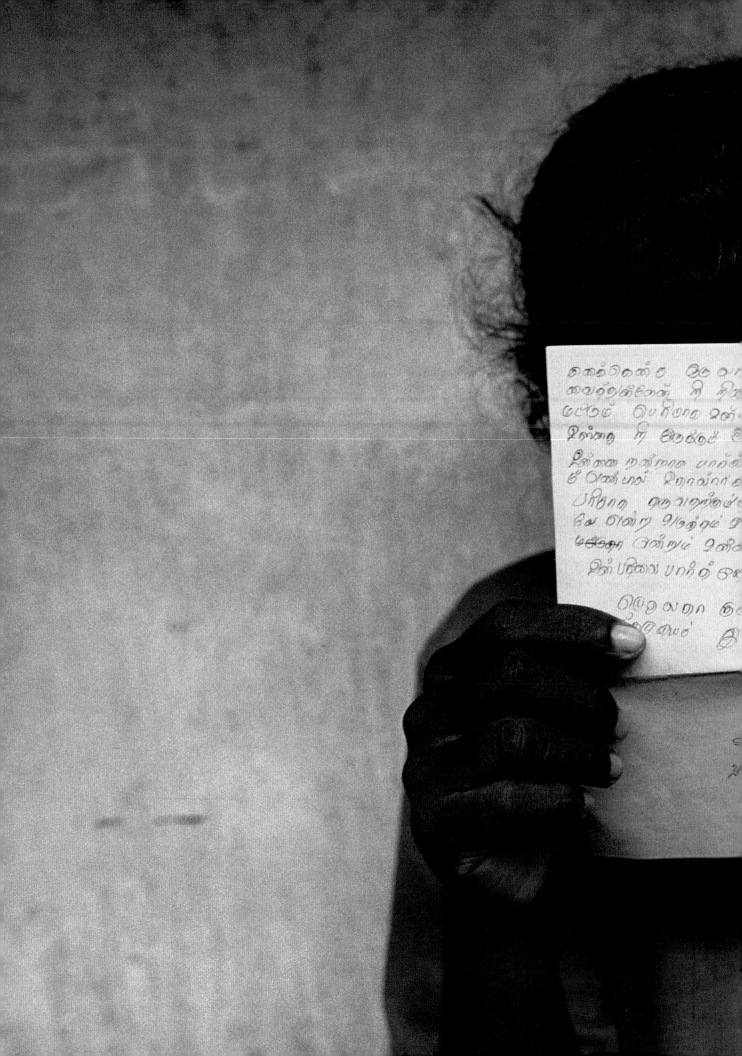

The LTTE took me to the front by force. They took me crying from my home. Then we walked for a very long time until we reached the jungle.

At the camp we had elder "sisters." These were female LTTE fighters. There had been a women's unit in the LTTE since 1983. They used to come lecture at school, back when service was still voluntary. They would say, "Women fight for your freedom, too."

The first night I cried so hard they let me sleep with them.

Some parents went to the LTTE leaders, begging to take their children back. But the LTTE would only return us if they paid a two or three million rupee ransom. Our parents were very poor; just providing food was difficult. How could they pay two million rupees?

Nugegoda, Sri Lanka 9.1999

Caption to picture on page : 20.21
Uma reads a letter from home at the Methsevana Government Rehabilitation Center for Girls in Nugegoda.

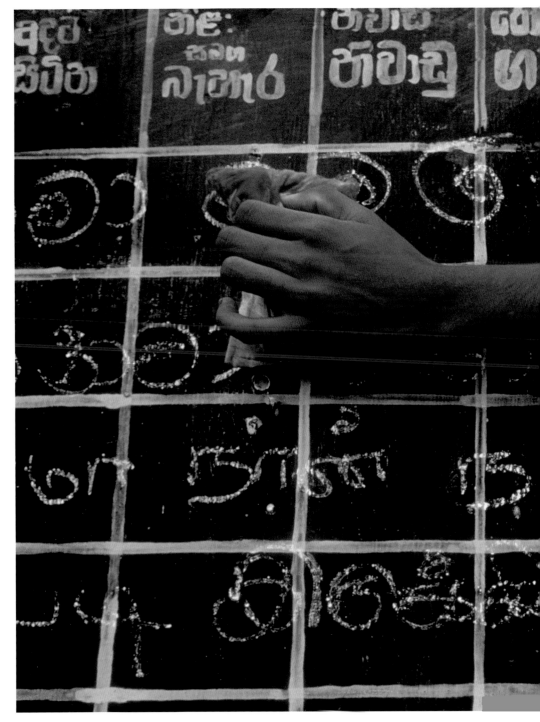

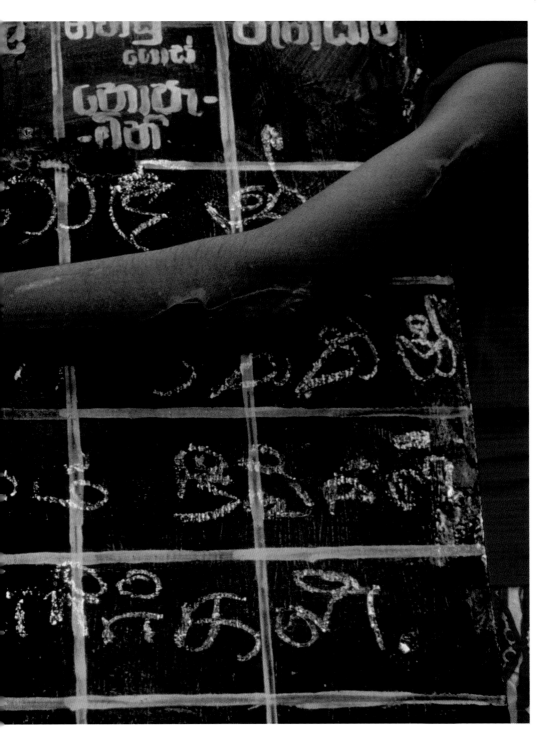

When I was sixteen the LTTE came to school and showed us war movies. Before that, they showed us karate videos. That's why I wanted to join — for the karate.

At first I liked it — the training, the uniform, the weapons. I didn't learn karate, but I learned how to shoot and I enjoyed firing a weapon. After training we were given AK-47s or the T56 which is lighter but still a serious weapon. I got a T56.

The training was two to three months long. During that time we were asked if we wanted to join the suicide unit. I didn't. Some wanted to die. Some children in the LTTE had no families, no relations, no protection; they were suffering.

After a while, I realized how much I missed my family and I felt such loneliness, I cried every night. But we couldn't go home. We were allowed to call, but most families didn't have a telephone. It was a one-way door; you could go in, but you couldn't go out. And they cut the girls' hair very short, so that if you escaped you would be easy to spot.

My leader ordered me to put a bomb under a bridge. It was the size of my palm, and as I was placing it, it exploded. It was eight at night. My leader and the others ran off. I was in so much pain that I ate the cyanide capsule we wore around our necks to use if we were ever captured. I blacked out. I should have died — but I suppose the capsule was old, expired, so I lived.

Nugegoda, Sri Lanka 9.1999

Piriya learns to write in Sinhalese at the Methsevana Government Rehabilitation Center for Girls in Nugegoda.

1960 1970 1980 1990 2000

LIBERIA

1989 to 2003

1910 1920 1930 1940 1950

Founded by freed American slaves in 1820, Liberia enjoyed relative peace until the violent coup d'etat of ethnic Khran military leader Samuel Doe in 1980 and the execution of President William Tolbert led to the end of the Americo-Liberian era. In 1989, Charles Taylor, an American-educated former Liberian procurement officer, led a rebel invasion of the country to topple Doe. Although Doe was killed, fighting continued through the next decade, pitting various ethnic groups — namely the Khran, and Gio and Mano peoples — against each other, turning half the population into refugees, and embroiling neighboring nations. This civil war ended with a peace treaty signed days after Taylor's forced exile in August 2003.

NAME:
Liberian Civil War
TYPE:
Ethnic/Religious
CASUALTIES:
Over 200,000 killed

| 1960 | 1970 | 1980 | 1990 | 2000 |

I'm twelve years old. I was on the front from 1990 to 1991. When the war started I was with my friend in Harbel, where I'm from. Sometimes my mother used to send us out to the gas station or the market, and we would stop and play. That's when the NPFL came, put us on a truck and took us to the front.

They asked us if we wanted to fight. My friend agreed, but I was afraid. I didn't want to fight. I carried the gun on my back, but I never used it. Most of the time the fighters killed just to get food. One time they killed a pregnant woman with a knife. She was under a cotton tree.

Another time they fought against the ECOMOG [Economic Community of West African States Cease-Fire Monitoring Group], the peace keeping forces. When the fighting really heated up, my group retreated. But I got lost. I ended up in ECOMOG territory, where they caught me and took me off the front.

When they tried to reunite me with my family, they found that my father was dead. They could not find my mother. Now I live on my own. I sleep in the waterside area of Monrovia with some other boys. We hustle for food. We go on "chicken missions." We go into the community and when we see a chicken, we just grab it.

Monrovia, Liberia 2.1996

Tamba is cleaned up by an aid worker before being taken for medical treatment in Monrovia.

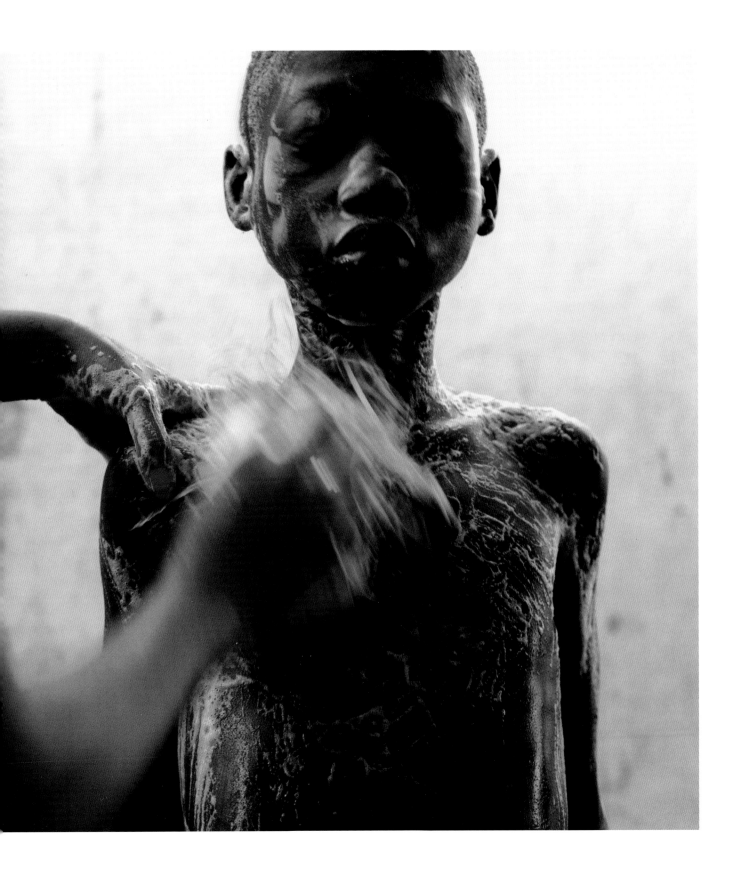

I became a fighter with the NPFL when I was ten years old. I had to join because the NPFL killed my parents, my sister and brother, and if I didn't they would keep killing my friends and family. Today, my aunt is the only family I have left.

I was afraid during the war, but at the same time it felt good to hold a gun. My job was to take care of the ladies wing on the military side. I was a lieutenant. The ladies had a specific group just like the men. They called us the "wives." I was "Lieutenant Wife." We were responsible for washing, cooking, reconnaissance and fighting.

It was hard to see my friends take another human being and cut off their head. Some killed children and babies, not me — but I saw it. If they were hunting tribes, they would kill the baby and the mother just because they were from a different ethnic group. People were crying and screaming. That's how it was.

Monrovia, Liberia 2.1996

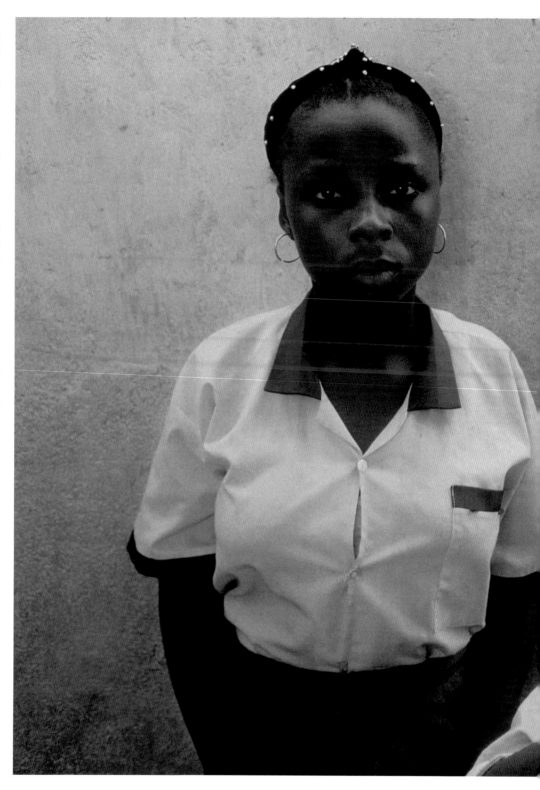

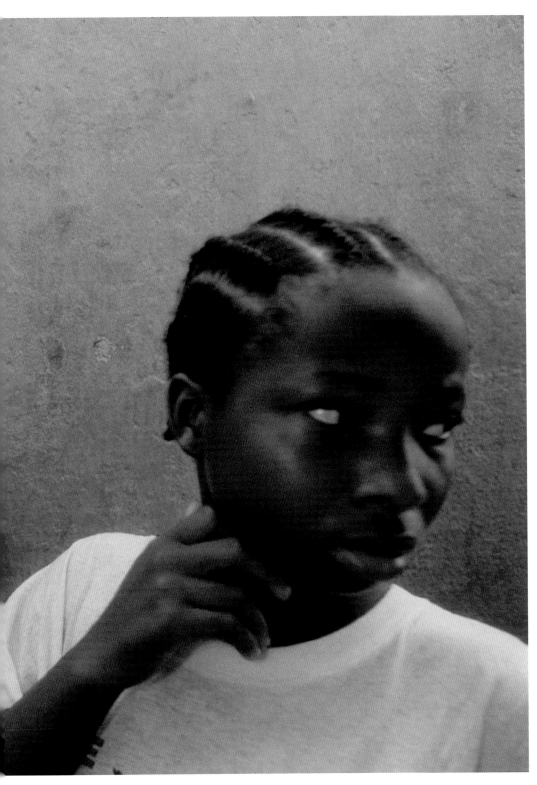

I was with the LPC. I joined in 1994, when I was thirteen, and was demobilized the following year. My fighting name was "Woman Death Squad."

I did reconnaissance work. I heard the guns, but I never fired one. We would act like civilians or pretend to be deserters. We would infiltrate the enemy group, study their activities, then slip back and give our group the information.

My parents were killed in the war — that's why I fought in the beginning. I stopped because I didn't know what we were fighting for. Brothers against brothers and sisters against sisters — it was just a useless thing.

Now my friend Lovetta and I are selling fish in the market.

Monrovia, Liberia 2.1996

Lovetta and Jeanette outside of Assembly of God Elementary School in Monrovia where they now attend the third and fourth grades.

1960 1970 1980 1990 2000

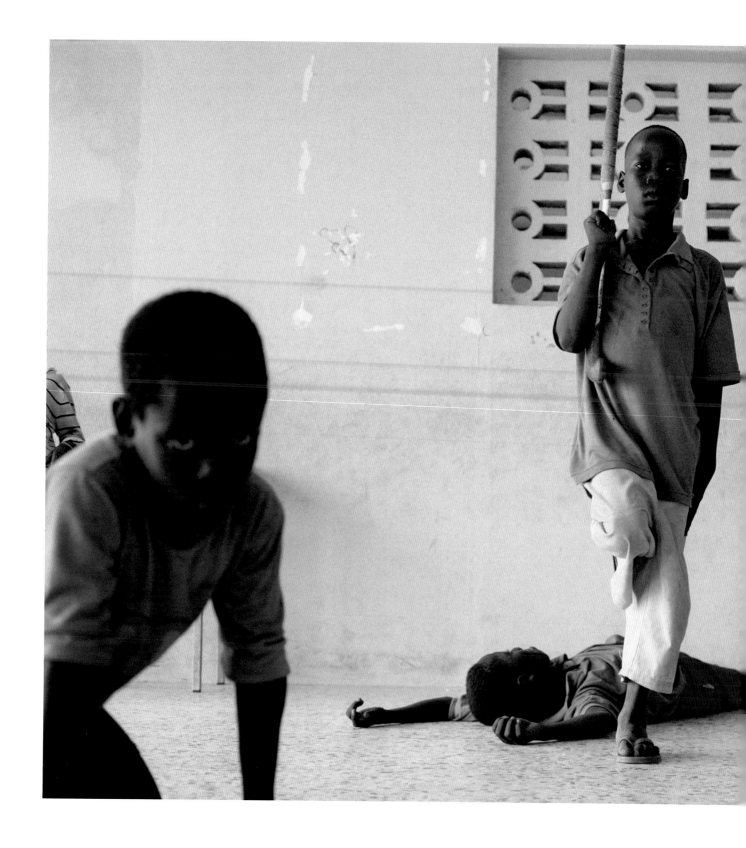

AFTERWAR : Lori Grinker LIBERIA : 1989 . 2003

Otis:

I was living in Harbel when the war began. Then the NPFL came to town and took all of us, thirty-six boys. I was nine years old.

The war was hard, but I was never scared. I was happy because Charles Taylor took us in a convoy and I was selected to be in charge. I was assigned six boys as guards; the rest of the twenty-nine were under my command. I was a full colonel. They called me "C.O. Dirty Ways" — that's "Commanding Officer Dirty Ways."

People were afraid of me because I killed in bad ways. I'd be killing and laughing at the same time. Sometimes I would use a knife and poke their stomach or take out an eyeball. I didn't like to do it, I just did it. It was the drugs — in the middle of the night they gave us drugs mixed in water, and they injected us in our shoulder or thigh with 10 ccs of something else. When we woke up, we would be numb. It can make you strong — give you the urge to do things.

War is not a school. In school you go to learn something and remember it. War is something you do to destroy — you destroy and you are finished with it. You don't remember how many you killed. You kill and you go.

But I regret the killing. I have bad dreams. I have this one dream where I am wearing a suit and a tie. And Charles Taylor comes up to me and asks me to give him some money. I say to him, "You took me to the bush and messed up my life and now you come to ask me for money?!"

I sleep with my friends now. I am afraid to sleep alone.

Joseph:

I was with the NPFL. I joined when I was nine years old. I'm thirteen now.

I was a major. They called me "Major Rebel Baby." I didn't like fighting, I found it scary. We were living a loose life, anything could happen. Sometimes we would go in the bush and kill animals, like raccoons, and eat them raw. It was a terrible life.

Once, I was ordered to execute a girl, a civilian. My commander told me that she was his love and had betrayed him with a lower ranking officer. He ordered me to shoot her. I kicked her and pushed her. She was screaming and crying and begging me. I was crying too. Then, when we were out of his sight, I let her go. I shot two times in the air to make my commander believe she was dead. I gave her a little money, and she ran away — and she said that she would always remember me for letting her escape.

Monrovia, Liberia 2.1996

Otis and friends reenact military drills at the Don Bosco Center for Boys in Monrovia.

NORTHERN IRELAND 1969 to 1998

1910 1920 1930 1940 1950

In 1969, growing Catholic protests and civil unrest lead to the deployment of British troops in the UK's contested province of Northern Ireland (Ulster). Soon long simmering tensions between pro-British Protestants and minority Catholics erupted into deadly sectarian war. For the next 30 years, Northern Ireland was scarred by conflict, often terrorist in nature, as British soldiers and Protestant and Catholic paramilitaries clashed in a war of bombings, assassinations, and murder waged against both fighters and civilians in Ireland and England. Often remembered for the deadly events of 1972, including the killing of 23 people by British soldiers on "Bloody Sunday" in Derry, and the death of 10 imprisoned Irish Catholic hunger strikers, the conflict came to an official end with the Good Friday Agreement of April 1998.

NAME:
The Troubles
TYPE:
Sectarian, Ethnic/Religious, Terrorism, Decolonization
CASUALTIES:
3,500 killed
36,000 wounded

1960 1970 1980 1990 2000

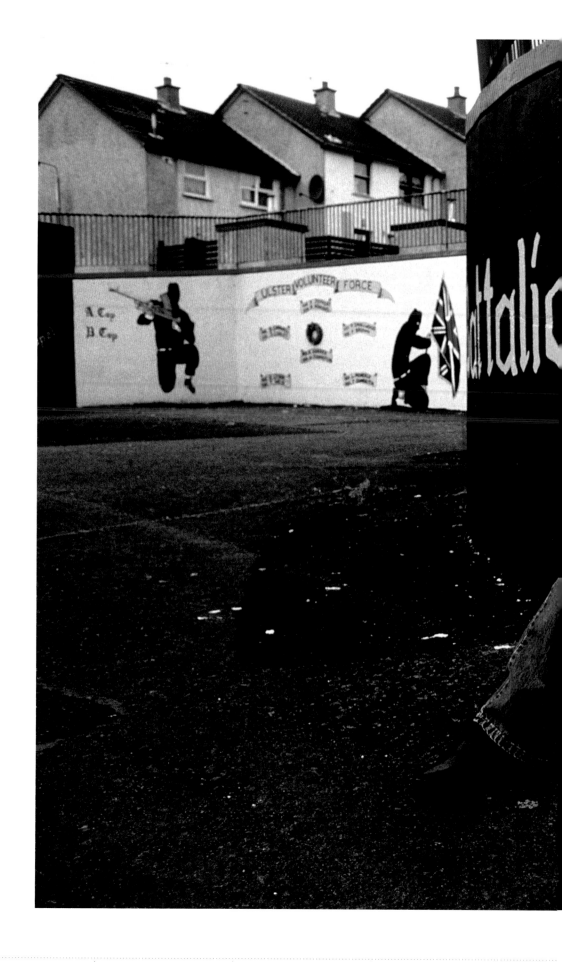

AFTERWAR : Lori Grinker **NORTHERN IRELAND** : 1969 . 1998

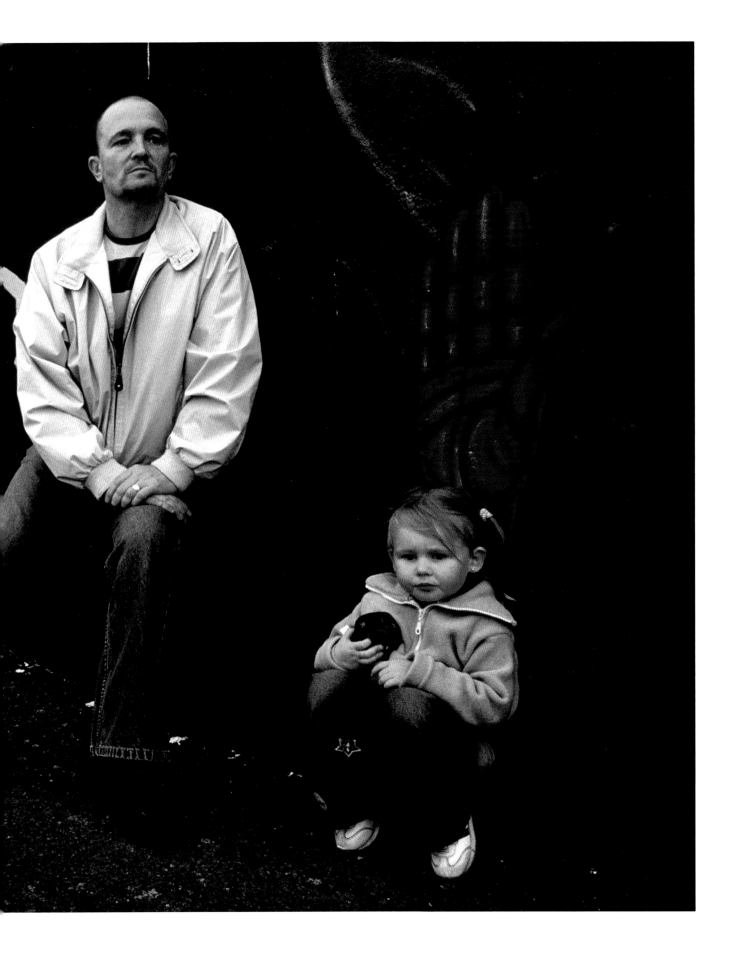

As a young man in my teens I was strongly influenced and led by Dr. Paisley. My uncle was a "Paisleyite," and he took me to Paisley's church on Sundays to listen to him preach. He preached anti-Catholicism; he had people believing that there was going to be a complete civil war under the force of evil, and I believed it.

It wasn't until I was about thirty, about five years into my life sentence in prison, that I started looking at things from my own point-of-view.

When I was about sixteen or seventeen, I was led to join the paramilitaries in Dundonnell. The vast majority of the people in these areas didn't get involved. They were living a normal life there, but for one reason or another I found myself led to this place with the UVF.

At the start I wasn't involved in anything severe. Then I got married and moved to the heart of East Belfast. There I found myself more involved in the goings on. I was trained there, lots of weapons training, short arms. They trained us in people's houses, mostly with handguns, submachine guns. It was thrilling then.

In a period of eighteen months I made it clear to my superiors that I was prepared to do whatever was necessary, targeting people, getting involved in armed robberies for fundraising, collecting intelligence, getting arms, shooting people dead.

The first time I was involved in a killing it was random. We were looking for a particular man from the IRA [Irish Republican Army], but the attitude then was: if you're going into a Republican or Nation-alist area, armed to the teeth, and you see someone else, either a Catholic or a player, then you can take the opportunity to shoot them dead. At the time I thought nothing of it. We got out of the car and walked up to him and shot him dead and sped away from the scene.

Over a period of about a month I was involved in several murders, several attempted murders, several armed robberies, and basically I was up to my neck in stuff nearly every day of the week.

Two of the people I killed were young men in their twenties, one a man in his fifties, and the other was an old woman around seventy. What happened with her was I burst into a house with two other gunmen looking for some men in their forties. There was a woman and some others in the bedroom who started screaming. One of the other gunmen pushed passed this old woman and shot the people in the bed, then walked out of the house and shot the old woman. Because I was at the scene I was also charged with the murder, although I didn't pull the trigger then.

A year after I was arrested, in

1910　　　　1920　　　　1930　　　　1940　　　　1950

1982, I was sent to Crumlin Road Prison for two and a half years, awaiting trial for four murders. Then they took me to Long Kesh. At that time it was easier to just plead guilty rather than pleading innocent and dragging your victims' relatives through the trial and all. That's what I did, cause I knew I was going to have to serve for at least one of the killings. One guy I killed had been an active member of the INLA [Irish National Liberation Army]. I might have gotten off for that one with manslaughter due to who he was, but the others were murder.

I received four life sentences, 350 years. I was in my early twenties. At that time I didn't think much about what I had done.

At about the eight-year stage of my sentence I had trouble looking forward. Somebody suggested that I start writing to a pen pal. I wrote the first letter and this girl wrote back. She saw that I was in for life and wasn't looking for a girlfriend. We became pen friends and three years later she began to visit me. When I got my first leave, I went to see her and we became lovers. We got married during Christmas of 1996 during my ten-day parole. It hasn't all been roses, there's an awful lot of things that sixteen years in prison has done to me.

I do regret that I took life, but I also regret the state that this country was in when I was led to take those lives. I believe that I was let down by a government that didn't protect their people. I'm not saying that what I did wasn't a criminal act, but it was a situation that I couldn't see any other way around.

Working with the young people today, helping lead them down a better path than I was led down, is the best way I can say I'm sorry. I work in the community. We try to improve the quality of life for those who are living in the interface — the areas where the Roman Catholics and Protestants live "cheek to jaw," separated only by the width of the road and what is called a "peace wall." Something like five hundred people in Belfast have been shot dead within a hundred yards of these peace fences, so we try and keep the peace in these areas. The war is over but they still clash, they are brought up to fear one side or the other. It's inbred.

To be honest, when I come to work through a Republican Nationalist area, I still feel the need to vary the route I take. For example, I was coming to work this morning and I saw a guy who was the head of intelligence for the IRA. He passed by and looked at his watch as he passed me. That was enough to tell me that I should get a bus to work tomorrow at a different place and a different time. I may have been reading into something that wasn't there, but you can never be too careful — especially when you have a past.

Belfast, Northern Ireland 10.2002

Caption to picture on page : 34.35
Noel Large with his daughter Courtney at home in Newtownabbey, near Belfast.

My earliest memory of going to school was being spat on and called names. As a teenager, you began getting harassed by the RUC [Royal Ulster Constabulary] and the British army. You clearly saw the injustices and inequality, and in some way or another you got involved.

In the early 70s most people rioted. It came out of a sense of frustration. Whenever homes were raided people came out to support those who were being arrested. Probably there weren't as many girls and women as there were young men. In Irish society, women were always seen as the caregivers and the mothers. They were the backbone of the people who were out on the streets fighting.

I was trained in the youth wing at fourteen, in 1974. I considered the situation here a war. You had a foreign part in government whom you had the right to take up arms against since they were oppressing you. You never wanted to do it. It was never something that you liked doing, but you were there for as long as it took, and you never questioned whether or not you were willing to die for this. You just moved forward and accepted it.

I was arrested on Friday evening, March 21, 1980. There was a shooting at a checkpoint, and two of us were in a van nearby which had bombs in it. We were caught and sentenced to twenty years.

It was just two weeks after I turned twenty. The jails were in serous conflict, those in the H blocks from 1977 and the women in Armagh women's jail had just recently started the "no-wash" protests. There were some very sad times, particularly during the hunger strike — times you just wished you weren't there. But on the whole, prison was a learning curve for me and a lot of positive things came out of it. One of them

was the comrades, friends that I made. I missed my family and all, but there were a lot of people worse off then myself.

We served ten and a half years each, getting out in 1990. I didn't realize the effect that my imprisonment had on my mother until one time when they opened the prison for visits after it was closed down. I brought my mommy into my former cell and she started crying, saying she couldn't believe I was living there for ten years. I wish I hadn't brought her there, I had no idea that it would have this effect on her. To me it just looked like a cell, I was accustomed to it. That was the first time it really struck me how bad it had been.

Belfast, Northern Ireland 10.2002

Jennifer McCann with her three children in front of the Twinbrook Road "Plastic Bullets" memorial mural in West Belfast.

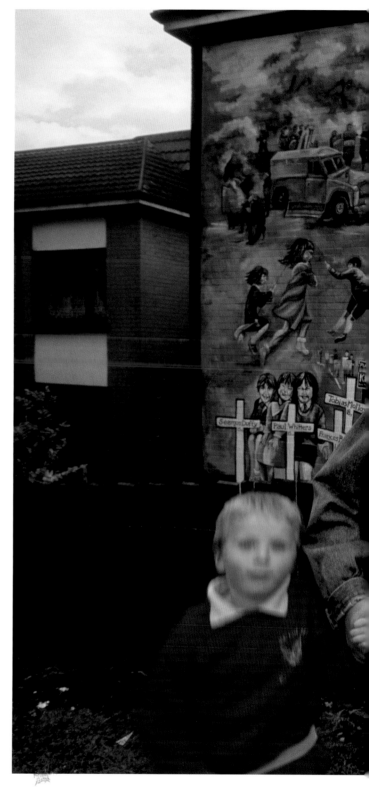

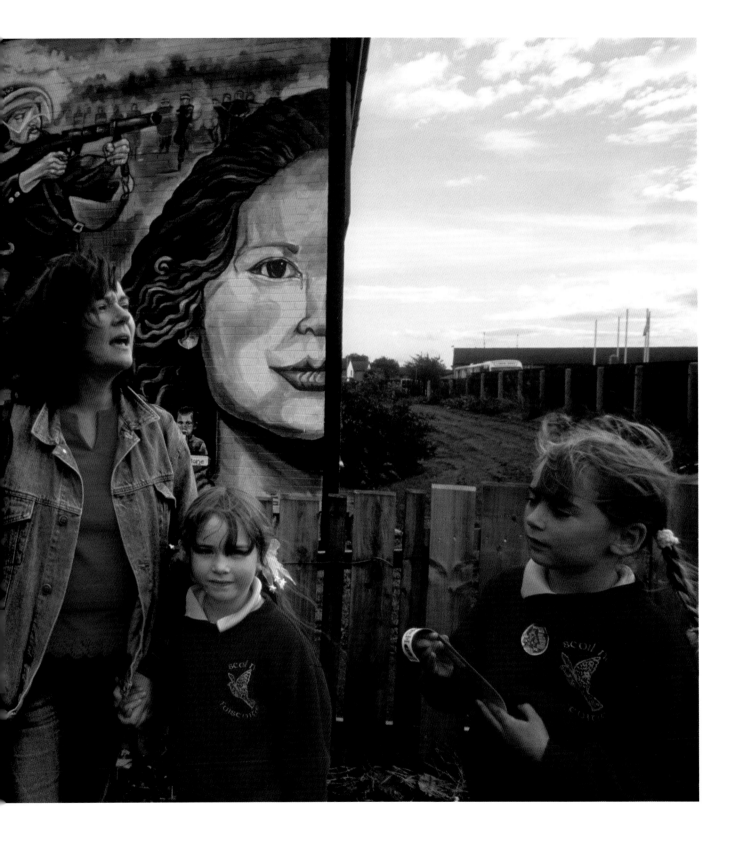

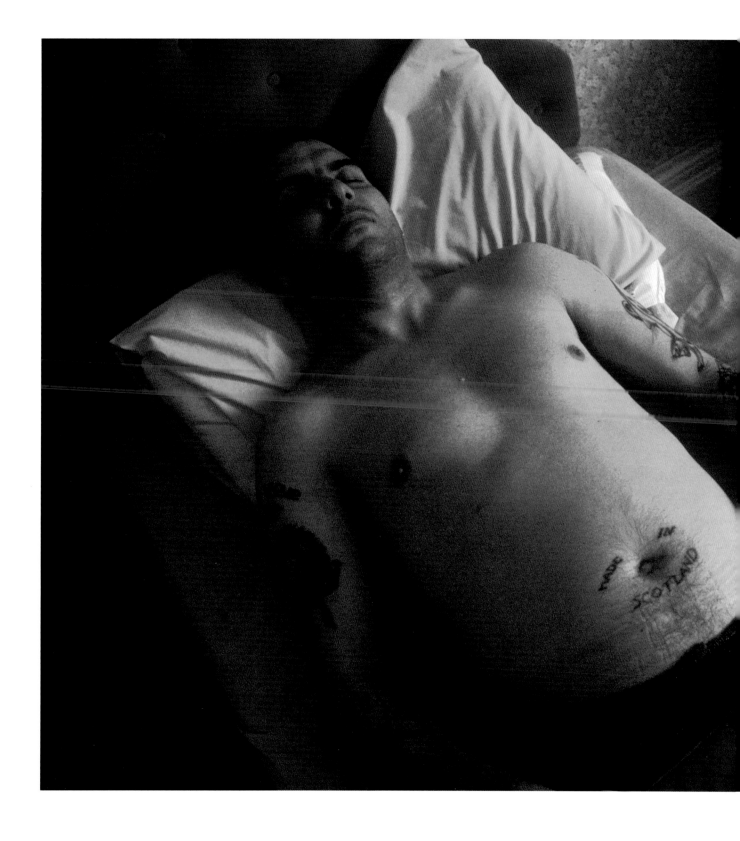

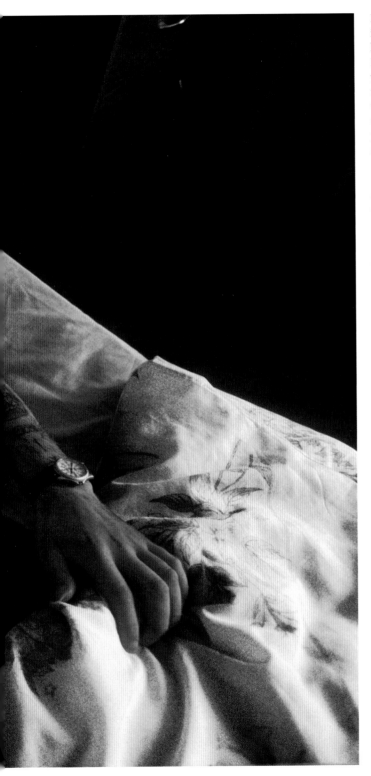

It's an aggressive place. They had it in their minds to kill us and I had it in my mind to kill them. Before you go to Northern Ireland, you hear on the television that there's a "not to kill" policy — that's rubbish. Our company commander offered a bottle of champagne to the first to kill or maim a terrorist.

I was sixteen when I joined. I'd always wanted to join — for the discipline, the glorification, to be proud to say I am in the army.

For years they train you to kill. Then they let you back out on "civvy street," but you're no longer allowed to be aggressive. You don't trust anybody and you can't quite understand what has happened. I can't hold down a relationship or a job. I've lost everything — my relationships, my friends. I lost my family for a while. I'm thirty-one years old now.

I hear Irish voices and I start to sweat. I tried to pop off someone's head in a bar. The people on civvy street just don't understand. The only people we can speak to is one of us. Only someone who's been there can know. If you've got a physical wound, fair enough, but if it's up here in the head they don't want to know from you. This is the last chance saloon. It was either this, the gutter, or suicide.

I tried suicide and the rope broke.

Llandudno, Wales U.K. 8.1998

Graham Cunningham in the Ty Gwyn center for Post Traumatic Stress Disorder in Llandudno.

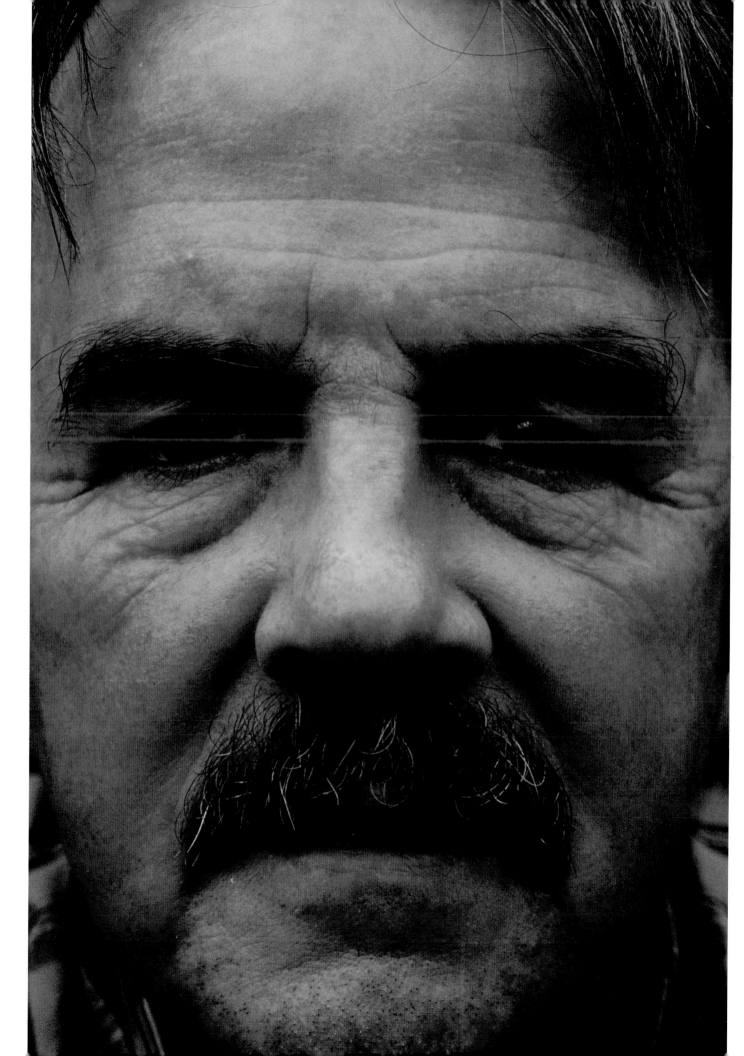

In 1967 I was twenty-two and I was curious. I was always interested in current affairs, in the civil rights protests and marches, and when possible I would attend them. The demands of the civil rights association were pretty innocuous, we weren't asking for anything too radical, but we were still batoned off the streets by the RUC [Royal Ulster Constabulary]. Come 1969, when The Troubles spread to Belfast, I witnessed the forces of law petrol-bombing working-class homes and pubs on the Catholic side of the community. It was then when I realized that the force of argument would no longer carry any weight, so I and many others decided to try the argument of force.

I joined the IRA. It was my decision to join, a decision based upon my own experiences. It was, however, made more difficult by the fact that I had one brother in the RUC and another in the British Army.

My brother who joined the RUC did so because he was a good athlete. We lived in an area made up predominantly of police families who lived there since the 1920s, and one of the men convinced my brother that he would have a great time in the RUC because he was an athlete. That's why he went in. I remember clearly one night when I was living with my mother, and some RUC arrived in our district. I was involved in a riot with these policemen and my mother, shocked, said, "but your brother is an RUC policemen." I said, "Yes, mother, and if he comes I'll stone him too."

My other brother joined the British Army because he was living in England at the time and couldn't find work. In 1971 after I was arrested by the British Army and tortured while incarcerated, beaten and shot in the hand, he came to visit me and was brought face to face with the workings of the

state. After that he went AWOL. The first time I was arrested it was Boxing Day of '71. Two comrades and I had had a couple of drinks and went back to my house for a cup of tea. It was really hard to stay at your own home at this time, due to the periodic raids by the British Army, but it was nearly three in the morning, so we decided to stay there. At five, the house was raided and the three of us were arrested. We were brought to the Holywood Barracks and badly beaten for the next three days. Then we were put on the prison ship, the Maidstone. I was put on the boat on New Year's Eve, 1971.

Eighteen days later we escaped. There were two iron bars that covered the prisoners' porthole. We had sawed through them, and one by one, seven of us, blacked up with shoe polish and smeared with butter to protect ourselves from the freezing water, slid down the hawser into the bay. It was a quiet night, which made it more difficult, and of course there were soldiers on the top decks and on the bridge of the boat. The lights from the ship were incredibly bright and I thought for sure that someone would see me. I turned around and saw my comrades' faces in the portholes. When I realized I was in the clear I swam calmly to a pier on the other side. The water was freezing but because the adrenaline was pumping so hard I didn't really feel it. It took about twenty-five minutes to reach the shore.

From the docks I made my way home and got some clothing, and then my comrades and I made our way to Dublin; the British authorities couldn't arrest us in the Republic of Ireland. When we arrived in Dublin there was a lot of publicity. Some of our wives and children came to meet us to make sure we were safe. We made great of these victories. They were few and far-between so you

milked them at all sorts of press conferences.

After all the propaganda I came back to Belfast and again became involved in the conflict. I was rearrested in August of 1972. I was held in remand and charged with escaping from lawful custody, but lawful custody wasn't lawful at the time, it was internment. I was held without charge until December 1975 in Long Kesh, which was like a prisoner of war camp with huts and compounds.

In July 1972, one of the conditions set by the Provisional IRA when they negotiated a truce with the British government was special status for all prisoners convicted of terrorist-related crimes, which was effectively prisoner-of-war status, and meant that prisoners did not have to wear prison uniforms or do prison work, and they were allowed extra visits and food parcels. In January 1975 the Gardiner Committee put an end to this. From March 1976 anyone convicted of a terrorist-related offence would be treated like an ordinary criminal and would have to wear a prison uni-

form and do prison work. We felt that wearing the prison uniform criminalized our struggle for a free democratic Ireland.

The "screws" preyed upon us. Some of the guards were there to make your life hell.

Then in March 1978, after being harassed by prison officers when we went to the toilets, we began the no-wash protest, or the so-called "dirty protest."

This was where you were spreading your excrement on the walls of your cell. After a while you become accustomed to it. The H-blocks had been set up in four wings, A, B, C, D, shaped like the letter "H". The four arms were the

wings. The cross piece of the letter was the administration section where the screws ate and had their offices. They kept one wing empty so as one got dirtied up they'd move these people lock, stock and barrel into the empty wing, which was clean, clean the other wing, and keep on like this in a continuous movement. Then you went back and dirtied them.

Then came the hunger strike. Bobby Sands died in May 1972. The last person died towards the end of that year. It was a terrible time, you felt so helpless, people were dying very close to you and you couldn't do anything about it. Had my name been accepted, I could've had the same ending as them. Everyone put their name forward for the hunger strike. But they tried to select people who weren't married, who were doing long sentences.

I was released from prison for the last time in 1986. I graduated university with a degree in English in 1990.

When I joined the IRA I thought I was helping to bring a real change for all the people. I thought I was going to help change the social economic order and bring about a socialist egalitarian state.

What we brought about was just to exchange one leader for another.

At that time we would plant bombs. If you put a bomb somewhere, to the best of your know-

I nor any other former or serving IRA person would describe our actions as "terrorist" or "crimes" — therefore we refused to wear the uniform and from 1976-82, rather than go naked we just wore blankets the whole time.

ledge, there would only be British servicemen or RUC men, and there'd be no warning. If you put a booby trap, say you blew up a car or a place just to take out British soldiers or RUC people, there was no warning. Wherever there would be civilians, or if you are going to do some government building or shopping precincts, then you give a warning so the innocent people could be taken away. But there were times like July 21, 1972, when the IRA put some thirty bombs in Belfast expecting that people could be moved away, but people were moved away from one bomb and close to another. It was horrific, Bloody Friday. I wasn't directly involved, but I'm not going to wash my hands of it. I was heavily involved in the preparatory stage.

I wouldn't do it again, no way. I feel like all those years were wasted, all those lives were wasted. The changes happening now would've happened anyway; they are incidental to the war. More Catholics are moving into so-called power — the war has very little to do with that.

Belfast, Northern Ireland 10.2002

(from left to right) Tommy Toland, Jim Bryson, Peter Rogers, Tommy Kane, Tommy Gorman, Martin Taylor and Sean Convery, known as the "Magnificent Seven" for their 1972 escape from the Maidstone prison ship.

Caption to picture on page : 42.43
Tommy Gorman at home in West Belfast.

BOSNIA ^{1992 to 1995}

1910 1920 1930 1940 1950

Bosnia-Herzegovenia, composed of Muslim Slavs, Catholic Croats and Orthodox Bosnians Serbs, was created in February 1992 in the vacuum left by the breakup of the Soviet Union and the former Yugoslavia. War erupted soon afterwards when Serbian forces, who opposed independence, fearing a Muslim state, attacked Sarajevo. Over the next two years, Serb snipers killed and wounded thousands of civilians, and paramilitaries conducted what would come to be known as "ethnic cleansing," forcing over two million to flee their homes, sparking the worst European refugee crisis since World War II. A NATO bombing campaign against Serb forces in 1994 led to the U.S.-brokered Dayton Accords in December 1995, but not before the worst massacre of the war, killing an estimated 7,000 Muslims, took place in the UN-declared "safe haven" of Srebenica in July 1995.

NAME:
Bosnian Civil War
TYPE:
Ethnic/Religious
CASUALTIES:
200,000 killed

1960 1970 1980 1990 2000

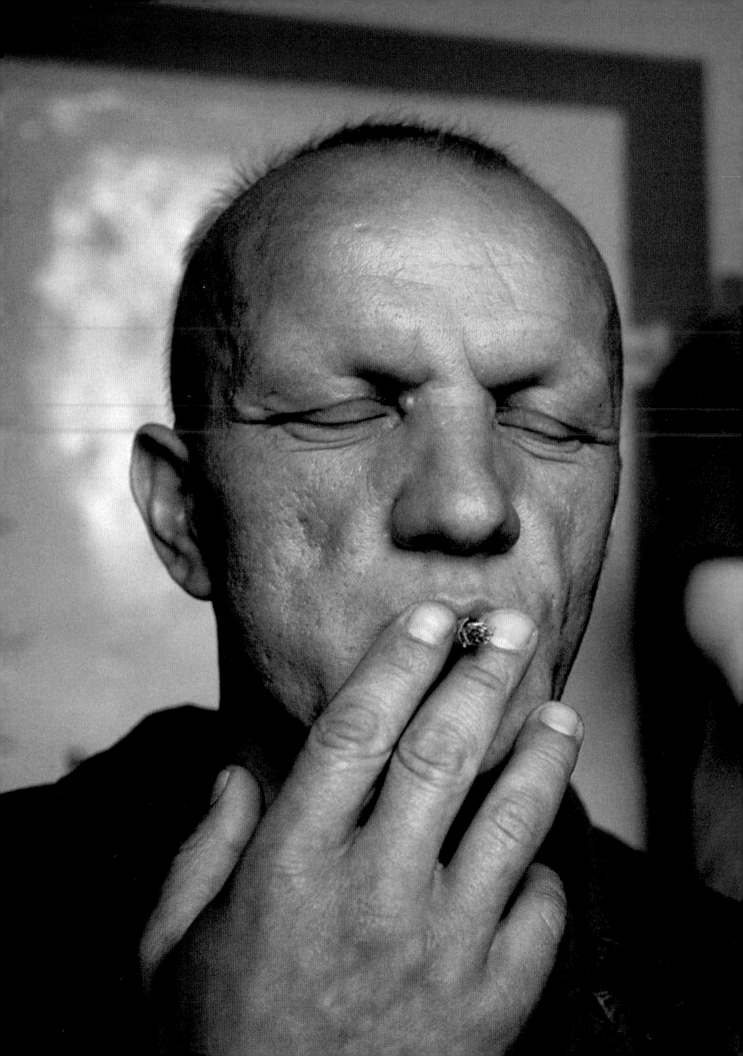

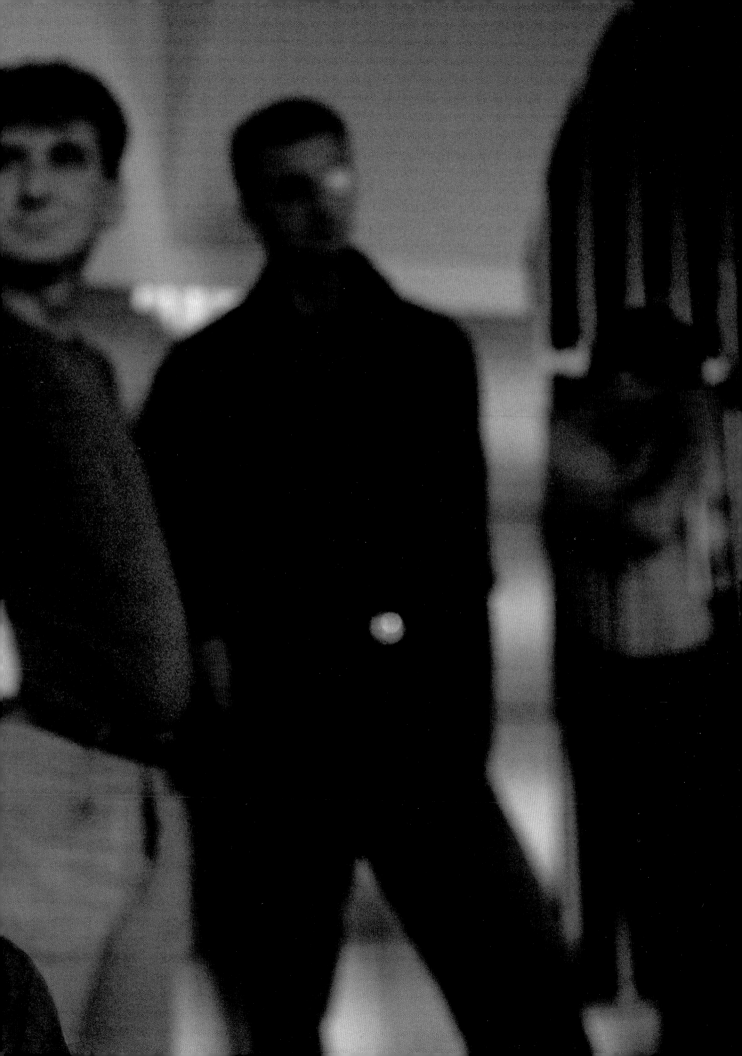

We were between twelve and twenty well-armed and well-trained guys, and I was assigned to be the commander. For eighteen months, my unit and I defended practically the whole area, the whole town, in fact. I returned from Croatia because my roots are here. I didn't want to become a hero or anything I just wanted to have a real country.

I had been on the frontline with my soldiers for twenty-five days when they gave me a forty-eight hour leave. There was a big anniversary celebration in town, and afterwards everyone went to the house of one of the commanders. I met my brother, who was working for the military, too, and we walked to the house together.

A few of the commanders at the house were supposed to be on the frontlines. They had left their soldiers on the front, with nobody in charge. I immediately ordered them back. All of them went, except for this one guy.

Some of the soldiers started to sing, including my brother. Maybe they started to sing a little too loud. They had been drinking and they began to sing with their souls. The commander who had refused to return to the front was drunk and started to complain. He told the accordionist to stop playing. Seeing that something ugly might happen, I ran over to my brother

and told him not to mess with this guy, to go home, take a rest. He was angry, but he left. Then, after he walked away, I heard four shots.

I went outside. I saw that commander holding my brother's gun. I thought for a second that maybe he killed him. We were all a bit drunk, but him most of all.

I asked him what he had done to my brother. "I didn't do anything," he said, "I only took his gun." After an argument, he gave me the gun and I walked away. But he followed me. "I'll show you how a man shoots a gun," he said. I retreated into a dark little room. "Don't come in here or I'll kill you," I screamed. He opened the door, just standing there. Through the open door, by the moonlight, I saw my brother lying on the ground.

I really don't know what happened then. It seems my mind just snapped. I saw this man about to shoot me; he was picking up his gun from behind him, trying to point it towards me.

It seems I just grabbed the gun and shot him. When I woke up, I saw my brother laying there and realized I had shot twenty bullets. I didn't check to see what happened to the man. I picked up my brother and left.

We went to our uncle's place

nearby and I called the police to find out what happened. They told me that I killed a man. They came for me and put me in the same prison where I used to bring captured enemies. That's how the story ends: a sentence of ten and a half years.

I consider this experience a part of the war, because in the war just a little music and a little drink and you'd lose yourself. The war puts something in your head — maybe you don't know it immediately, but it's inside you. I was an ordinary guy occupied with my job. I never broke the law. And now, I'm in prison, in a worse situation than the war.

How can a man stay calm and normal?

Zenica, Bosnia 7.1997

Caption to picture on page : 48.49
Kopić Nijaz, "Ninja," in a prison in Zenica.

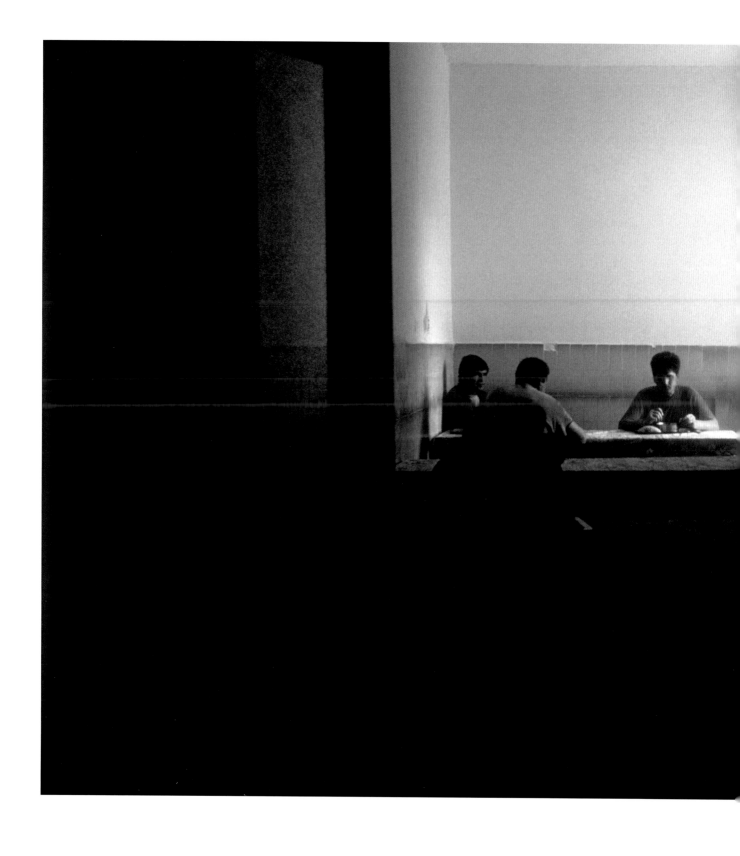

AFTERWAR : Lori Grinker　　　　　　BOSNIA : 1992 : 1995

I was with my friends at the front and we didn't have anything to do, so we drank a few bottles of plum brandy — well, we had a little dispute about who was a hero and I guess I wanted to be one, so after a little while, when they went to bed and I was on guard duty, I decided to attack the enemy line.

Our bunker was on a hill in a very hilly area of the forest, no road. As I walked, I tried to remember the way, but it seems that I was walking in circles.

Then I came across one of their bunkers. There was no guard and I crept up to the entrance and just shot a lot of bullets inside. I didn't see anybody. I think they had been sleeping and tried to reach for their weapons leaning on the doorway. Maybe that's how my bullets killed them all.

I saw a duffel bag and took it as a trophy. Then I ran for a short time until I came to a village. I recognized a hill, and from there I was able to find my way back. Somebody stopped to ask me where I was coming from. I said that I had been on enemy lines, that I had killed some enemy soldiers and destroyed their bunker. He told me that enemy soldiers had hit and destroyed one of our bunkers.

They searched the bag I had taken. On it they saw the initials of one of our guys who had been killed. The following morning the military police came and interrogated me. After they told me all the facts, I realized that I had shot my own men.

In two years I'll be a free man. I will never forget what I have done, but I hope I manage to enter back into society. In Bosnia, when somebody commits a bad act, his family is marked. I am married and have a six-year-old daughter.

My reputation will follow my family all their lives. It's going to be very difficult to live in that environment.

Tuzla, Bosnia 7.1997

Mujanović Nihad (right) in the mess hall of the Tuzla prison.

1960 1970 1980 1990 2000

ISRAEL-PALESTINE 1987 to 1993

1910 1920 1930 1940 1950

Seeing little change in their stateless refugee status, Palestinians took the streets in Israeli-occupied Gaza and the West Bank in late 1987 demanding change. For the next five years, they waged a campaign of strikes, closures and violent demonstrations, fueling the rise of militant Islamic groups such as Hamas. The "David versus Goliath" conflict between stone-throwing Palestinians and heavily-armed Israeli soldiers captured world attention and helped create the international pressure that resulted in the Oslo Accords of 1993 which set the agenda for the establishment of two states, Israel and Palestine, living peacefully side by side. The peace process, however, was disrupted by Israeli prime minister Yitzhak Rabin's assassination by a Jewish law student in 1995.

NAME:
The Intifada, War of Stones
TYPE:
Popular uprising, Ethnic/Religious
CASUALTIES:
900 killed

1960 1970 1980 1990 2000

I was injured during the Intifada. There was a street battle and I was putting on a mask. An Israeli soldier told me to stop. I did, but he shot me three times in the back anyway. Then he took me to the hospital — Hadassh Hospital in Jerusalem — the same soldier who shot me. I've filed a lawsuit. I'm taking him to court. I don't think I will get anything, though.

There are many like me from the Intifada.

Psychologically, my life has not changed. What has changed is my way of living, my environment. My injury was hard on my family, but they got used to it. One adapts. People are very compassionate. Now I'm treated like a person who defended his land and was shot for it. Still, this wasn't my idea of a hero.

I hadn't made plans for the future, but now I am thinking of sports. I know the Jewish man who brings the wheelchairs. He brought me to their team. They liked my playing and let me join. I don't think I could be friends with them — they are the enemy — but I still want to play. Only now the roads are closed.

Ramallah, West Bank 3.1995

Arafat Jacoub (center) during basketball practice for the Sports Union Federation for Handicapped in Ramallah.

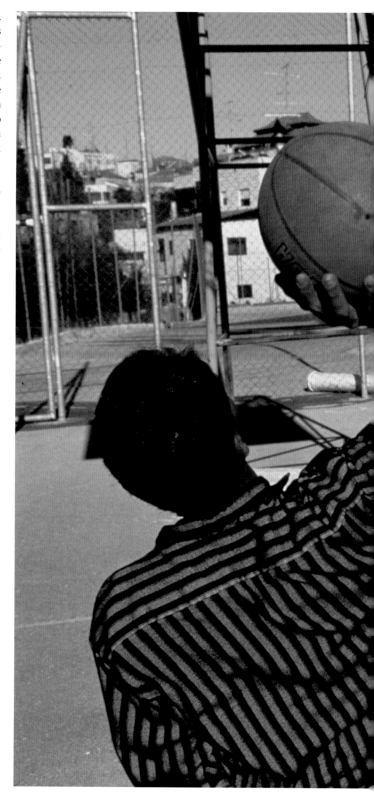

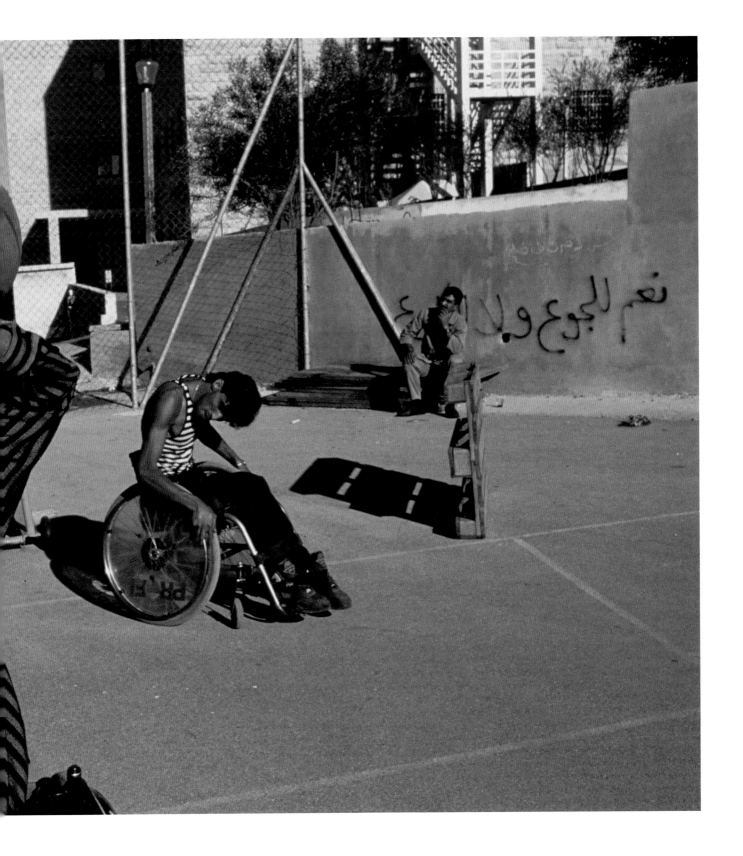

The whole thing was just a coincidence. During my month of reserve duty, I was on patrol in Gaza. I should never have been on this particular patrol, but they changed the location because the Shabak [Israeli security forces] wanted to arrest some suspects. On top of that, I was supposed to be in an armored vehicle, but I switched to the jeep. Instead of windows, the jeep had metal bars. The Molotov cocktail, probably meant for the street's regular patrol, passed between them.

There were three of us inside, and the jeep caught fire. The fuel tank was full and it was about to explode, my skin was hanging from my arms and face — but I didn't lose my head. I knew nobody could get inside to help me, that the only way out was through the fire to the doors. I wanted to take my gun, but I couldn't touch it because my hands were burning.

I plunged through the fire. When I got out the other soldiers put me on the ground and rolled me around, but the fire started again, so they put a blanket on me and extinguished the flames. Afterwards, a helicopter took me out of Gaza to a hospital on Mount Scopus.

I came home after six months. Over the next three years, I had surgery every two or three months, about twenty operations in all. Then I started physiotherapy, including painting. I took up painting at Beit Halochem. The pictures are beautiful, like a story about nice things, not things that destroy, exactly the opposite of the destruction.

Before the war, I thought the most important thing was land. Now I think the most valuable thing is life, because human beings come into this world as visitors. We come and we go, and we don't take anything with us, not land, not property, nothing.

People who see me, see what war really does.

Tel Aviv, Israel 3.1995

Yossi Arditi receives skin massage therapy at Beit Halochem (Warrior's Home) in Tel Aviv.

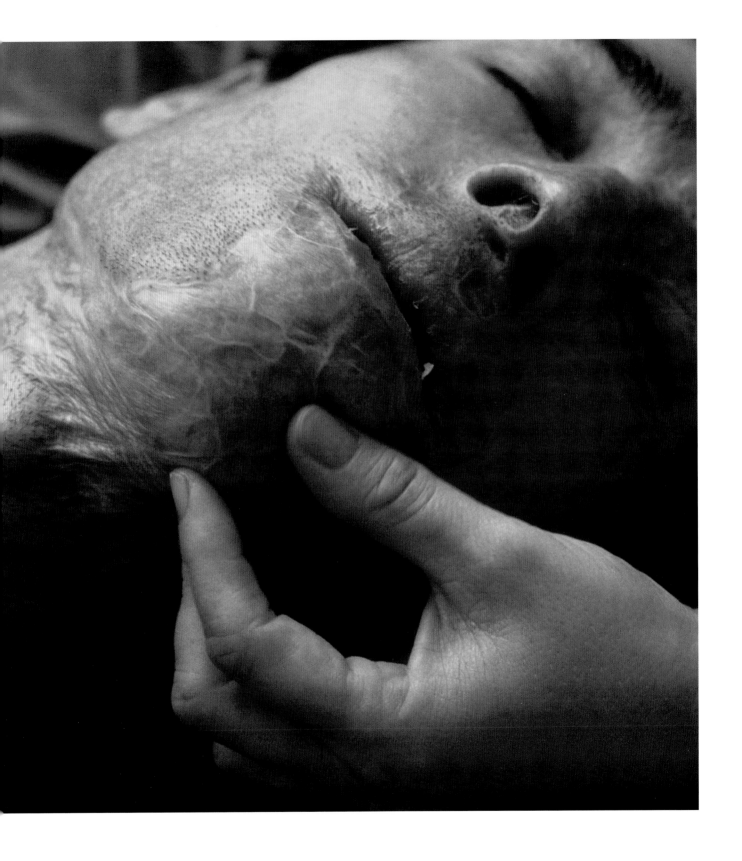

EL SALVADOR 1979 TO 1992

1910 1920 1930 1940 1950

Confronting the unresponsive Salvador military dictatorship that had ruled the country for the previous fifty years, the 1970s saw a rise in local opposition to the government from both the Salvadoran Left and the Roman Catholic clergy. The government reaction was repression. By 1979, this led to the birth of several guerilla organizations which rose to fight the dictatorship, notably the Marxist group, the FMLN. American support for the government — despite the murder of Archbishop Oscar Romero in 1980, the killing of three American nuns and a lay worker the same year by right-wing "death squads," and numerous other human rights violations — substantially increased after Ronald Reagan became U.S. president in 1981. The war continued until the signing of the Accords of Chapultepec on January 16, 1992.

NAME:
El Salvador Civil War
TYPE:
Popular Uprising, Cold War conflict
CASUALTIES:
Over 75,000 killed

1960 1970 1980 1990 2000

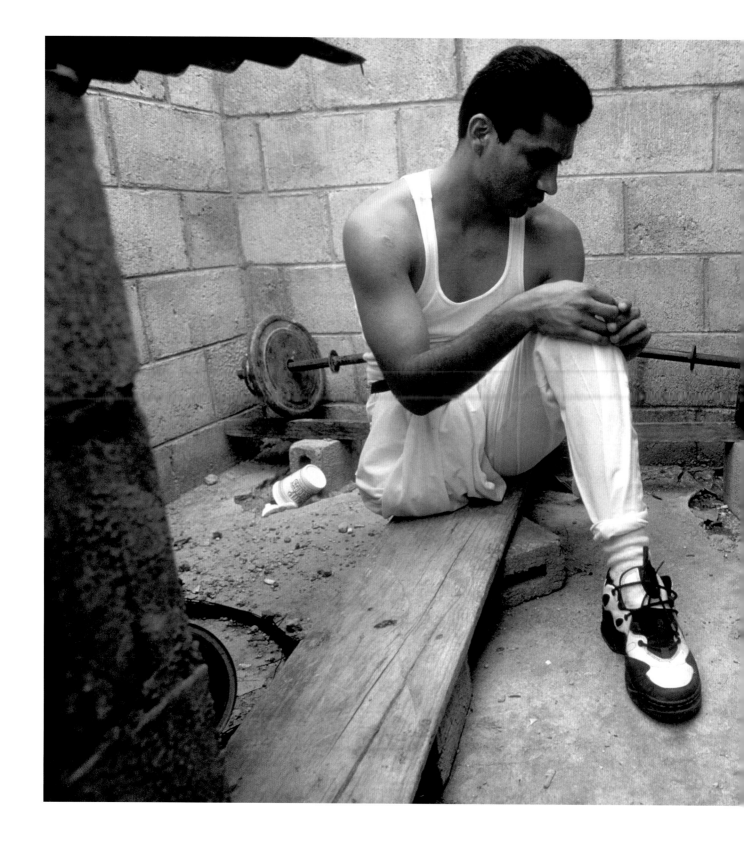

I was a sniper. I shot at crowds. I was trained to fight guerillas in a special American school in the jungles of Panama, and I was very proud that they had chosen me.

After I was hit, I knew that I was wounded but I didn't know that I couldn't see. About my legs, yes; I knew I'd lost them because I touched them and realized there was nothing there — but I kept my eyes closed. I thought if I opened them I would see.

When I arrived at the hospital and had the surgery, I didn't know what they were doing but I knew it was something tremendous, the hardest thing in my life. For days I was in a coma. I woke up on January 2, 1990. I started asking why it was so dark, but nobody told me that it was because I had lost my eyes.

One day my girlfriend arrived. She had been my girlfriend in the military and we had planned to be married. But when she saw me in the hospital — I don't know exactly what happened, but later they told me that when she saw me she began to cry. Afterwards, she ran away and never came back.

San Salvador, El Salvador 4.1997

Saul Alfaro in the backyard of his home in San Salvador.

In 1980, they took eight of us. They tied us up and a soldier said, "Walk, walk." I left my eight-month-old son in the backyard. Another woman left her three children.

One soldier said, "Okay, here, here, stop." Then they began to shoot. My mother-in-law and a pregnant woman who was about to have her baby ran away. I stayed there and was shot; they shot me and I fell to the ground. Afterwards, Imela fell, then Sebastian, then la niña Juana — all of them — and finally Toña. They lay there spread all over on the ground.

After a little while I heard the soldiers coming back. They stood over me and said, "This one's not dead" — so they shot me again. "She's dead now," one said.

When it started getting dark, I got up and tried to walk. My hands were still tied and I heard soldiers in the distance. They were following my trail of blood. I hid in a cluster of reeds and was trying to untie myself when I saw a soldier crawling on his belly with a rifle. I ran to a cornfield and he lost my trail.

When I was in the cornfield, I thought I was going to suffocate. Then I heard somebody say, "She's here, she's here ... Anita." It was my first cousin. It was dark, eight at night, and they brought me to a comrade's house. They took care of my wounds, took out the bullets, and at five in the morning brought me to the FMLN camp.

The next day my comrades went back and found the children we had left behind — alive. The others were all dead: my sister-in-law, my mother-in-law, and my husband.

My husband was shot to death; the boy's belly had been cut open with a machete; my sister-in-law, who was fourteen years old, they took to a little house and raped; then they stabbed her in the back with a machete and killed her. I was the only survivor.

I was twenty-one years old. Three months later I began to walk again.

Now life is the same as before the war — things didn't really change. I have six children from two different fathers who were both killed in the war. My only dream is to be able to work, to feed my children, to have every day a little tortilla to eat.

San Salvador, El Salvador 4.1997

Anita Maria Alvarado (left) and her sister Maria Wilma outside their home in San Salvador.

I joined in 1975 with my sister, father, and a brother who was killed. Altogether, six members of my family fought in the war.

What I remember most is running at night and firing a gun. These animals up in the sky — we didn't put the clothes out to dry because they could see them — left behind deep craters in the earth. Later we hid in them with the children, just in case.

The war made me a little crazy; now I suffer from depression. I don't sleep at night. I have three children and no husband — but at least I'm no longer afraid.

San Salvador, El Salvador 4.1997

| 1910 | 1920 | 1930 | 1940 | 1950 |

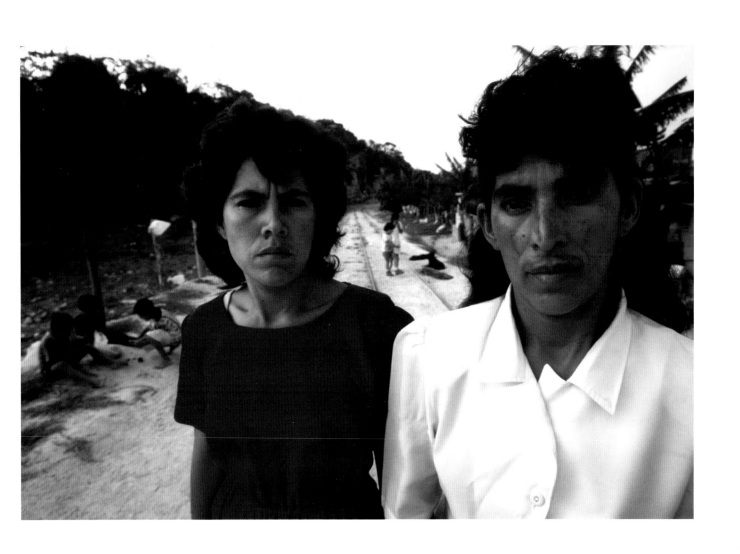

CAMBODIA 1979 TO 1991

After the last U.S. soldiers withdrew from Vietnam and
Cambodia in 1975, the Maoist-inspired Khmer Rouge,
led by Pol Pot, took over Cambodia and proceeded to
plunge the nation into unprecedented nightmare of
collectivization, massacres, starvation and torture that
would kill approximately two million people. Responding
to Khmer border raids in Southern Vietnam, in late 1978
Vietnam invaded and occupied Cambodia, forcing the
Khmer leadership into hiding, and beginning the world's
first sustained conflict between two Communist regimes:
Vietnam, backed by the Soviet Union, and the Chinese
and U.S.-backed Khmer. Largely unsuccessful in their
attempt to pacify Cambodia, in 1989 the Vietnamese
withdrew the last of their troops. A peace treaty between
all parties was signed in September 1991.

NAME:
Cambodian Civil War,
Vietnamese Intervention
TYPE:
Regional conflict, Civil war
CASUALTIES:
50,000-250,000 killed

1960 1970 1980 1990 2000

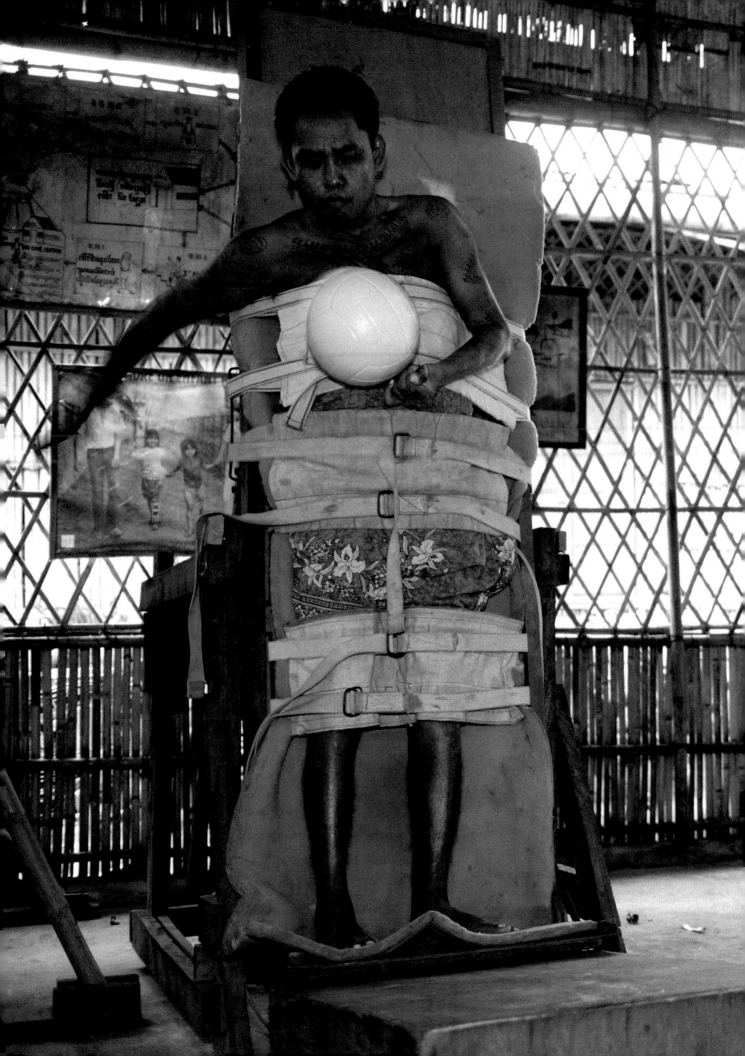

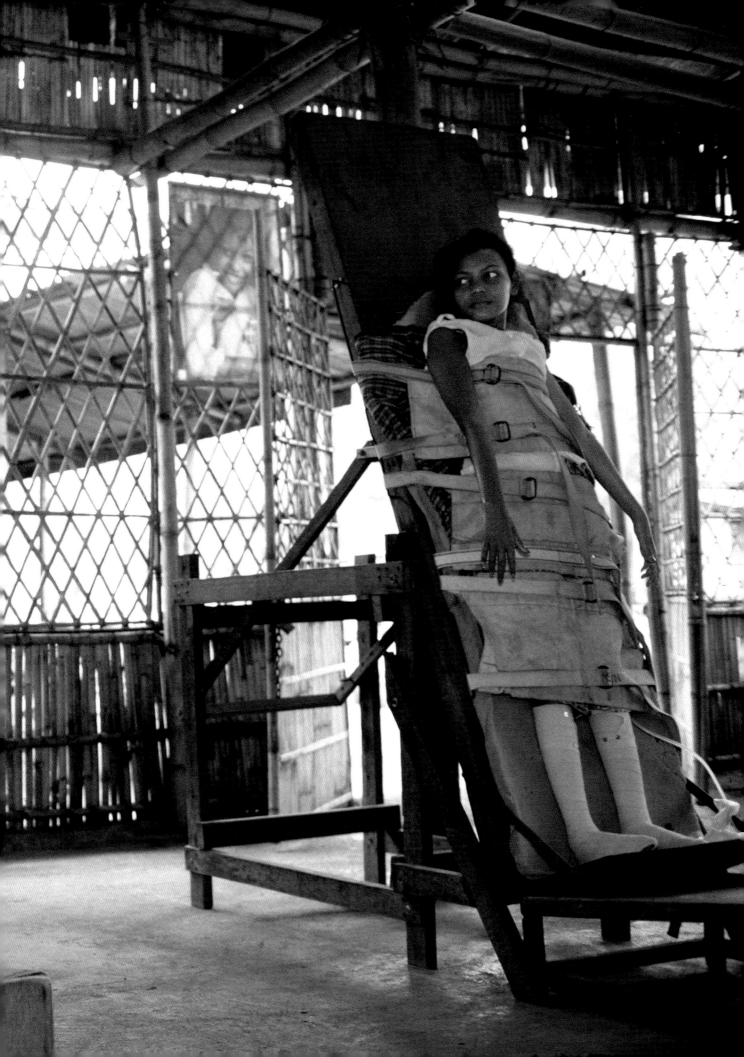

When I first arrived on the Thai-Cambodian border in 1979 it was a quiet place, but after a few months the Vietnamese were shelling our camp. I didn't want to fight, but I had to fight back. I'm very sorry now.

Sihanouk's group was very small then, so in 1982 I escaped and joined with Son San's group. Then in 1985, I had the mine injury, a very big Chinese mine.

During all that time I was a soldier, I didn't think about my wife and child; it was too painful. I didn't think about my life, I didn't think about death. I thought about the war. I don't know what happened to my wife and child. We were separated in 1974, when I was a Lon Nol soldier. In 1979, when I left my homeland, I stopped looking for them. I don't know where they died, but I know they are dead.

My living situation is very difficult now. I don't have any money. It is impossible for me to be self-sufficient, to have my own house. I just lie here all day long thinking about my life, my damaged leg and arm, my situation. When I am unhappy I take the tape recorder and play music.

The happy times are in the past.

A lot of Khmer Rouge come to the camp but I feel nothing towards them. Some are children, the new ones. The old ones died during the Vietnamese period. I don't think these young Khmer Rouge really understand what went on during Pol Pot's time.

There is a civilian boy here, who lost his leg on a land mine, who helps me. He holds the cigarette to my mouth when I need to smoke. He is seventeen and we are from the same district in Cambodia. Sometimes when I have nobody to push me in my chair, he and the other children help. These people are my family. They treat me special. I'm the old man, the father in OHI [Operation Handicap International]. This makes me happy.

Aranyaprathet, Thailand 4.1990

Caption to picture on page : 68.69
Chea Sarouen at the Koh-I-Dong, OHI refugee camp in Aranyaprathet.

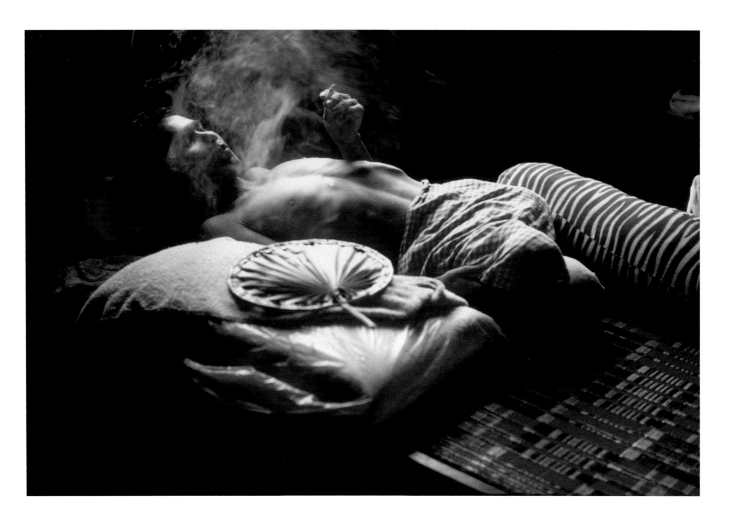

CHHENG | **born** 1959 **served** 1984-1989, Cambodian Army

We hit the mine, four of us. Good
friends. Now I sometimes get
confused and think I still have
both legs. When I realize that I
lost my legs, at first I feel upset.
Then I look at my friends who
also have no legs and I think that
it is normal.

Kompong Speu, Cambodia 4.1989

Chheng in the Kompong Speu Hospital.

1960 1970 1980 1990 2000

NGUYỄN TIEŃ DIŬG | born 1957 **served** 1977-1980 Vietnam Army

There are a lot of American soldiers inside my belt and my eyes are equipped with a lens made of artillery from China and the United States. I dream that I am flying in the sky and that we are all fighting.

Ba Vi, Vietnam 5.1994

Nguyễn Tień Diŭg at the Center for Psychiatric Treatment in Ba Vi.

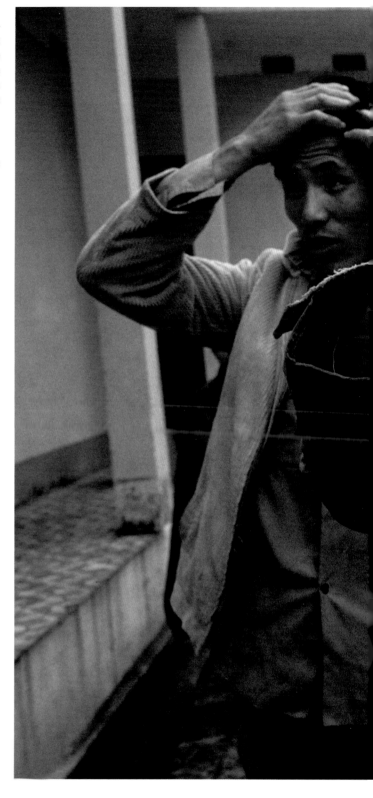

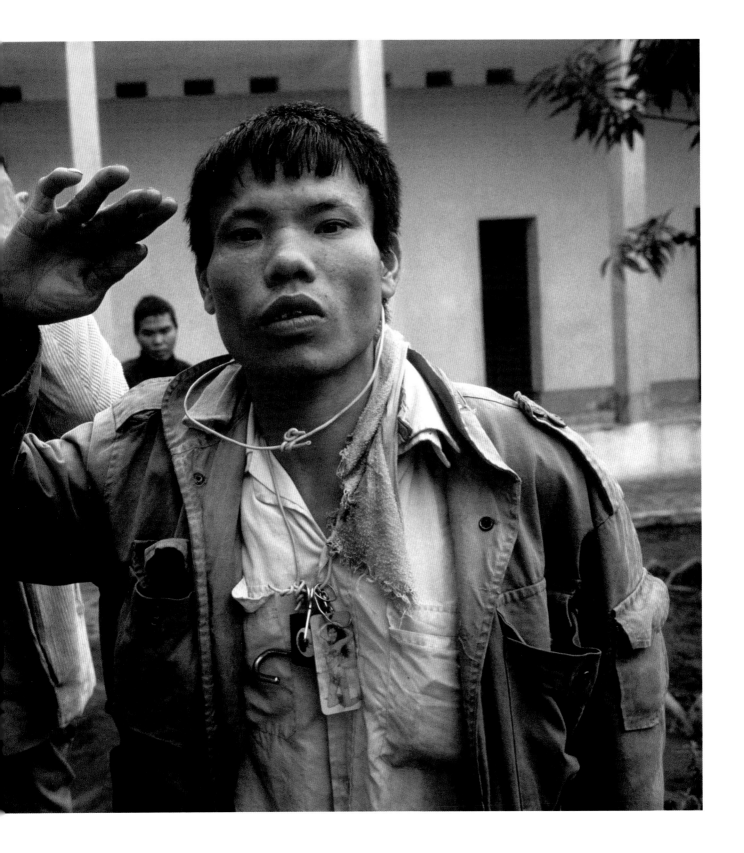

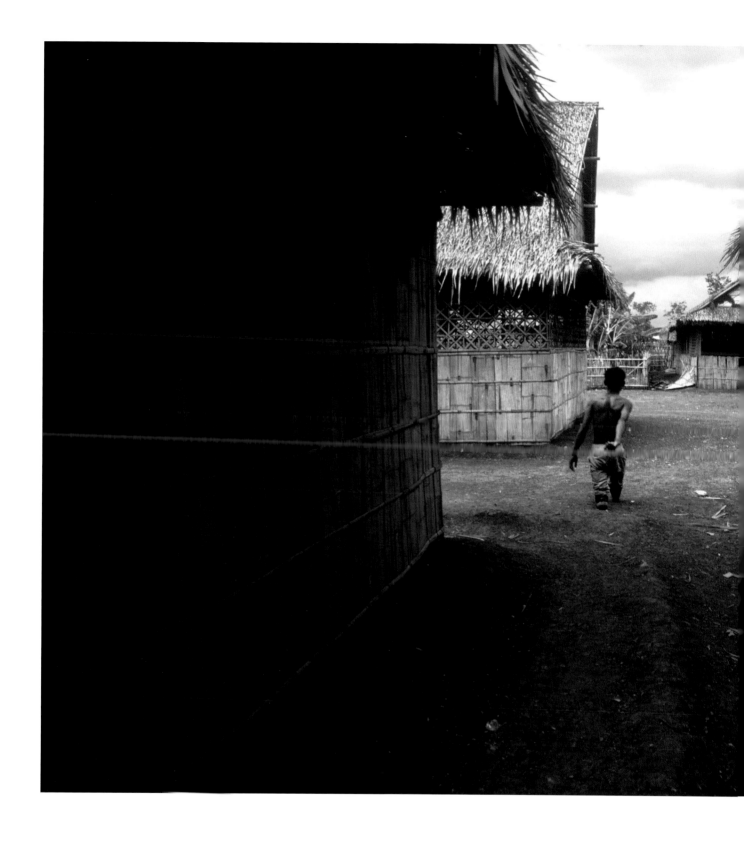

In Pol Pot's time, I was young and lived with my family. My family was poor and had no education. We wanted all the factions to share power, to unify our people — Khmer are Khmer. Of course from 1975-1979 the Khmer Rouge killed a lot of people, but I think the killing was from Khmer in Vietnam. Pol Pot didn't know about it; he didn't see what was going on in the countryside.

If I hadn't lost my legs I would have kept fighting.

When I first became an amputee, I was ashamed to use crutches. This is a special prosthesis invented by Mr. Hak, a type I've had since 1985. I tried others, but my stump is very short and didn't fit well in the socket. I was married four years ago; my wife took pity on me. We have a son and she is pregnant again. Now I'm training. I've been working in the workshop for four months. So many others lost their legs, I want to help provide them with shoes.

At the beginning, I used to think about what life was like back when I had legs — now I wonder how to work or do everyday activities. There's pain, as if my leg is still there, as if there's something burning inside of it.

Aranyaprathet, Thailand 4.1989

Chhoeung Pann at the Handicap International Site #8, near Aranyaprathet.

I miss all the things in my head and I can't think of anything. My head was wounded in so many places, it's difficult for me to speak.

I told the monk that I wanted to commit suicide — he said that we cannot decide our destiny and nobody can say when you or somebody will die, that you should enjoy life as it is, wait and see. After the monk's blessing I feel like I have a new life. Before, when I was unhappy, I used to yell at my wife. Now I go to see the monk.

Phnom Penh, Cambodia 4.1990

Caption to picture on page : 76.77
Sam Ngin at the Phnom Penh Wounded Soldiers Center.

1960 1970 1980 1990 2000

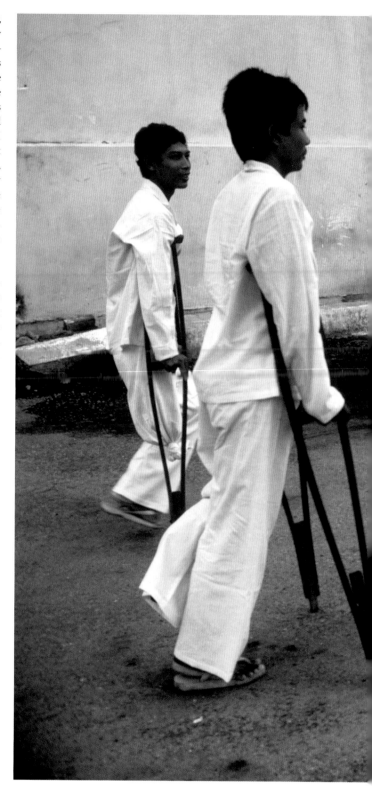

My parents, my brother and sister, they were farmers. I don't know why Pol Pot killed them. Afterwards, I lived in the children's camp. There, Pol Pot's troops made me cut these small trees that were used as fertilizer for rice. It was hard work to find these trees. I had to walk far from the camp, and I was so small, they were difficult to carry back from so far away, two times per day. I did this for three years. If I couldn't carry the tree, the troops would beat me with a whip. I thought I would die. I watched many die in the camp — sometimes two or three a day.

In 1980 I went to live with the monks, and in 1984 I joined the army. I joined the army to protect my people from Pol Pot. I have no memories of happy times. When I began to understand something about life, it was the Pol Pot regime. My whole life is about Pol Pot.

Phnom Penh, Cambodia 10.1989

Amputees, (left to right) Chap Malay, Ieng Sovann, Iam Sareurn, San Sareun, and Choun Chan Ponleu Raksmey at the Military Hospital in Phnom Penh.

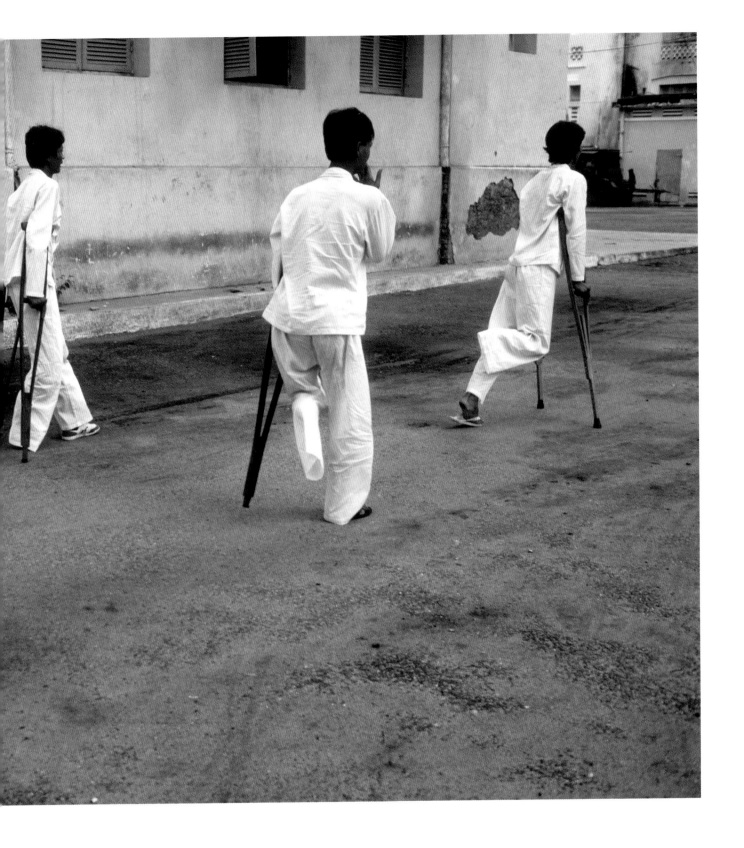

ERITREA-ETHIOPIA ^{1974 to 1991}

1974 to 1991

1910 1920 1930 1940 1950

Ten years after the departure of the Italian colonialists from Eritrea, in 1962 the Tigray and Arabic-speaking country was annexed by Ethiopia with support from the United States. But an Eritrean separatist movement gained ground after the overthrow of Ethiopian emperor Halie Selassie in 1974. Although a long-standing conflict between ethnic groups, when large-scale conflict broke out in 1974, each side was led by a Marxist secular leadership, with the Ethiopians supported by the Soviet Union. After nearly two decades of war, the conflict came to an end after Eritrean military gains and the fall of the Ethiopian government in May 1991. On May 24, 1993, Eritrea was declared independent, receiving formal recognition from the UN several days later.

NAME:
Eritrea War of Independence
TYPE:
Ethnic/Religious, Secessionist
CASUALTIES:
Over 130,000 killed

| 1960 | 1970 | 1980 | 1990 | 2000 |

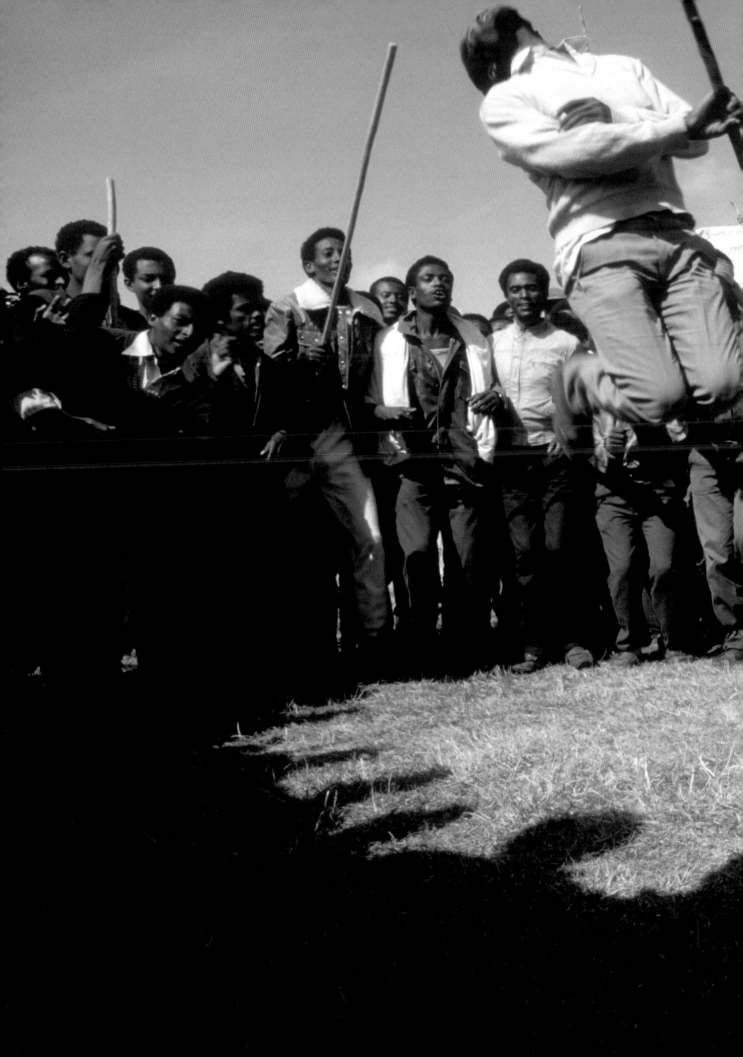

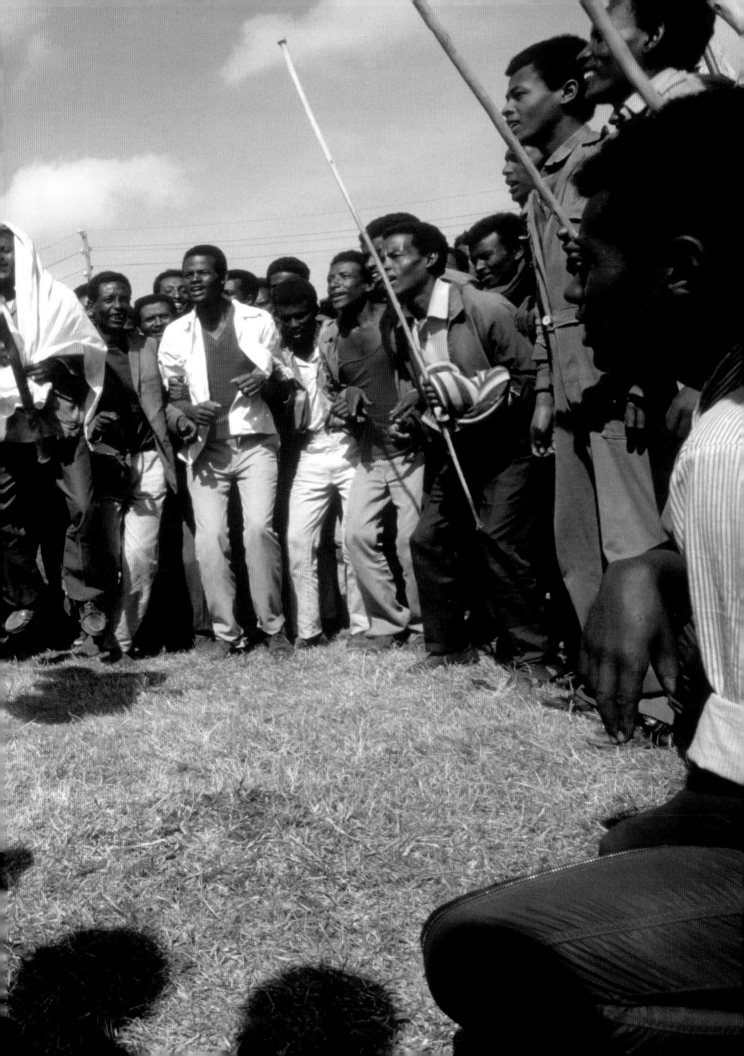

Confessions:

I was a simple soldier in Shahab where four hundred children were killed. We were the 9th division of the army and went in with tanks and bombs. Four children whose mother had died were walking here and there, confused about where to go — so I shot them. I killed them. I didn't know why, I just became crazy. The children were so little they thought I was their father, they were following me, coming to me. I didn't know what to do, so I shot them.

We were angry about all the Ethiopian soldiers the Eritreans had killed, so we captured this female soldier from the EPLF [Eritrean People's Liberation Front] and we raped her. We raped her and then we stuck a sword inside her and left her to die.

Tatek, Ethiopia 3.1992

Caption to picture on page : 84.85
After confessing war crimes, freed former fighters of the Ethiopian armed forces celebrate their new liberty in Tatek.

They took me to Mariam Ghembi prison. I was stationed there for seven months. We couldn't talk to the prisoners. When the Eritreans were brought there, they would break their hands, they would kill them. I saw it. They call me a traitor. I have been suffering. I am not a criminal, but many around here are criminals.

I was in Mengistu's army for ten years. For eight years I believed

1910 1920 1930 1940 1950

the propaganda that the Eritreans were going to sell the country to the Arabs and we killed them whenever we saw them. I was just a farmer; I wasn't conscientious.

Some didn't want to fight. I knew Mengistu's propaganda wasn't true, but there was no democracy and the soldiers didn't trust each other enough to share their ideas. You had to watch your back or you'd end up in prison.

The sons and daughters of the Dergue were studying in Europe. They were studying in America like ambassadors sons, and we couldn't even find water to drink. There was no education. In Eritrea we were shooting animals to eat. Those who did the killing in Eritrea are now killing people and stealing here. The 2nd Division Revolutionary Army, they're killers. We were all killers and many of us now are killing in the streets of Addis Ababa.

I was elected by my people to save the country. I was fifteen and I fought for fifteen years. I believed that I was fighting for the unity of Ethiopia, but now we know the Ertireans were right. For thirty years they fought for independence and they won — I support them.

We took the nuns from the monastery and raped and killed them.

We captured a female soldier from the EPLF. One of the guys with me was a coward. So to make him stronger, I had him practice how to shoot by killing her.

We were farmers in Harar. I was twenty when they tied me up with rope and took me to the army. I was a soldier from 1983-89. There was always someone behind me; if I didn't fight they would kill me. This was a foolish war, just for the benefit of the commanders. We killed each other, but now I realize that I killed my brothers. That's why I am suffering — Mengistu is having a good life in Zimbabwe and I am having a miserable life here.

I went to this war as a volunteer. I fought for bread and now I have nothing. I am begging for money. Some of our commanders don't want the war to end, they don't want peace. They are making money from this war, they are making business.

1960 1970 1980 1990 2000

We need medicine, antibiotics,
sheets, blankets, bread, jobs. We
have to find our families. We
have no shelter. Our lives have
no definition.

Debre Zeit, Ethiopia 3.1992

Farise during physiotherapy at the Debre Zeit Reha-
bilitation Center.

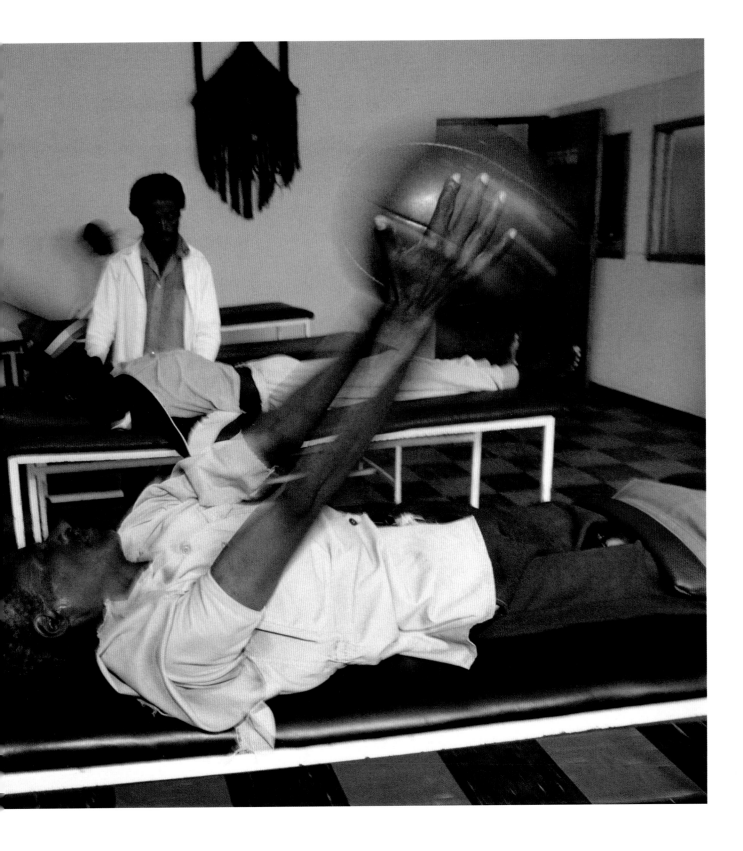

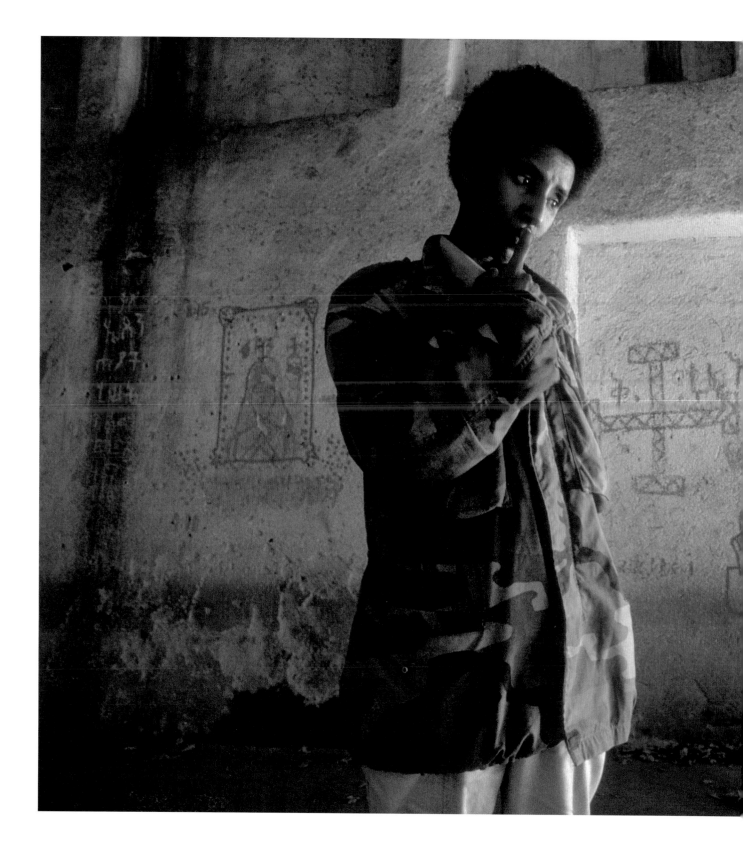

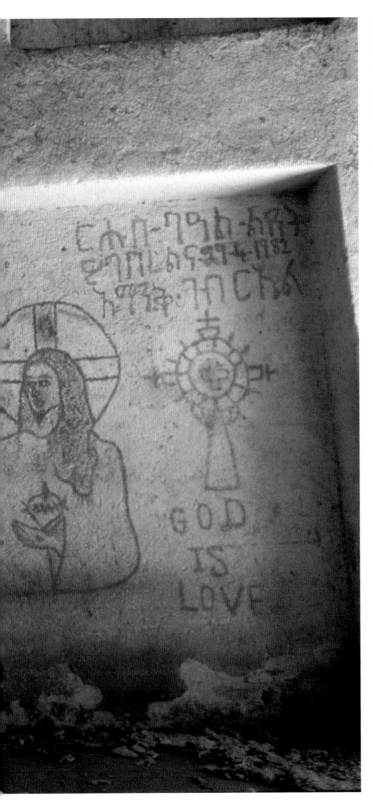

I had been in a cell since I was fourteen, while I was still in school. We would hand out pamphlets and send supplies out to the field from the city. Of course, we never told our parents anything; they would have been afraid and stopped us from becoming involved.

Then one day one of my comrades was arrested and informed on me; that's how the Ethiopians found me.

The first prison they brought me to was Mariam Ghembi. We arrived at 5:30 in the afternoon and they put us in this little house for torture. After the torture they brought us to their doctor for some first aid. Then they brought us back and repeated the torture. They would try to convince us to give information. "Tell us who you were working with in the city, or we will kill you," they would say. I never told them anything. Some people told the truth and they killed them anyway.

The women were tortured the same as the men — but something special was done to the women who were very strong, even some of the smaller women. They would do torture #9. This is where they force you to lie on your stomach and tie your hands to your toes behind your back with a long string. Then they hit your head with a stick, and the string that is attached to your toes is pulled by one man while another kicks you in the back. This bends you into the shape of a nine. It lifts your shirt up and your breasts scrape on the floor.

They tortured us every day for six months. We were not allowed visitors. I couldn't even see my parents. At the beginning we were eighty-three women, but soon we were as many as four hundred. That's when they stopped giving us supplies, even medicine. You were given a tiny square mat for sleeping. If you had a baby, you got another mat half the size. They didn't give us menstrual pads and you were only allowed ten minutes in the toilet, which was especially tough if you needed to wash out your pants. Ten minutes, three times a day, eighty-three women in one room for washing. We couldn't even speak to each other. If they heard you speak, they would chain your hands together.

Now I am married with an eleven-month-old son, but I still feel it. Whenever there is a cold breeze, I am in pain. And when there's a hard knock on the door, I jump — because in prison just to hear the sound of the door being opened or shut was terrifying.

Asmara, Eritrea 3.1992

Saba Asier visits her former cell at the Mariam Ghembi prison in Asmara.

1960 1970 1980 1990 2000

PERSIAN GULF 1990 to 1991

1910 1920 1930 1940 1950

Following Iraq's invasion of oil-rich Kuwait on August 2, 1990, an international coalition of 34 nations led by the United States began Operation Desert Shield to protect the resources of neighboring Saudi Arabia. After the United Nations voted to authorize military action against Iraq, on January 16, 1991 the coalition launched an air war featuring "smart bombs" that decimated Iraq's Republican Guard divisions. One hundred hours after the ground invasion of 700,000 coalition troops began on February 24, U.S. president George H. W. Bush declared a cease-fire to the lopsided battle that killed hundreds of times more Iraqis — an estimated 100,000 — than coalition fighters, many of whom died while retreating north along the main Kuwait-Iraq highway, dubbed the "highway of death."

NAME:
Persian Gulf War, Operation Desert Storm, Thirty-Country Aggression
TYPE:
Invasion
CASUALTIES:
100,000 killed

1960 1970 1980 1990 2000

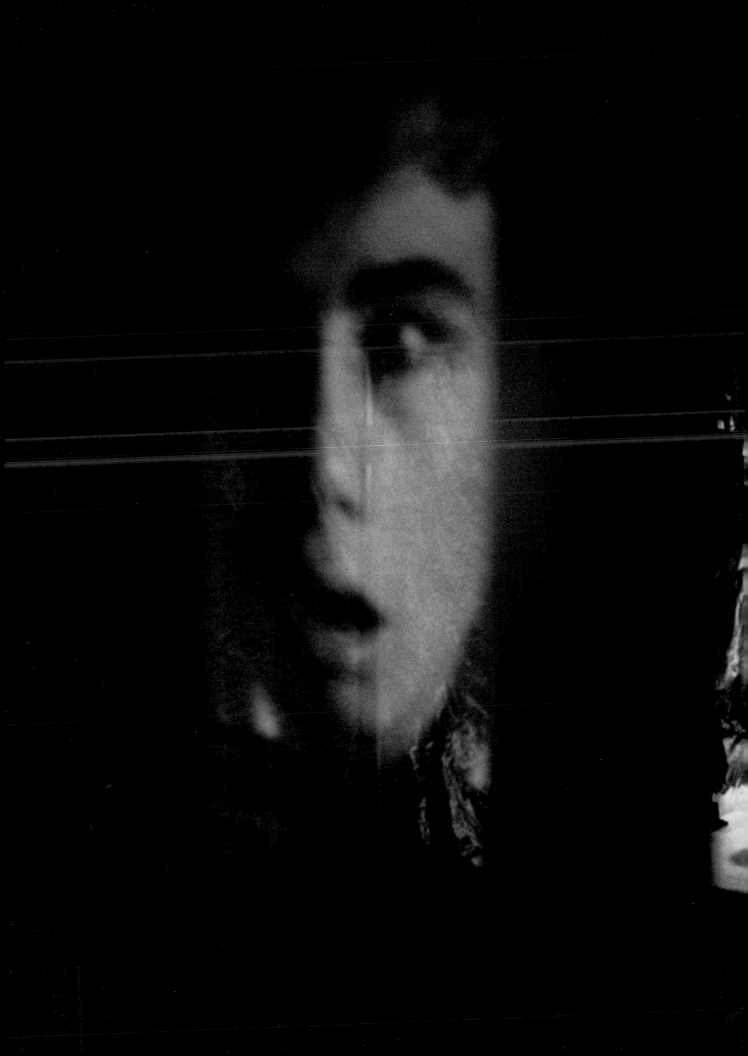

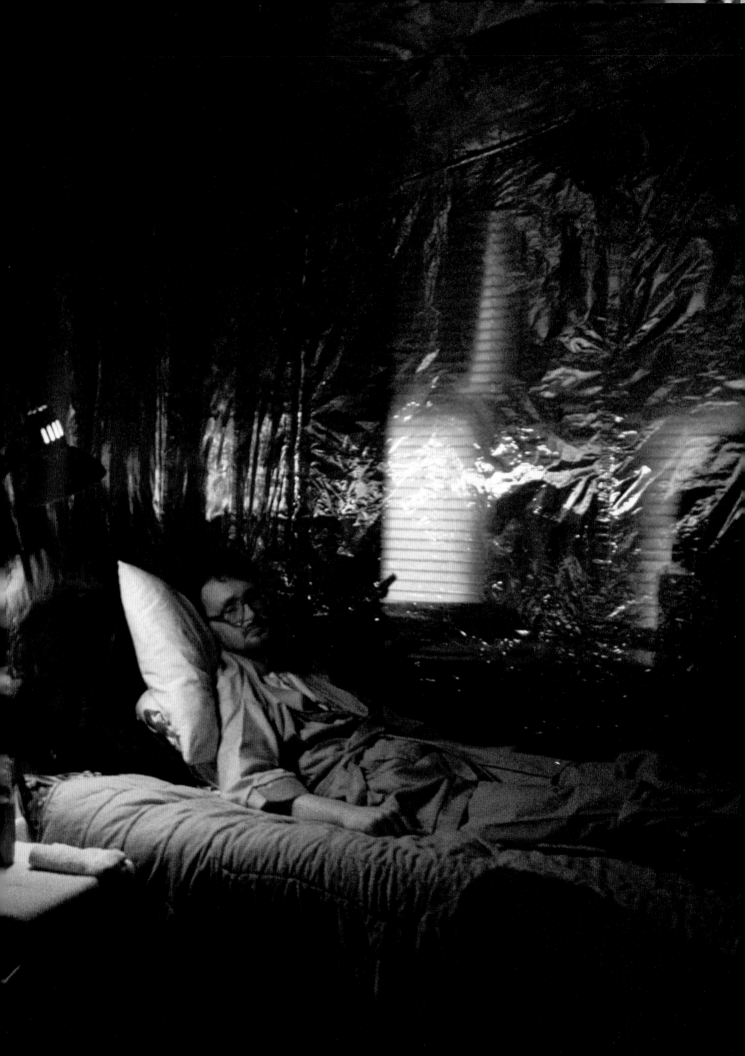

My dad had been in the air force, served in Vietnam. He doesn't talk about that too much, he's very withdrawn — but he'd always told me that it was good to serve your country, and I guess I fell for it. I always loved boats, so I joined the navy.

When I joined, I knew that the possibility of going off to war was there, but I never thought that I would see it. I certainly didn't expect to see everything in flames the way they were. The way I had looked at it, with all the ships that went down there, and knowing that Desert Shield was going on for some time, I figured that since we had given Saddam a deadline, he would back off. I mean, look at the Indians: they would back away when the cavalry came. I figured it's the same thing.

I was in the region for seven and a half months. We arrived in the Gulf in January and we were there until the war ended. Then our stay was extended because we had to do mine sweeping.

After I came home, I began having problems from bronchial asthma — I never had asthma in my life — plus severe headaches, aching bones, and terrible fatigue. A lot of people on my ship felt the same way as me. At the time we didn't connect it to the fires or smoke, or being there. I didn't see anybody wearing a respirator or anything like that. I took it for granted that if we were in danger, they would

1910 1920 1930 1940 1950

have told us to put on a mask or something. No orders came down, so I never thought about it.

I was a manager trainee for the grocery store chain, Food Lion, hoping to one day own my own store. I kept my job until I was hospitalized. They kept saying I just had asthma. Twice it got so bad that my wife Betty took me to the emergency room. They advised me to see a pulmonology specialist. We went to Fort Worth to see this specialist, and he says, "This is the strangest thing; It's kind of like Lou Gehrig's disease, but it's not." I went back to work on Saturday, and on Sunday I couldn't get up. Betty rushed me back to the hospital and they admitted me. They couldn't explain my problems, why I could barely walk, and the massive headaches. It was becoming more painful every day. Finally one doctor said it must be something I picked up in the Gulf.

By this time there were three or four other people who had been in the navy who had the same symptoms. The specialist who was brought in for the VA had diagnosed me with Chemical Sensitivity, and advised the VA about it. Yet I was discharged without compensation. The VA does not recognize this as an illness. The government is now giving me one-hundred-percent disability because I can't work, but they are not covering any medical costs or treatment. They are only

paying for the oxygen, and it took an act of Congress to get that.

For seven months I was hospitalized and we lost everything. Basically they put me on the curb and said, "okay, fend for yourself." I was living in a fantasy world where I thought our government cared about us and they take care of their own. I believed it was in my contract, that if you're maimed or wounded during your service in a war, you would be taken care of. Now I'm angry. They spent so much time telling me that I'm depressed or something, when they could have been treating what was wrong with me. I could possibly be back to work today and not in this predicament if they had taken care of me when we first noticed that something was wrong. I didn't want a handout, I only wanted to nip this in the bud and get on with my job. Now, lying here, I feel like a prisoner of war.

Waco, Texas, USA 5.1993

Caption to picture on page : 94.95
Affected by Gulf War Syndrome, Gary Zuspann lives in a special enclosed environment in his parents' home in Waco.

I was in good health when I went off to the Gulf. I had a low back sprain — which they called "low back pain" — but it's never prevented me from being deployed anywhere throughout my fifteen-year military history.

Now I have been diagnosed with damage to the left thalamus of my brain. I have also been diagnosed with a distended bladder and I have to catheterize myself in order to urinate. My rectal sphincter muscles don't work so I need to wear diapers in order to control my diarrhea. I have the mysterious rash that they talk about, along with ridges in my fingernails and the graying of my hair. And I have memory problems too.

I was in the 41st Combat Support Hospital, which served as a frontline hospital. We treated Iraqi civilians, babies who had played with grenades, nomads who stepped on land mines while tending to their sheep, and malnourished POWs. We went through areas heavily hit by artillery, and while some other heavy convoys had to get through we had to wait there amidst the blown-up tankers, burned Iraqi buses and charred bodies. I didn't think those charred bodies looked normal — they weren't like other burned bodies that I had seen; it looked like we nuked them. They were as black as can be and some of the bodies melted into the vehicles.

We spent fifteen days, half a mile from the Basra road, unprotected. I have learned since that depleted uranium particles are disseminated through the air and in wind. They can be blown anywhere — but we were never told to put on our masks or to take cover. We were not told of any of the possible dangers of depleted uranium.

I don't have a problem serving my country, but if you get into a problem your government should be behind you, taking care of you, not tell you it's just in your head. Maybe in three or five years they will find an answer for us. Or maybe it'll take ten or twenty years like the Vietnam guys, or forty years like the World War II guys. We went and we did a job, and we came back with ailments, but nobody wants to admit to anything. It's just not right. With so many people having the same problems, it can't just be in our heads.

San Antonio, Texas, USA 5.1993

Carol Picou watches a video on Gulf War Syndrome at a veterans support group in San Antonio.

1960 1970 1980 1990 2000

In 1964 I was accepted at Baghdad University, but my family was from the countryside and couldn't afford it, so I attended the military university instead, which was free.

Later, I was on the frontlines in the war with Iran.

At the end of my career during the Gulf War, I was in charge of psychological warfare for the Ministry of Defense. I met Saddam Hussein three times. I saluted as a soldier, and when he offered his hand, I shook it.

At that time, we were obliged to discuss the morale and psychology of the Iraqi troops every day. I spoke up the most. I was very keen on telling the truth. morale was very low. For this, after the war, I was accused of interfering with army security, of aiding the enemy. I was imprisoned for five months, then kicked out of the army and the Party.

The Iraqi military is a closed circle; that's how we lived. It's like being in a family circle and if one member of the family breaks the boundaries to go out of that circle, it's a kind of shame which cannot be mentioned. A circle of fear. This was how they created a force of idiots who could never say no. They hit him and he said yes; they cursed him and he said yes. Nobody trusted one another. If my wife and I happened to share a political joke, for the next three or four nights we would lie awake afraid that someone might find out.

After I was released from prison, the director general of General Security asked me to come back and to bring with me an apology put in the form of a report. In return, I would receive a better position than the one I held previously. The most courageous decision I have ever taken in my life was to refuse this offer.

I realized that there is a point of patience, of tolerance, human beings have that we are not conscious of — this ability to hide feelings, to keep them inside in order to survive. We Iraqis managed to develop many "faces" in order to adapt. But my son lost four years of university studies, and my daughter has completely shut down; she's twenty-eight and hasn't achieved anything. My youngest son suffers nightmares; he wakes in the middle of the night because of the missiles that fell in our neighborhood. One of my brothers-in-law was killed in the Iran-Iraq war, and my other sister's fiancé was killed.

I am under so much pressure; it's like there's a boulder, one hundred tons, on top of me. It's like all the Iraqi people are living underground with a heavy rocket planted on our chests.

I need help to lift this rocket off my chest.

London, UK 3.2003

Saad Alobaidi has breakfast in his London apartment.

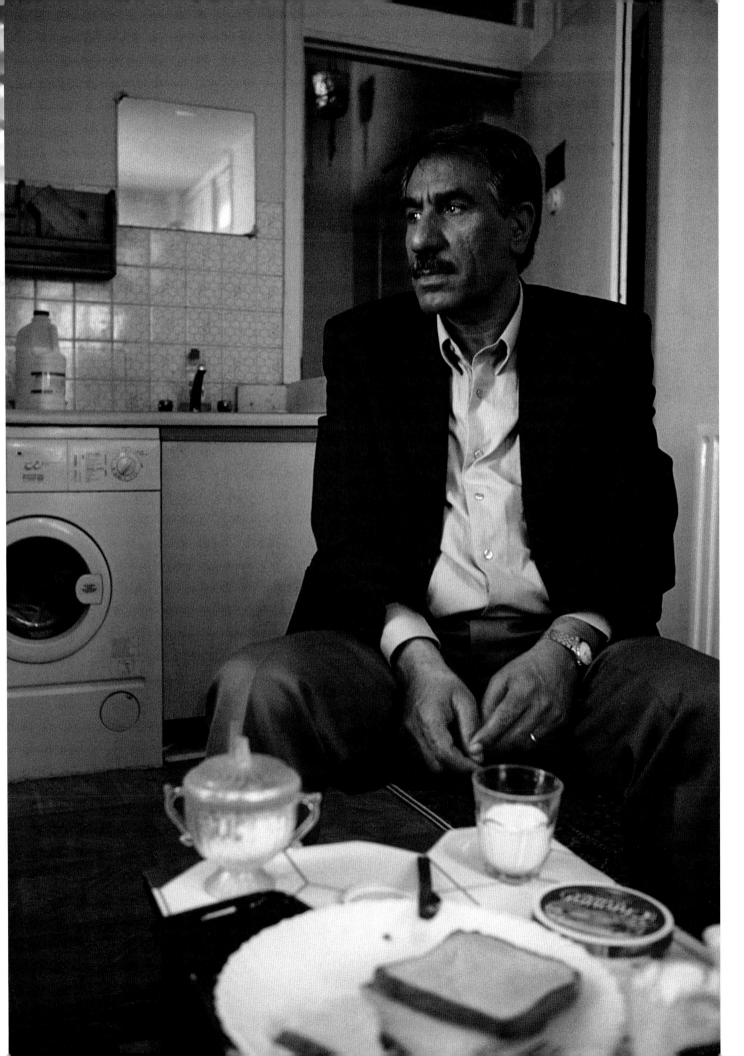

AFGHANISTAN 1979 to 1989

1910 1920 1930 1940 1950

Long a pawn in international relations due to its strategic position between the Far and Middle East, Afghanistan became a crucial finale in the cold war endgame when Soviet forces invaded in December 24, 1979 to prop up the faltering Communist Afghan regime. They were soon to be met, however, by the newly-formed mujahedeen, "those who wage jihad"— an Islamic militia. Attracting Afghan refugees in Pakistan as well as foreign volunteers from Arab nations such as Saudi Arabia and Egypt, the mujahedeen waged a tenacious guerilla campaign that slowly bled the crumbling superpower. Aided by American arms, the mujahedeen were able to force the Soviet departure in 1988, after which Afghanistan subsequently descended into civil war, and the Soviet empire quickly unraveled.

NAME:
Soviet Invasion, Soviet-Afghan War
TYPE:
War of occupation, Cold War conflict
CASUALTIES:
1.3 million killed over 460,000 Russian
soldiers wounded or debilitated

| 1960 | 1970 | 1980 | 1990 | 2000 |

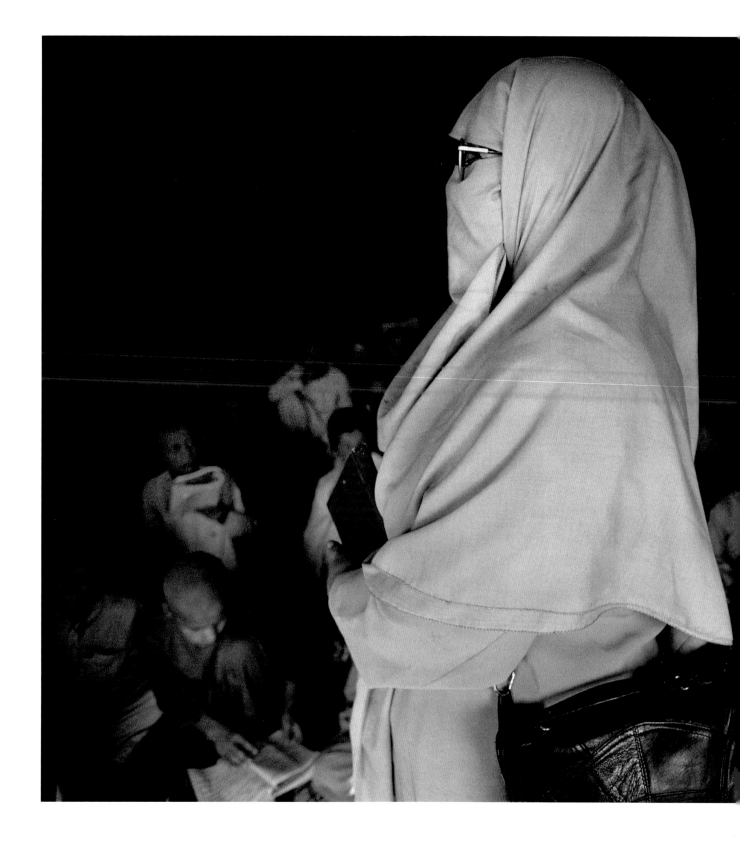

I was born into an intellectual Muslim family, and when the Russian army invaded Afghanistan we all decided to take part in the jihad. My father and his friends trained me. They taught me how to use the weapon, how to clean it, how to fire it. All of this was done inside our house.

We had two types of warriors, one fought face to face, and another who was in the city like a spy. I headed up operations inside Kabul. I was pregnant at the beginning of the war, so after I gave birth my mother helped take care of the baby.

I was involved for all nine years of the war. There were many groups inside the city and we were all in touch with each other, organizing operations. I moved arms from one city to another. We would wrap each part in a piece of cloth, tie it up, and attach it to our abdomen. If anyone saw us, we would appear to be pregnant. The Russian men were not allowed to search Afghan women, but there were Afghani women working with the Russians who would. Before moving the weapons we made sure we knew the women working at the checkpoints well enough to exchange greetings. We would say hello and give them some fruit or something — they always wanted a small bribe, a gift, like a smoke or chewing gum — then they would say, "okay go" and let us through. At some checkpoints there were male Russian soldiers. We gave them a "gift" too — they liked to smoke hashish, and if we gave them a piece they would just wave us by.

I was imprisoned twice, in 1981 and 1987. The first time I was in a Russian-controlled prison. I spent twenty days there before my family was able to get me released. I was beaten and assigned to hard labor. They had women working there who would get drunk and beat us with a leather strap. They also had

a big fire going and would put our hands or feet over the fire. When I joined the jihad, I knew this might happen and I was ready. I was ready to die.

About one year after the Russians left, the next war began in Afghanistan. Women had been sent to the frontlines the same as the men, but when the Taliban regime came to power they wouldn't allow education for women, they denied women their rights. This is the aspect of jihad I am now involved in. We give training courses in carpet weaving and embroidery inside Afghanistan. This is not permitted. If we get caught we will receive lashes or beatings.

I no longer fight with a gun, but with my voice. I wouldn't join a jihad to fight another war. War destroys people's fortunes in every way, nothing remains, no life, no assets, no belongings, people turn to cultivating poppy and hashish, instead we have to help people stop fighting, stop growing poppy, and convince the government to restore women's rights; with job opportunities and school facilities, there will be no room for the fundamentalists to work.

Peshawar, Pakistan 11.1999

Sayeda Aysha Aziz overseeing a school in the Kacha Garhai refugee camp in Peshawar.

1960 1970 1980 1990 2000

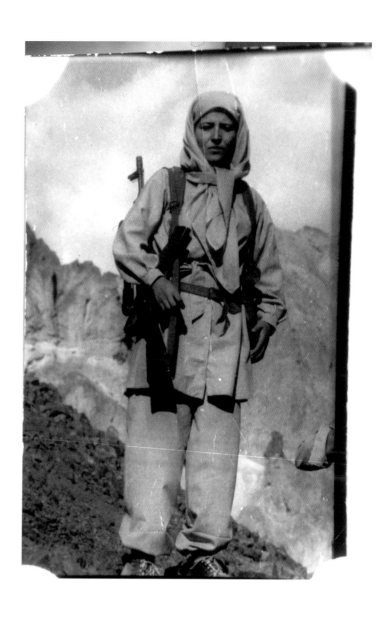

I was seven when the war began. My father was a commander and founder of the Mujahedeen. In the summer I studied in Kabul, and in the winter I visited him in the Shash Pol district in Banyan province. There, I saw all the weapons in the house and took an interest in them.

When I was thirteen, I received training. Early in the morning, after the prayers, the teacher would show us how to use the weapons. Then we had breakfast and a class on religion. Afterwards, lunch and another class in Islamic ideology. By the end of the afternoon we were chanting slogans about martyrs and freedom.

The Russians invaded us, took away our freedom, humiliated us, and my father, my mother, and all of the people of Afghanistan wanted to fight. I never thought about friendships or my childhood; my only thought was to get the Russians out.

Our uniform was gray pants with a long shirt and a gray head scarf, and we were a part of the first group that included women. The Mujahedeen were educated men and by including women they sought to give us equality. Sometimes others said, "you are not true Muslims." We replied that Muhammad took his wives and female consultants with him, too.

The Russians were in the capital and we were in the surrounding villages. In the winter most of the area was continually bombed by fighter jets, so we stayed in a mountain cave for protection. On top we had a Russian anti-aircraft gun that took an hour and a half to reach on foot. We stayed up there for a year, just our small group of women. Every night a commander from each family, always a man, would stay up there with us. He would show us how to fight at night. In the day, if we felt at risk, we would signal with the gun to call for help. The top of the mountain was the safest place, though; we could attack, but no one could attack us. I liked it, fighting for our freedom. But I was afraid when I heard the bombs. I remember the day the Russian troops left, the jet fighters flying over the Banyan sky dropping as many bombs as they could on their way out ...

Although I loved using them during the Russian time, I hate seeing weapons now. Today, the war is between different tribes. At first I thought the Taliban, being religious, would bring peace. But they killed people, beat minorities; they chopped off the hands of people accused of stealing, kept women at home. I was in my last semester of medical school, but they banned education. Then, a month after they took power in Kabul, I lost my father. He and four others, all Mujahedeen founders, were killed by terrorists.

I don't wish for anything anymore, because I know peace will never come. Now I am working to support my family, thinking of how to find money to survive, and how to find a boyfriend. Crying all the time will only make me ill. Smiling is the easiest way to forget.

Peshawar, Pakistan, 11.1999

Samayyah during the war at her post in the mountains of Banyan, Afghanistan.

1960 1970 1980 1990 2000

I was young when I decided to go, twenty-two years old. I was strong-willed and I wanted to feel accomplished, to know I could stand on my own two feet and be an adult. When you know that you might be needed somewhere, more than where you are ...

I went there to help, but I didn't think about the reason for the war, not then. When I saw thousands of guys crippled, I knew better. After the war, every night for two years my husband, who I met in Afghanistan, would scream in his sleep. It's one thing to defend one's country, it's another to interfere in someone else's conflict.

I don't think of it as having been brave, but as having been dumb.

Ruza City, Russia 8.1999

Nina Elstova (right) and her friend Elena in the Ruza Sanitarium near Moscow.

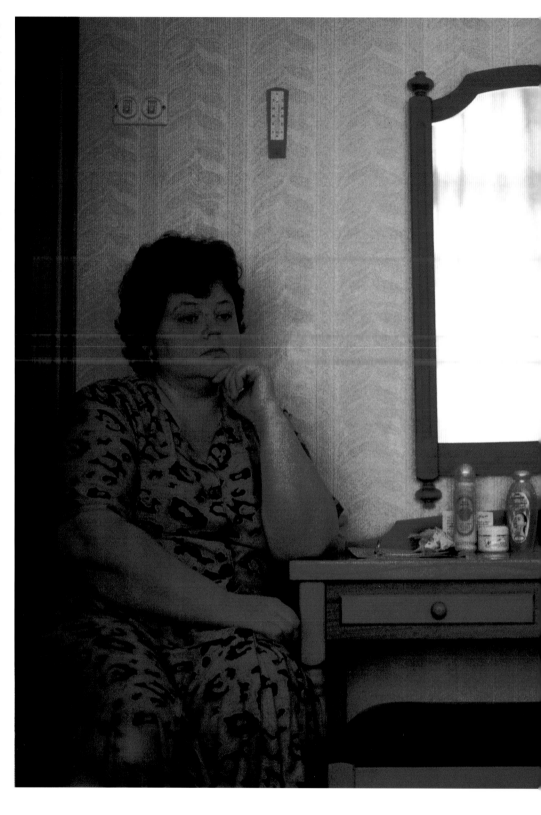

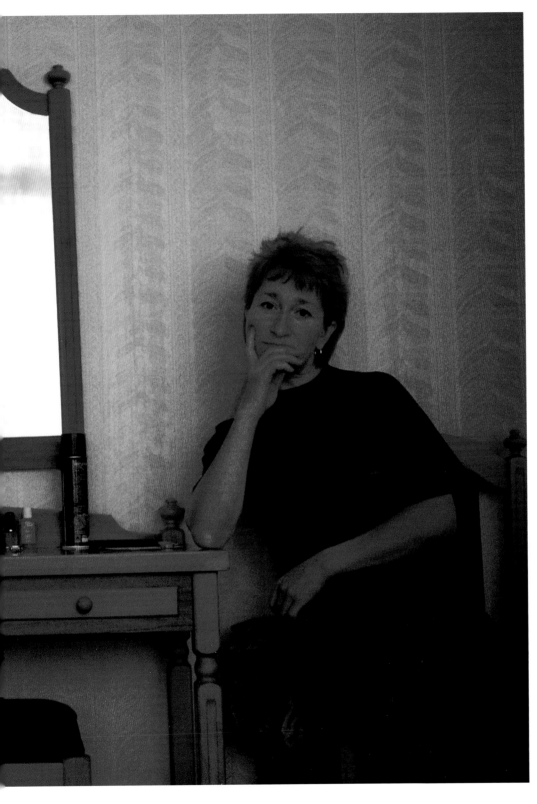

I was asked to serve in Afghanistan. It was voluntary, but if asked, medical workers were obliged to go.

We knew geography, we knew where Afghanistan was, but we had no idea why we were there or what to expect. The only images of war we had were from movies and books about World War II. But to know war, you have to experience it yourself. You look at life differently after; you take things more seriously. After war you are looking for something bigger in your life, something more meaningful.

I met Elena here in the sanitarium during one of the annual visits set up for veterans. It is so nice to have her here. We talk about the war. It's something that unites us.

Ruza City, Russia 8.1999

1960 1970 1980 1990 2000

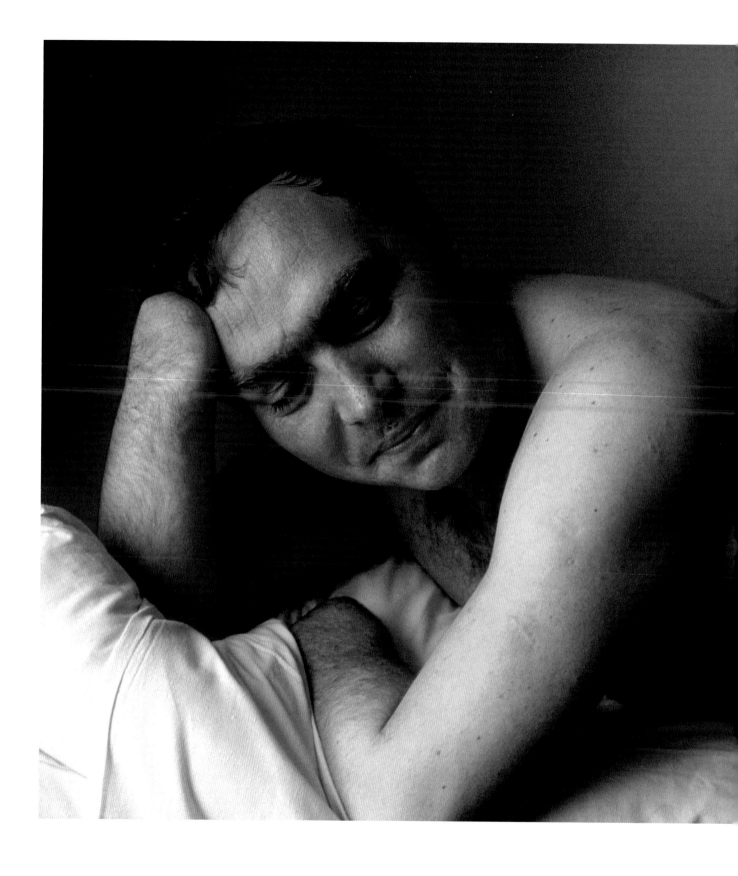

AFTERWAR : Lori Grinker AFGHANISTAN : 1979 . 1989

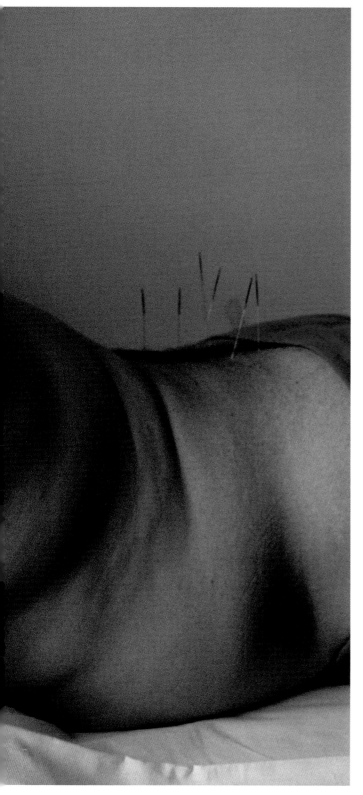

I was brought up thinking that the capitalist countries and the communist countries were enemies. So when I joined the army, I believed I was defending our Soviet homeland. We thought we were helping people who asked for it.

Half a year into the war my patriotism faded.

The operation began quite peacefully. I was in a convoy moving fuel to another city, maintaining radio contact with a helicopter flying overhead, accompanying us. Suddenly, one of the cars blew up. The explosion hit our vehicle. I didn't even know I was wounded until I reached for the door and realized I didn't have a hand to open it with. The car was on fire and I was thinking that I wished I had time to say goodbye to my family. I carried a prayer my mother had given me when I left for Afghanistan, and at that moment I asked for its protection.

In 1985, after all the hospital stays, I went home. The second day back, the director of the local school invited me to come to the school to talk. He offered me a job, helping to organize events and chaperon students. He wanted to give me the opportunity to be around people, to talk with them, to feel I was participating.

The youngest students took an active interest in me, they really noticed my limbs. The older ones knew about the war, so they just asked about it straight out. At first, it was hard. I couldn't bear to look at the photographs I had from Afghanistan when I was complete down to my hands and my legs, when my body was whole. But I got used to it. I don't feel uncomfortable anymore. I think it's something people should see.

In my dreams I still have hands. When I wake up, I can even feel my fingers and tighten my fist.

Although it's there, it's not there. It's as though there's something invisible covering my hands and that's why I can't see them.

Ruza City, Russia 8.1999

Oleg receives acupuncture at the Ruza Sanitarium near Moscow.

LEBANON 1982 ᴛᴏ 1985

1910 1920 1930 1940 1950

Long harassed by Palestinian Liberation Organization attacks on its northern settlements and alarmed by the recent Syrian placement of surface-to-air missiles in Lebanon, on June 6, 1982, 60,000 Israeli troops crossed the border, striking at PLO and Syrian positions from the air and ground. Israel agreed to a truce on June 11, but conducted a 70-day siege of Beirut until the PLO leadership left the country on September 1. The toll on civilians, a quarter of which fled the country in the early 1980s, was disproportionately high. In a massacre on September 12, 1982, an estimated 800 Palestinian men, women and children were killed by Israeli-supported Phalangists in the Sabra and Shatila refugee camp. Israeli soldiers stayed in Lebanon until 1985, after which only a token force remained to patrol a border security zone.

NAME:
Israeli Invasion of Lebanon, Operation Peace for Galilee
TYPE:
Ethnic/Religious
CASUALTIES:
2000-3000 killed

1960 1970 1980 1990 2000

In 1982, I led my unit of eleven Patton battle tanks over the Lebanese border. I was on the lead tank, first in the convoy. I had years of practice, but this was my first experience in an actual war.

I was twenty-two and comanded forty-four men. Today I wonder how I could have taken on so much responsibility for so many young men, being so young myself. One of my soldiers was so afraid that he collapsed and made a mess in his pants. I had to set an example. I told the soldier to wash himself and to rest while I took over his guard duties. Later, I told him to go outside like all the others.

There was no other choice.

On the fourth day of the mission, a Syrian command fired missiles at us. One of them hit my tank. I was sitting in the rear. The marksman was dead and the driver badly wounded. It was hot and loud. I looked down at myself and saw blood and mud. My feet and lower legs were mangled.

I learned a lot through my injury. After several surgical operations I even learned to walk again. Now I can walk for ten to fifteen minutes before the pain gets too severe. I lost my legs for the "Peace in Galilee" — that is what our campaign into Lebanon was called — but there is still no peace. We still occupy parts of the land. We wasted lives and blood, mine and so many others.

When I was a kid, I couldn't wait for my chance to be a soldier. It's crazy, it's a sickness. Any kid who wants to hold a gun must be a little crazy — but back then I thought that was the only way to survive here. Now I think we are losing our morality; our soldiers are fighting against Arab children throwing stones, and most people would rather go to war than give back land. But I don't believe in land. I believe in life. I have a lot of friends who are smelling the flowers from underground.

Tel Aviv, Israel 3.1995

Dani Shimoni in the pool at Beit Halochem, (Warriors Home) in Tel Aviv.

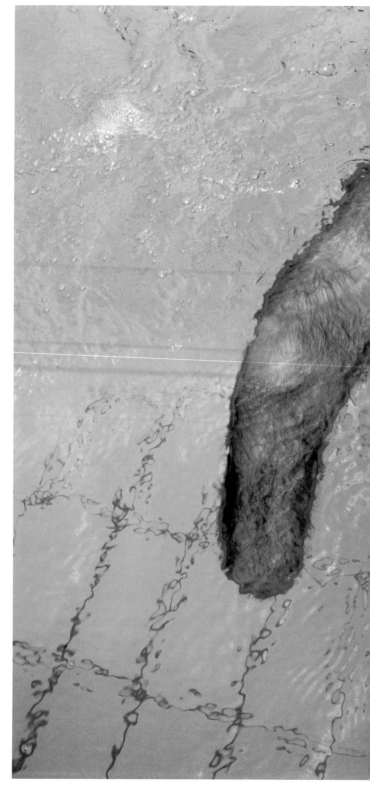

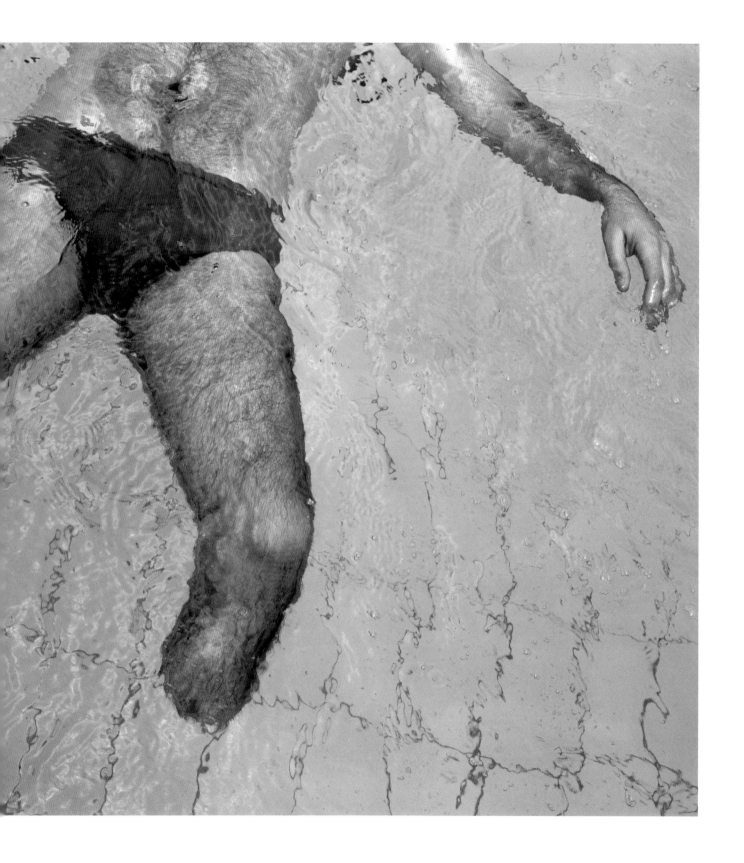

FALKLAND ISLANDS ¹⁹⁸²

1910 1920 1930 1940 1950

On April 2, 1982, Argentine troops of the foundering military junta invaded the Falkland Islands, which Britain had administered since 1833 but was long-claimed by Argentina, hoping to unite the country and shore up its political support. Despite popular enthusiasm and a lethal conflict between the Argentine airforce and the British fleet, which soon surrounded the islands, the British made an amphibious landing on May 21 and were able to retake the whole of the islands within a month. On June 20, after 72 days of fighting, the British declared the conflict at an end. The defeat discredited the Argentine military, leading the way for an era of democratic civilian rule in Argentina, and consolidated conservative rule over Britain for the rest of the decade.

NAME:
Falklands-Malvinas War
TYPE:
Invasion, Territorial dispute
CASUALTIES:
1000 killed

| 1960 | 1970 | 1980 | 1990 | 2000 |

AFTERWAR : Lori Grinker **FALKLAND ISLANDS :** 1982

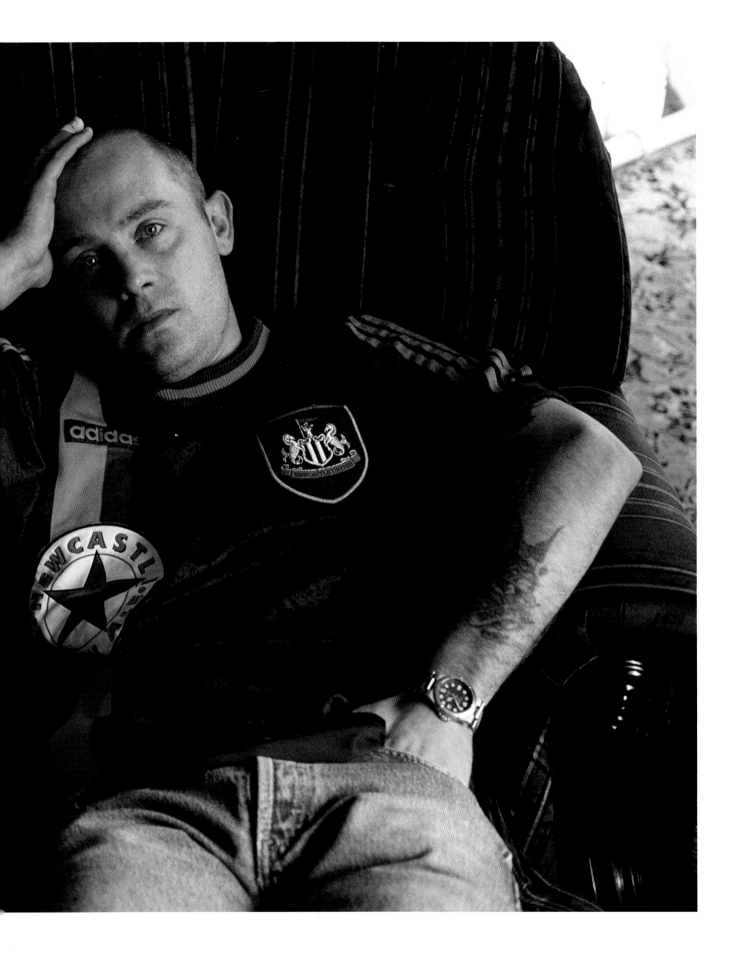

In 1980, I couldn't find a job in Newcastle so I applied to join the navy. I had wanted to join the army, but my mom wouldn't sign the papers because she didn't want me to go to Northern Ireland. There were too many people getting shot.

I was sixteen.

In October 1981, I joined my first ship and they told me I was going to the Falklands. I didn't know where it was. I thought it was in Scotland. We were the first ship, the pinnacle of the task force protecting the land forces. We were supposed to stay in this one place for forty-eight hours and then go back to the task force, but they commanded us to stay twenty-four hours more. We knew we couldn't make it with all their planes overhead, but they made us stay.

We didn't last. They bombed us with three one-thousand-pound bombs. We got hit about four o'clock tea. At first we didn't even know we were sinking. You just felt a shudder, then another shudder, and another. Then everything went black. Smoke started pouring in, water started pouring in, and people were running around with their skin hanging off where they'd been burnt. Somebody from below opened the hatch and said to get out because the ship is sinking port side. We had no communication, so we hadn't been told about it. The chief petty officer in charge said, "Nobody's going anywhere. We haven't received orders." By

then we could tell the ship was sinking. It was a total nightmare. People just pushed him out of the way and he kept pulling us by our legs to keep us down there. When we finally got on deck, the ship was on its side. We lost all the life jackets, gas masks, and we had to jump over the side. I went back down to get a life jacket. I had to take one off of a bloke who was caught under one of the consoles; we couldn't get him out.

The next thing I remember, I was sitting in a dinghy with eighty-five people hanging on and it couldn't go any further; we had to get off. We went to a boat with the officers and they wouldn't let us on. They told us it was an officers-only life raft, but there's no such thing. They were just panicking in case we all got in and sunk it. There was no order at all. We ended up having to swim to shore. We were still getting bombed and shot at. We must have been in the water for an hour or more. I just remember it was dark.

After we got to shore we sat for two days getting shot at while waiting for relief.

The QE2 came and took us back to England. When we got back, they didn't do anything but send us on three weeks-leave, then put us back in service. A year later, they put us in a psychiatric hospital for about two months, where we played volleyball in the morning and had basket weaving in the afternoon.

They program you to have no emotion — like if somebody sitting next to you gets killed, you just have to carry on doing your job and shut off. When you leave the service, when you come back from a situation like that, there's no button they can press to switch your emotions back on. So you walk around like a zombie. They don't deprogram you. If you become a problem they just sweep you under the carpet.

To get you to join up they do all these advertisements — they show people skiing down mountains and doing great things — but they don't show you getting shot at and people with their legs blown off or burning to death. They don't show you what really happens. It's just bullshit.

And they never prepare you for it. They can give you all the training in the world, but it's never the same as the real thing.

Llandudno, Wales, UK 8.1998

Caption to picture on page : 118.119
Steve Annabell at the Ty Gwyn Center for Post Traumatic Stress Disorder in Llandudno.

1960 1970 1980 1990 2000

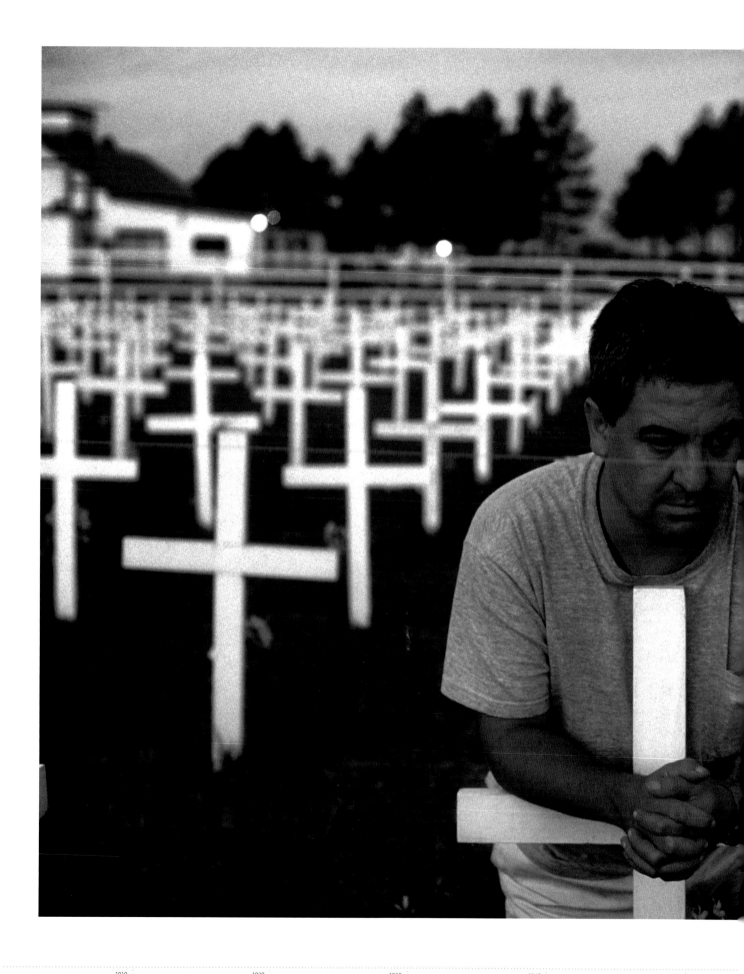

AFTERWAR : Lori Grinker FALKLAND ISLANDS : 1982

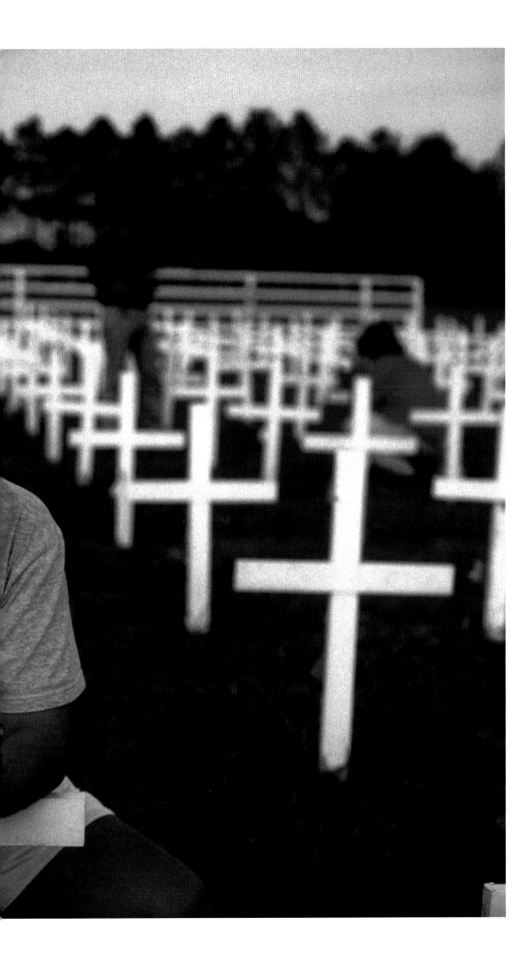

I had eight days left in my service when the war began. I didn't think of it as a real war; I thought of it like a football match — you know Britain and Argentina are classic football rivals — and when I saw all the people rallying in the Plaza Mayor in Buenos Aires on television, I couldn't imagine what they were doing.

Because we were trained in the infantry they ordered our company to the front. We were completely drunk when we got off the plane in the Malvinas. It was very cold and the whole atmosphere was just weird, the people, everything. First they gave us these pep talks: "We are here to ..." Then we had to dig trenches. I didn't work very hard, I only made a small hole, so when the first attack came I tried to jump in someone else's trench — but they wouldn't let me in. Then I dug fast, I was so scared. Enemy soldiers were landing in small boats from the ships, and the ships were attacking us to cover the soldiers coming ashore. I didn't shoot; I hid behind a little tin shed and lay down on the ground, watching the bullets fly past. It was like a scene from some World War II movie.

After the first attack the war became real. People started to die and we were beginning to kill. I started shooting, too. In a moment I forgot everything, my name, where I was from. It's curious: when you're in the middle of a war you get overtaken by some kind of enthusiasm, some kind of deep-down excitement — this adrenaline rush. You feel something wild inside and are overcome by the smell of gunpowder, blood.

There's an animal instinct that puts you inside the war — not that you enjoy it, but it produces this fury. You lose your personality and become a killer. You kill people who have nothing against you, you kill without hate.

I fought until I took a bullet in my head. This was during the battle of Wireless Ridge, the last weeks of the war. There was this mayor who was a commander. He had a glass eye and was totally crazy. We had received some radios from Buenos Aires, which arrived in the Malvinas without batteries. But this mayor/commander was acting like his radio had batteries, as if he could receive information, just crazy. He said, "We are going to organize an attack." The captain was crying because he knew we were going to die. Then they made us line up in the valley and the commander waved a sword in the air and said, "Onward to the attack, to die!"

It was night, but by the time we reached the summit of the hill, it looked like dawn because of all the flares. I could see thousands of British troops. There weren't even a hundred of us, and there were three thousand British paratroopers. We saw these balls of light, antipersonnel missiles that

detect body heat. With no way to turn back, we began to shoot. Only twenty made it to the top. I ran out of ammunition and was reloading my weapon when I looked up and saw a gun to my head. Then, like an execution, I was shot.

Because of my helmet the bullet lost some of its force. It went through my skull around my ear and came out. I remember feeling like I'd been hit in the head with a hammer. Corpses lay strewn around me. Some moments there was a pause, this silence from both sides, and the only sound was from the wounded: people yelling, moaning, calling out names. Some had Walkmen on and you could hear the music coming from the earphones.

After I regained consciousness, I tried to crawl, but collapsed and fell over a precipice. Then, when they came to gather the bodies, they put me on the pile of corpses. When I reopened my eyes, I saw the commander with the sword. He was vomiting and later died.

Someone counting the dead and wounded saw me move and went for help. They gave me morphine and took me to the field hospital, but they couldn't perform surgery there and thought I was going to die. The priest gave me last rites, three times.

Later, when I called my mother and said, "This is Horacio," she said, "But you were on the list of those killed in combat." "No," I said, "I was only shot in the head."

I have two children now, a son and daughter. Military service is no longer obligatory and I would never let them go. Nobody comes back from war the same. This person, Horacio, who went to war, doesn't exist anymore. It's hard to be enthusiastic about normal life; too much seems inconsequential. You contend with craziness

and depression. Many who served in the Malvinas committed suicide, many of my friends. I was lucky; after war, I had the support of my family. I was able to work, and that helped me recover. But it's difficult to maintain a normal life. I had an official job for a while, but preferred to go fishing rather than make a meeting on time.

Today I could say, "I'm a hero," but I could just as easily say, "I'm a criminal." I'm peaceful, but like a time bomb. I don't feel any impulse towards violence, but deep down I know that I can explode in a second. I think this evil instinct exists in everyone. In some people it's deeply hidden, in others it's more evident — but in certain situations it comes out. During the war, I went beyond the limits. I did things I never thought I was capable of. I acted like another person.

Now I see two people in my dreams: one is me, and the other is this person from the war coming after me. Often, I can tell that the other person is me, too. I try to keep my distance from him. I'm against violence, but now I know who exists inside of me.

Buenos Aires, Argentina 2.2000

Caption to picture on page : 122.123
Horacio Javier Benitez visits the Monument to Malvinas near Buenos Aires, a memorial for soldiers buried in the Falkland Islands.

1960 1970 1980 1990 2000

VIETNAM 1965 to 1975

1910 1920 1930 1940 1950

Following the collapse of the French colonial presence in Vietnam and the division of the country into a Communist north and a non-Communist south in 1954, the United States soon took over the main support of the government of South Vietnam, hoping to prevent the spread of Communism in Southeast Asia — the "domino theory." Alarmed by the guerilla action of the North Vietnamese-supported "Viet Cong" in the south, the U.S. became involved gradually, first with military advisors and supplies, then combat troops which first arrived in March 1965. The number of American troops would swell to over 500,000 by the end of the decade. Supported by the North and the USSR, the Viet Cong waged a successful battle against the technologically superior United States, capturing Saigon in April 1975.

NAME:
The Vietnam War,The American War,
The Second Indochina War
TYPE:
Cold War conflict, Civil War,
Popular uprising
CASUALTIES:
2-3 million killed over one million
military wounded

1960 1970 1980 1990 2000

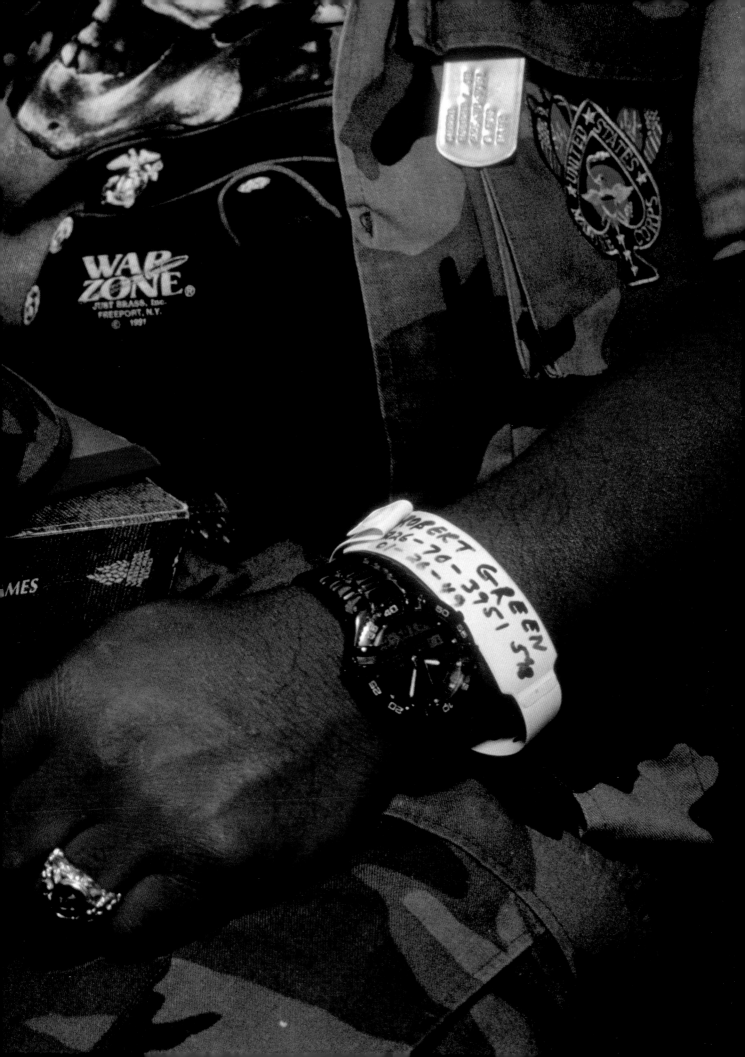

AFTERWAR : Lori Grinker VIETNAM : 1965 . 1975

It was strange because I had lost my cousin over there — they even had a picture of him in the class yearbook: "In Memorial: James Preston Smith" — and I was in the same unit as him: First Marine Division, Third Battalion, Fifth Marines. I was also in the same group, the "I Corps." I was stationed in and around Danang, the same place as him. I walked the same ground that he did.

Everybody wants to see what the enemy looks like. I saw the enemy. He looked normal, like me. It's all so fresh, seems I could tell you what went on month by month, day by day.

I was a combat engineer, looked for booby-traps, mines. I was young and dumb. It was exciting. Then one time my friend and I spotted a stick to hold up our tents and both went running for it. He got there first and grabbed it and his body went up about one hundred feet in the air and when it came down there was nothing there.

We lost two guys in my platoon. They were both named Brown. When I went to the Wall, I found their names.

When I got out, I got a job as a truck driver, delivering mail for Dupont. After I had several heart attacks, I could no longer work and I started looking for the guys I was in Nam with, I needed to know where they were. I remembered their family names, and I found them. One is in Delaware, one in Florida, West Virginia, and another in Lebanon, Pennsylvania. I talked to them and realized they were having the same problems I had.

Every time I hear an explosion today, it's like I'm involved in it. Every time I turn on the television, there is something that reminds me of Vietnam. The stuff going on in Iraq now doesn't help. My wife is very supportive, but she doesn't really understand. I'm always going to sleep with one eye open. People on the block think I'm a crazy man. But I'm in my own little bunker and I don't take any trash from anyone. You've got to deal straight up with me. If anyone gets in my little bunker I just push them away.

They tell me I'm a hard-nosed marine.

Bethesda, Maryland, USA 6.2003

Caption to picture on page : 128.129
Robert L. Green Jr. on the bus to the Vietnam Veterans Memorial Wall in Washington, D.C.

1960 1970 1980 1990 2000

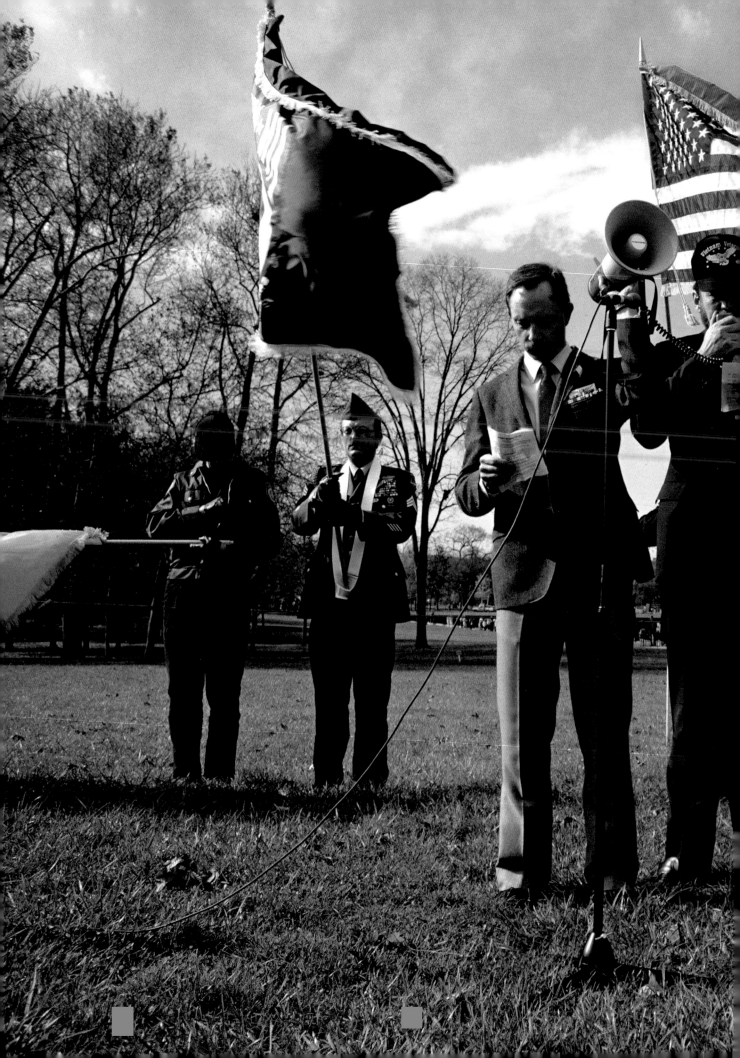

HA THI MACH | **born** 1946 **served** 1965-70 North Vietnamese Militia

My family were farmers living in Thanh Hoa province, and except for my mother they all joined — my father and six children. The Americans had come to destroy everything and we had to defend ourselves.

So, in 1965, when I was nineteen years old, with hatred for the enemy and love for my country, I went out to participate. My unit was trying to build and protect bridges in the north. We fought day and night. We slept where we could. It made no difference if you were a man or a woman, we all worked to save our country. We were ready to sacrifice, ready to die, and had no fear.

I was building a bridge along highway 1A when it was blown up by a U.S. bomb. Many were killed and wounded. I was in the hospital for three months. If you add the time I spent in the rehabilitation center, altogether my recovery took two years.

Of course I hated the war, and I regret losing my leg — before the prosthetic limbs life was impos-

sible — but if there was another war just like it, I wouldn't keep my daughter and two sons from fighting. It was a war against invaders. We hated the Americans then. It's different now; there's no more war, so the feeling has changed. In the war, we had to kill them on sight. Now, in peacetime, we must accept them into our homes. Even the one who dropped the bomb on the bridge where I lost my leg.

The people are good — it's the leaders who are not so good. We really appreciate the American doctors and veterans helping us now, like those who brought me this new leg. This new American leg is better than my other one. But I only have one, so I still use this old wooden leg. I want to keep the American one clean, so I only wear it for a few hours a day or on special occasions.

Ba Vi, Vietnam 6.1989

Ha Thi Mach at the Viet Duc Center for Rehabilitation in Ba Vi, near Hanoi.

radioman, the corpsman and the lieutenant. I wasn't trying to be a hero; I simply wanted to show my new men how to walk point. We walked that morning and stopped at noon to eat our c-rations. Gore asked if he could take over as point, but for some reason I told him that I would finish the day.

"Let's go marines," I said quietly as I led my men down an abandoned road in Quang Nam province in Vietnam. The road was probably constructed by the French a generation before Americans arrived in Nam. Bomb craters pitted the landscape, some of them twenty feet wide and six to seven feet deep. We were looking for land mines, pungy pits and undetonated rounds. On a mine sweep, you walk slowly, watching, listening, feeling. This particular road, very little of which was still distinguishable, hadn't been swept in two years. We made our way through a section of tall elephant grass and reached a clearing. The crumbling remains of a Buddhist temple were just in front of us. The grass was now knee high, leaving us dangerously exposed and in the open. A strange feeling came over some of the men. Something wasn't right. We didn't realize it at the moment, but we had just walked into a Viet Cong mine field.

One last step, and then it happened — my boot landed squarely on what felt like a miniature volcano.

A deafening blast rammed through my body. A cloud of black smoke shot into the sky, and hot fire surged through what remained of my legs. "Hit the ground!" someone yelled. "Mortar!" shouted another marine. Pieces of my own flesh literally covered the upper part of my body. Shrapnel from the blast pierced my forearms and the sides of my forehead, and had bent my helmet flap into a straight up position. My M-16 was blown in half.

I went in and out of consciousness as people scrambled all around me. The radio man, several yards to the rear of my position began to radio for a Medi-Vac. There was much confusion. Lee Gore knelt down and picked me up in his arms and braced my back on his knees. With tears running down his face, he was praying, asking God to help me. I was shaking terribly and covered in my own blood. The smoke and dust from the blast was still thick in the air. Men began shedding their t-shirts to help soak the blood flowing from my wounds. Some gave their personal bandages. The corpsman began working feverishly applying tourniquets to my upper thighs. In a weak, barely audible voice I prayed, "Oh ... God, not my legs ... Lord ... please ... get me home to mom and dad ... I'll do whatever you want me to do." Then, total blackness. I went out. I remember hearing the faint sounds of the whirling blades as we were flown to the hospital ship USS Sanctuary in the South China Sea. From there I was taken to Guam.

Mom and dad, during the next four-week period, received over thirty telegrams and personal visits from the Marine Corps. From a human standpoint, and from all they had been told, they never expected to see me alive again. My body weight had gone from 185 pounds to less than 80 pounds.

During the next several months I had thirteen major operations which left three inches on my right leg, and eleven inches on my left leg.

Coming home to Illinois, I went to my dad's church and made things right. Since that time I have preached all over the world that men and women may be saved by God's grace.

Washington D.C., USA 11.1991

Tim Lee at the Vietnam Veterans Memorial Wall in Washington, D.C.

I had been raised in a preacher's home — at ten years of age, while listening to my dad preach, I received Jesus Christ as my savior — but when I became a teenager, something gradually began to change inside of me.

Sports became the obsession of my life. During my junior year in high school, I set two track records in the long jump and high hurdles. My name began to appear in the local newspapers. The call of God became less and less important in my thinking.

After one year of junior college, I joined the Marine Corps. Within a matter of weeks a bus took me to Parris Island, South Carolina for boot camp. Within ninety days I had become a real marine, and, within a few months, I received orders for duty in Vietnam. Three weeks leave was spent at home with mom and dad. I went to church and tried to make things right with God.

I thought I had.

Eleven months quickly passed during my tour of duty, and going home was a little less than thirty days away. Nam had been a good experience for me, and one of the main reasons was the friendship of a very special marine — Lee Gore. Gore, a black marine, was a Christian and not ashamed of it. Many times he would sit on his rack and read his Bible. I had seen him pray and talk to other marines about the Lord. He often spoke to me about living for the Lord.

On March 8, 1971, orders were received to take my men on a mine sweep. I decided to walk point, which meant I would be the front man in the formation. Normally, I would have been in the back of the squad with the

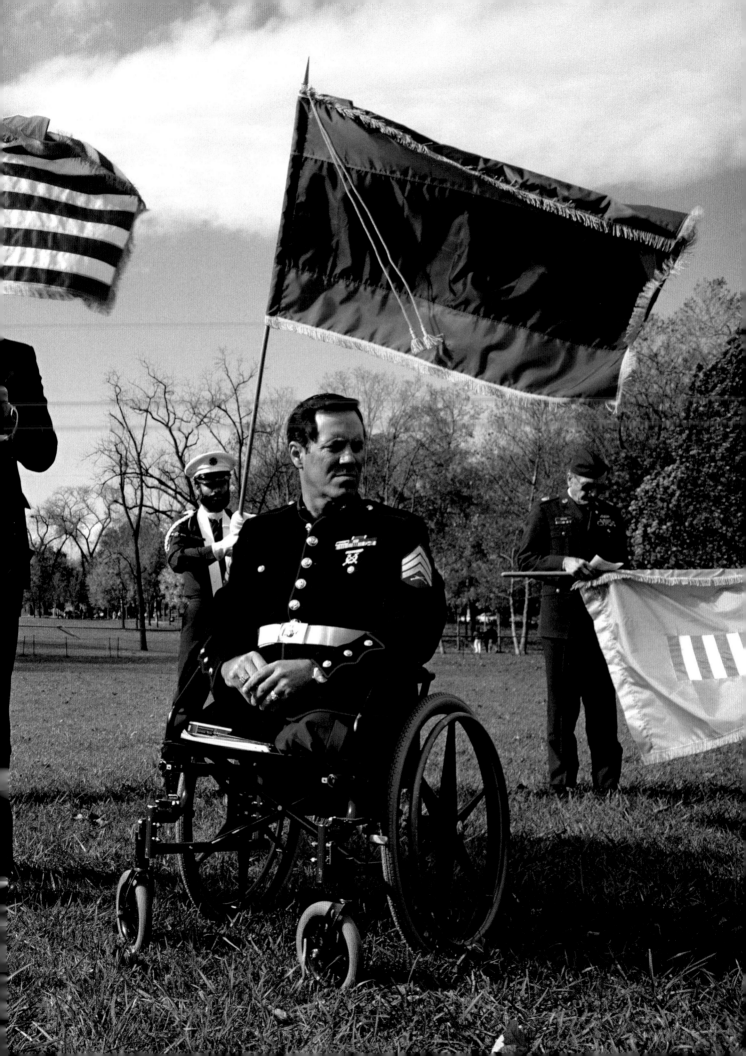

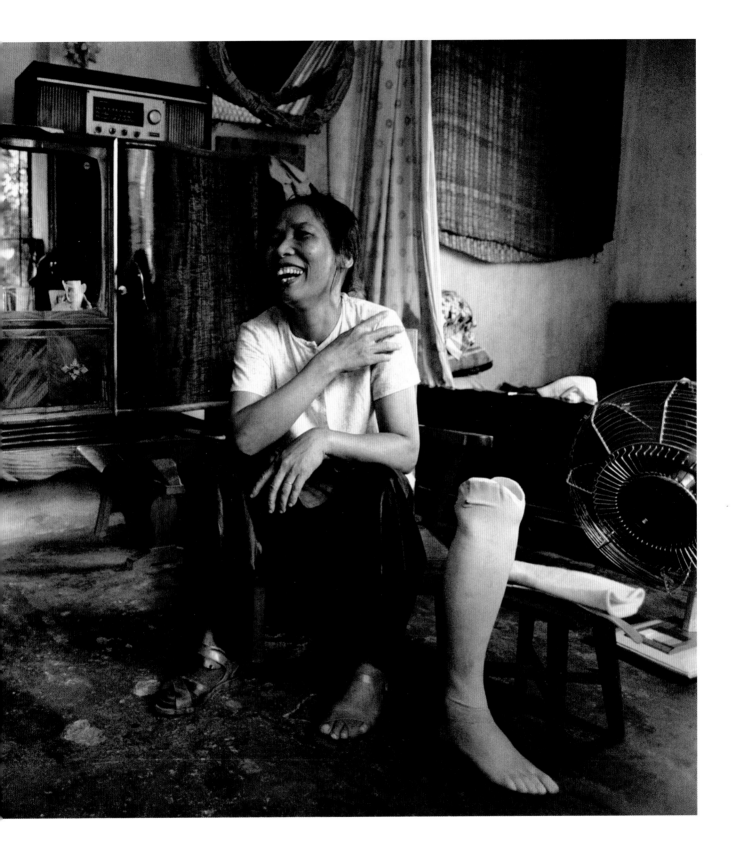

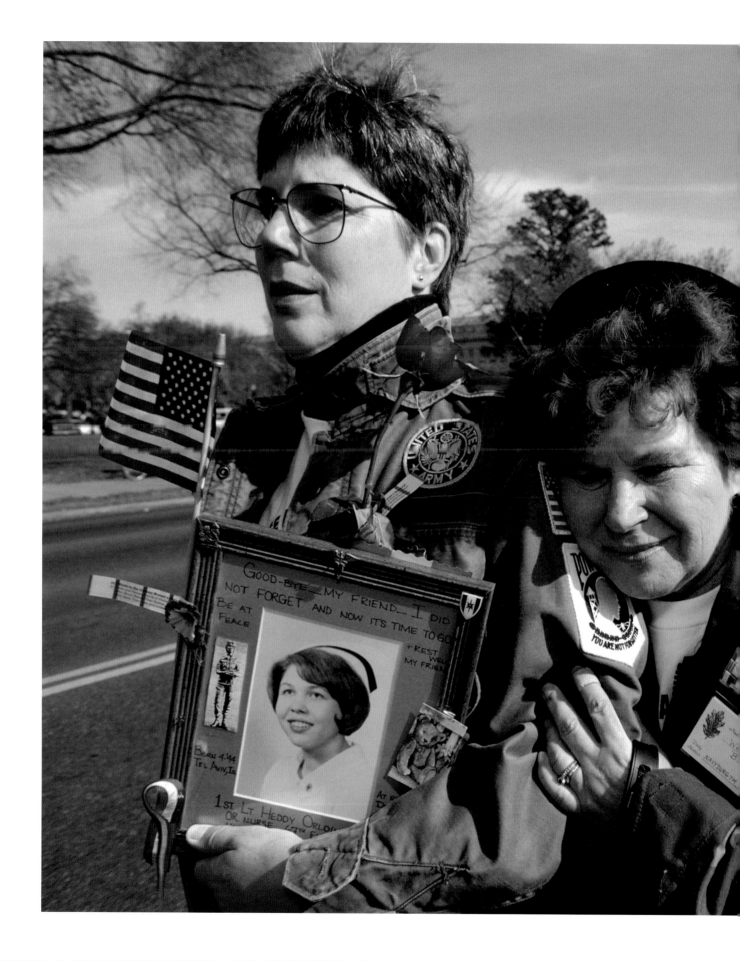

The photograph shows a handwritten memorial with a portrait:

GOOD-BYE MY FRIEND. I DID
NOT FORGET AND NOW IT'S TIME TO GO.
BE AT
PEACE

+ REST
WELL
MY FRIEN

BORN 4/44
TEL AVIV, I

AT R
D

1ST LT. HEDDY ORLO
OR. NURSE 67TH E

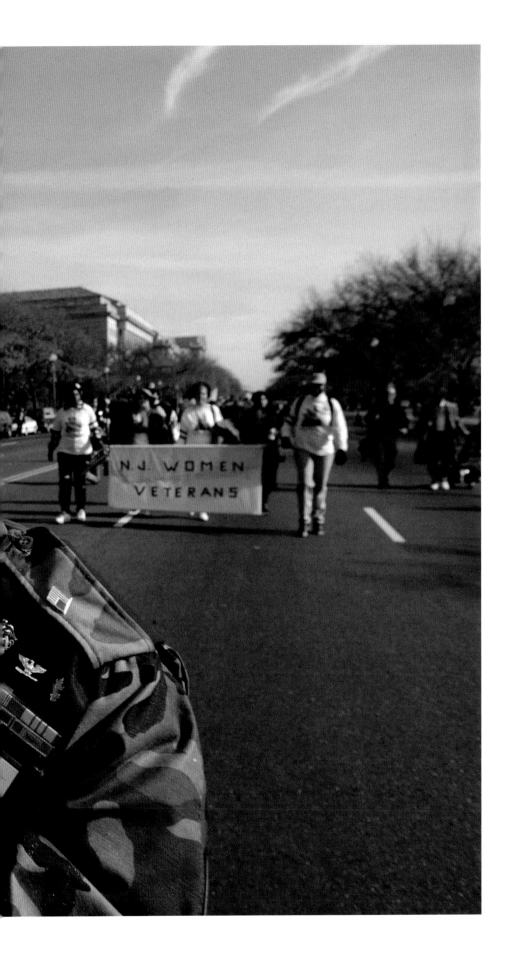

1960　　　　　1970　　　　　1980　　　　　1990　　　　　2000

My first tour in Vietnam was from September 1967 to September 1968 at the 67th Evacuation in Qui Nhon. My second tour from June 1970 to June 1971 was at the 24th Evacuation in Long Binh.

I joined up because I needed to pay for school and I always wanted to be in the army. I would have applied to West Point if I had been born thirty years later. I was immensely patriotic. Without hesitation I would have been most willing to lay down my life for my country.

I never felt like I was an active participant in the war. I never even felt like I was an active participant in the army! We were constantly told we were in charge of no one but each other and, possibly, our patients. We were "just nurses."

Our training was a joke. We were in an accelerated class in basic training with all types of other medical personnel. We were essentially walked through everything and came out able to properly wear our uniforms, salute the correct people, and know we had to have orders to go anywhere. We were issued old field equipment from Korea and World War II, shown how to shoot a 45, and told we would never be allowed to carry a weapon under any circumstance. We walked through a tent field hospital and pseudo Vietnamese village, watched a goat have a tracheotomy and gun shot wound debridement — but only men had any real training.

Patients would freely talk about the war, what they did, what happened to them and then ninety-nine percent of them would ask, "Why?"

It was a very different war during my first tour compared to my second. Prior to the Tết offensive in 1968, everyone was trying pretty hard to actually "win" the war and help out the locals. After Tết, everything changed in the attitudes of the government, which trickled down to the soldiers and medical personnel. By my second tour, the patients were still asking why, but the answers weren't valid.

This is a photo of my best friend who was killed in the war. Heddy Orlowski was a story unto herself. We met in 1967 when I first got to Nam. She was an OR nurse and I was in the Recovery Room, surgical ICU area, which were all connected. She was from Hamtramack, a suburb of Detroit near where my family came from and where I went to nursing school. We had similar interests, worked nights in the same area, and became good friends. She was one of the old timers who tried to protect me when the C.O. started hitting up on me. In retrospect, that was probably part of what put her on the short list of those to get sent out on TDY — temporary duty.

Anyway, Heddy had a fascinating history: born to two free Polish freedom fighters in World War II, she was born in Tel Aviv where

they had been sent after the war. In 1948 they were moved to England and they then immigrated to the USA. Her mom was a nurse and Heddy wanted to be just like her. She had become very disillusioned by the war and only wanted out. She did not wish to die for the USA or Vietnam. She just wanted to go home, go back to school, and get her nursing degree. Not a lot to ask, is it?

In the late eighties I decided to stop by Detroit and see her mom. She was still angry and took out all her pent-up wrath for the U.S., the army, Heddy, and the entire world, on me. She barely listened; she just ranted at the unfairness of her life and losses, how much she did not want Heddy in the army, much less Vietnam, etcetera. She ended the tirade with screaming that she wished it had been me. I tried to tell her, "so did I, so did I."

Incidentally, some of the wrath was well-earned, as the army refused to let me or anyone else accompany Heddy home. Instead they sent a telegram stating they regretted to notify her of the loss of her "son." Then they sent a Purple Heart — in the mail! When she launched an inquiry, the army only screwed it up more. She actually didn't believe it was really Heddy in the coffin, because it was sealed (there was not much of Heddy left that they could identify ... but, that's another horror story of the army's total cluelessness in that damnable mess!)

1910　　　1920　　　1930　　　1940　　　1950

What do I remember most? The horror and the waste. The lying, self-serving people that perpetuated the war — and the camaraderie, the challenge, the bonding, sharing, and love in being able to help those who needed it most despite the idiocy, harassment, and stupidity of those in command.

I definitely had the "1000 yard stare" when I returned, and I had it for years. It was a sort of protective device, where you could look and forever see your own world.

I think I finally accept that I did the best that I could. But if I could do one thing now, it would be to say to the families of those who died that they didn't die alone.

You were no longer limited by just the usual dimensions; you could be "elsewhere" if and when you needed to be. It may have been painful, but it was known, comfortable and understandable — as opposed to the world going on around us in the early seventies. It cut down on the sensory overload that was everywhere else.

I went to Ohio State University for my anesthesia certificate and was unnerved by the chaos of the sea of humanity there. So I lived forty miles away in the country until I could escape to northern Minnesota where three of us bought 240 acres of woods. In two years I was the only one left and stayed there until '89 when I sold it all and moved further north to twenty acres of woods.

Somehow, I had managed to work full-time all those years in many small hospitals, as well as Duluth, in trauma care and transport. I had flashbacks that occurred as I was working, saw myself doing the work from afar, but managed to always know what was going on and do the right thing. How? Probably by divine intervention I guess. But now all is well and it takes a real bad smell of something to take me back to the horrors of that war. Old blood and gasoline are avoided as much as possible.

I haven't thought about much of this for a very long time. I spent fifteen years in the woods of Minnesota to reach this point. I think it is in its proper place.

But it isn't very far away, really.

Washington D.C., USA 11.1993

Caption to picture on page: 138-139
Penny Kettlewell with fellow veteran Kay Bauer in the inaugural parade for the Vietnam Veterans Women's Memorial in Washington D.C.

Penny Kettlewell during her first tour in Vietnam, February 1968.

When I was a soldier we worked so hard, day and night, we had no time to rest. This seriously affected my health. Then, in December 1972, a bomb destroyed my house. Now I have nothing left. The war ruined my life.

I don't need to dream at night anymore. I dream all day, thinking of the war. So there's no need to dream at night.

Ba Vi, Vietnam 5.1994

Nguyễn Ngoc Tién at the Ba Vi Center for Psychiatric Treatment.

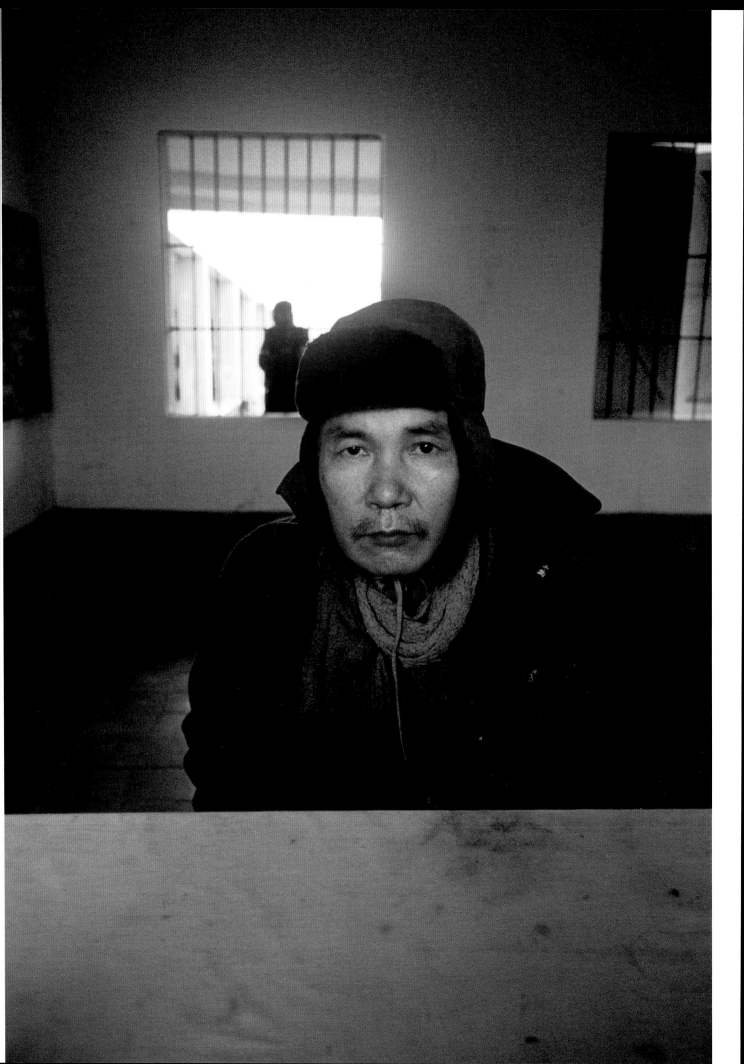

You see, a lot of my time in Vietnam — not all of it, about twenty percent of it — I don't remember. All I remember is good times, the times I had with my friends over there. First time I went to see the film *Platoon*, that rainy scene, where they had the rain and lightning and thunder — for the life of me I couldn't remember lightning and thunder over there. All I can remember is the rain. Why is it that I can't remember them? Bits and pieces come back, but I can't really put it together. I want to remember for myself. It's a part of my life. I don't want to keep pushing it on everybody else. It's like the old people say, before you go you should look back and say, I'm satisfied with the way I lived my life. If you can stop and look back at your life and really feel good about the things you did, then that's all you can ask for. That's what I want to do, to look back and remember all of it.

I was a radio operator, MOS-05 Bravo, in Ta Nanh and Rach Kein for five and half months with the 9th division. Then, when the 9th division went back to the U.S., they set me up with the 101st Air Mobile up in Phu Bi. I was clear up in the DMZ, Charlie 1, Alpha 1 ...

Early in 1971, I came face to face with the enemy. It was around noon and we were moving from one fire base to another when the truck we were on broke down. I stayed with the truck while the driver went to look for help. Then this Vietnamese guy appeared. He was just off the side of the road where the jungle starts, and we just looked at each other. We both had weapons and could've killed each other, but I jumped back in the truck and he went back in the jungle. I suppose it wasn't our time to go.

The war showed me man's callousness to life, how one man can just go and take another man's life. I had qualms about doing that, but it was a job I had to do, I was trained for it. All my training in the army was pointed towards killing, kill your enemy, get rid of your enemy, that's all I was taught. The idea they put in our heads at the time was to stop communism. If we didn't stop it there, it would spread. That gave us a right to take a life. It's just the setting. Outside of the military I couldn't do it, I couldn't hurt anybody. They taught me how to be a man. I went in as a boy; I came out as a man. I came back when most guys my age were still cruising around, going to parties and stuff. I was partying, but I was doing it to forget. I wasn't doing it for fun like the rest of them. I came back a man, but as a man with a lot of problems. I'd drink to forget it. That's what I mainly did.

It's the usual story of Vietnam veterans coming back. No one cared that you were there — or that you came back. When they did something it was to holler at you, spit at you, throw stuff at you.

After I got back, I talked to the elders, especially my uncle, and they took me to a sweat lodge and said, the best thing for you would be a sundance. At the same time I had dreams that I was dancing, so the next summer I started. Danced two years in Rosebud, and then we got the sundance back in Pine Ridge, and I've been dancing every year. You know, it wasn't until the Indians fought in the American forces that they allowed us to start sundancing again, to practice our religion, our customs. Up until 1956, they said it was savage. We had to sneak into the woods to hold our ceremonies.

It's just lately that they've been honoring Vietnam veterans at pow-wows. They caught on, on the reservation. It makes me feel good inside, makes me feel proud that I went and did my duty for my country.

I believe the government broke its promises to the veterans, the same way they broke their treaties with the Indians. Take the Sioux — in 1868 they gave them all of western South Dakota, part of Montana, a little bit of Wyoming and a little bit of Nebraska, to live for the rest of their lives. In 1869 they found gold in the Black Hills, so every year they took the land back. They're doing the same thing to the veterans. When we went into the service we were promised all these benefits when we got out. Hospitalization and care if we got sick. Every year they keep cutting it.

This walk relieves some of the anger that I feel towards the government about how the veterans are being treated. It gives me time to think back and reflect on why it is that we went over to Vietnam. The healing part really comes later, when we have the sweats, ceremonies. What the walk does, for me, it gives me a chance to think and it gives us a chance to get the message out to the people. But the healing really comes at the end.

During last year's walk, I thought I heard people walking behind me. I asked an elder about it and he said, "Remember who you are walking for. A lot of them are in the spiritual world and they're walking with you."

Oglala, South Dakota, USA 6.1991

Joe Brown Eyes during the "Last Patrol" walk in South Dakota.

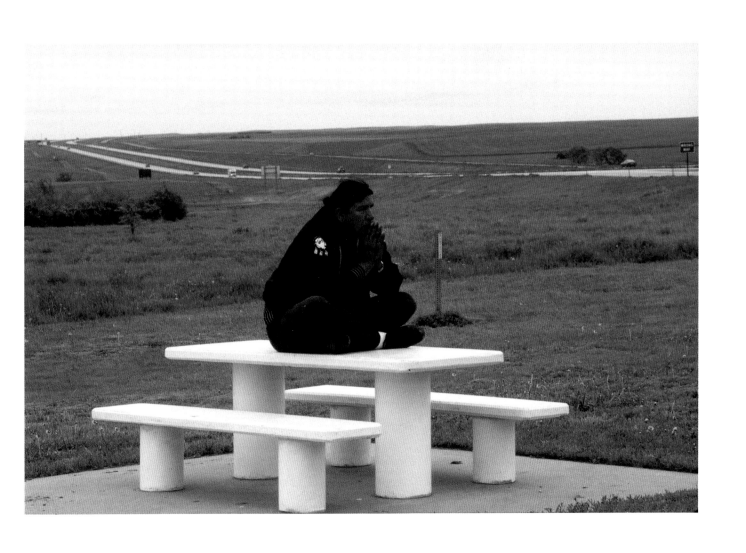

THE MIDDLE EAST [1973]

1910 1920 1930 1940 1950

Seeking to regain territory lost in 1967's Six Day War, on October 6, 1973, a joint military operation against Israel by Egypt, which attacked Israeli positions in the Sinai desert to the south, and Syria, which struck the Golan Heights to the north, surprised Israelis on the holiest day of the Jewish calendar, Yom Kippur (The Day of Atonement). The Israeli army, however, soon rallied and by October 11 had pushed Syria back across the frontier and stalled Egypt's Third Army near the Suez Canal. With Israel charging to within 40 kilometers of Damascus, under intense international pressure both sides signed their first cease-fire agreement on November 1973 at pre-war borders. Five years later, Israel and Egypt signed the Camp David Peace Accords, normalizing relations between the two nations.

NAME:
Yom Kippur War,
October War, Ramadan War
TYPE:
Ethnic/Religious,
Invasion,
Territorial dispute
CASUALTIES:
11,000-23,000 killed

1960 1970 1980 1990 2000

The director of the Rehabilitation Center for the Head Injured in Jaffa, Shlomo Katz:

Previously, people with severe brain injuries died. Now, with all the advances in medical research, more and more people are surviving, but those who survive lead very restrictive lives at home. Here we have psychological rehabilitation and social activities. They know what's missing in their lives, but they don't know what they are able to do. We expose them to a variety of things and find ways to fulfil their needs. We find meaningful activities and offer them autonomy. Students, engineers, art therapists, and other faculty from the university volunteer to work with them.

Israel has a high level of responsibility towards these people, more than if they were civilian wounded. You have people here who had good, sound lives, and suddenly they can't speak or are hemipalegic. Some have lost their wives and children. Something has died for them and now they must rebuild their lives. We can't change the disability, but we can improve the quality of life within the confines of the disability. And, objectively speaking, many attain a good quality of life.

If this center did not exist, many of these people would be institutionalized, especially if they were single young men. Many of them can function in here, but are no longer able to function in society. They are accepted here and they respond well if they have trust.

Jaffa, Israel 2.1995

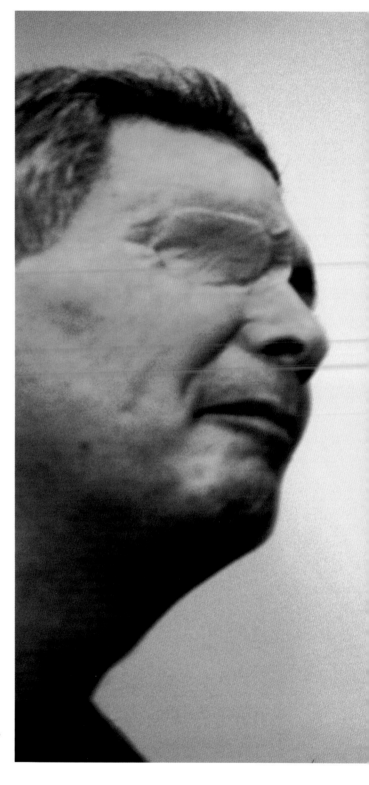

Koby Jacob (left) with Iftak Leiram, a veteran of Israel's invasion of Lebanon, at the Rehabilitation Center for the Head Injured in Jaffa.

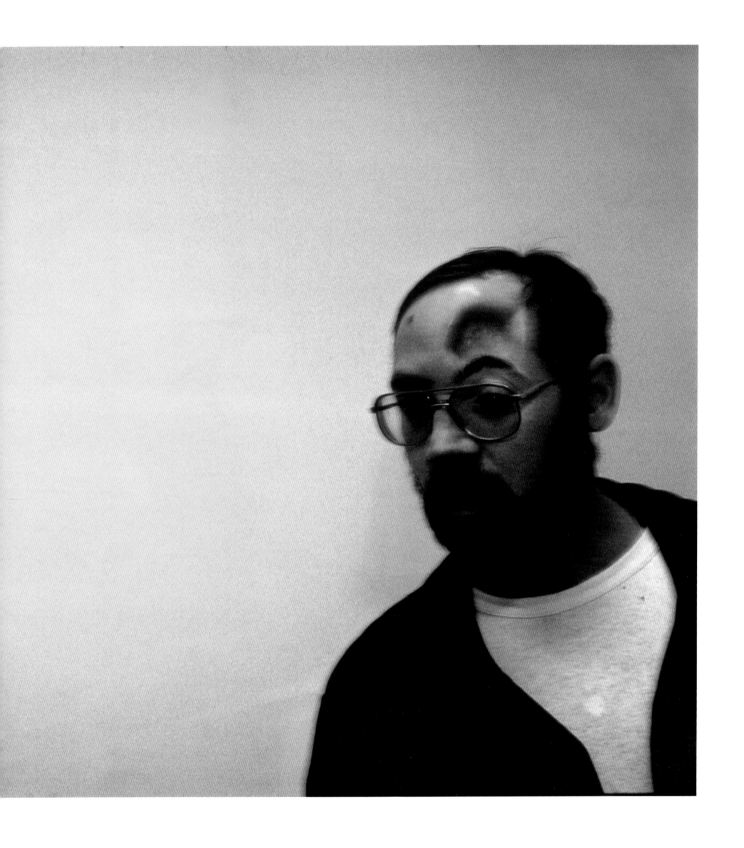

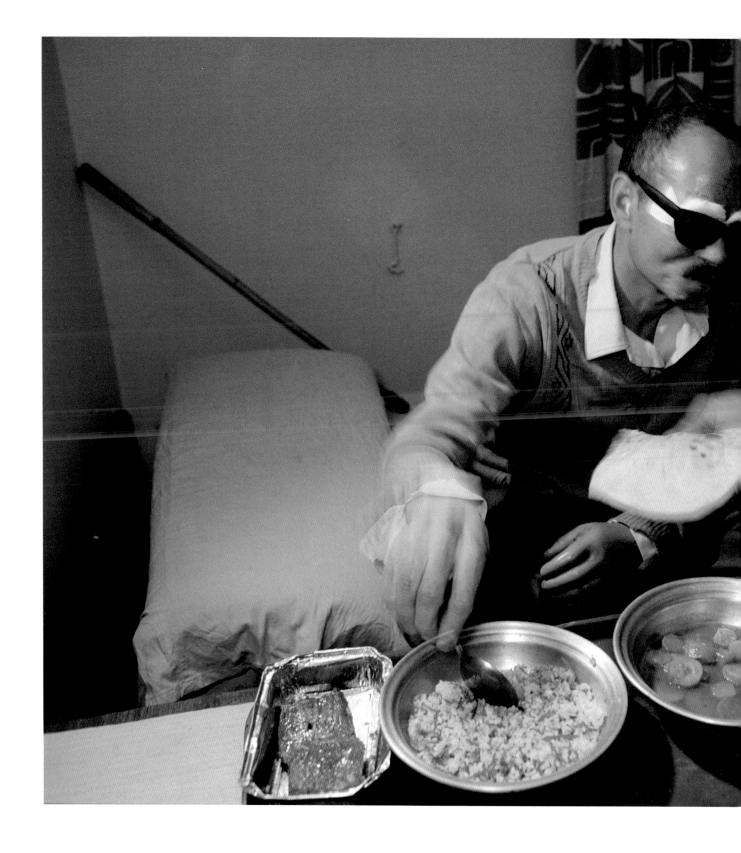

AFTERWAR : Lori Grinker **THE MIDDLE EAST :** 1973

I was wounded during an air bombing in the October War in 1973. I cannot speak of my activities; these are still military secrets.

I was married at the time I was wounded; it was a religious union. My eldest daughter is almost twenty and my two sons are sixteen and seventeen. I see them during religious feasts, or when something important is happening. According to circumstances, it's about once a month. I don't know if I am a part of their life. They are a part of my life, but only God knows if I am a part of theirs.

I'm still in treatment, my injuries are always with me. They make me feel the military experience all the time — but now I have a different focus, art and pottery. It helps me forget the injury.

I leave it to God. I am not sad. I am a pious man. I wanted to be a successful man, to be married, to have children and live among them — but everything changed.

If I had been normal, at least I would have been able to move around alone. I have to have a companion walking with me and doing things for me. I am not a failure; I'm just not able to walk alone. I am a man of peace and people should think of peace when they see me. This is all that is in my life.

Nasser City, Egypt 3.1995

Mohammed Bathala being served dinner at the El Waafa and Amal Society in Nasser City

BANGLADESH ¹⁹⁷¹

1910 1920 1930 1940 1950

In 1947, the division of the British Raj resulted in an independent Hindu India and a two-part, predominantly Muslim Pakistan separated by 1,000 miles of Indian territory. Conflict between impoverished East Pakistan, largely Bangla-speaking, and mainly Urdu-speaking Western Pakistan, which controlled the government, escalated in March 1971 when Eastern Pakistan declared itself the independent People's Republic of Bangladesh following a violent government crackdown against the rising Bengali nationalism. An estimated 10 million Bengalis fled to India before the Indian military intervened in December 1971 on the side of the Bangladeshis, leading to the formal establishment of the new nation in January 1972.

NAME:
War of Independence,
Indo-Pakistani War
TYPE:
Ethnic/Religious, Territorial dispute
CASUALTIES:
500,000-1,000,000 killed

1960 1970 1980 1990 2000

Text by Shafiqur Rahman, "Nana," and Abduk Ahad Choudhuri, director of the Freedom Fighter's High Command Office.

Shafiqur:

There are two hundred thousand freedom fighters, those who actually took up arms, living in Bangladesh today. In 1975, after our president, Father of the Nation Bangabandhu Sheikh Mujibur Rahman, was slain, nobody kept track of us, no one cared for us. For twenty-six years nobody took notice. We sacrificed our legs and our sight, we sacrificed our lives for our nation. We helped to liberate our country, but we could not provide for our children.

Just last year our prime minister, Sheikh Hasina Wajad, started a program to help those of us who were without shelter or food. Now I am living well. We are twenty people living in this one room. We can go back to visit our families once or twice a month, but prefer to be here where we can receive medcal treatment and food. And we are happy because the nation now recognizes us twice a year, on Independence Day and Victory Day.

Abduk Ahad Choudhuri:

In 1971, we were students. We had a daily routine in our day-to-day lives. We woke up, washed, had breakfast and then went to school. In the evening we would go to the playground and play as we wished. When we joined in the liberation war, our day-to-day routine changed. The students who took arms were given training and fought for the country. After victory, after nine months, our routine was changed. The student was converted into a soldier.

Many of us who joined the liberation struggle had our houses demolished or burned, our fathers killed, our families tortured. But we owned the country. The loss of our father's business did not seem to be a loss to us. What was the loss of one shop when we had liberated the entire country? We didn't want to return to our studies — what did we need with that? We owned the land, were leaders of the country. What could we do in a classroom?

Dhaka, Bangladesh 2.1998

Shafiqur Rahman, "Nana," with his wife, Rehana Akter at the "Freedom Fighters Village Project" in Dhaka.

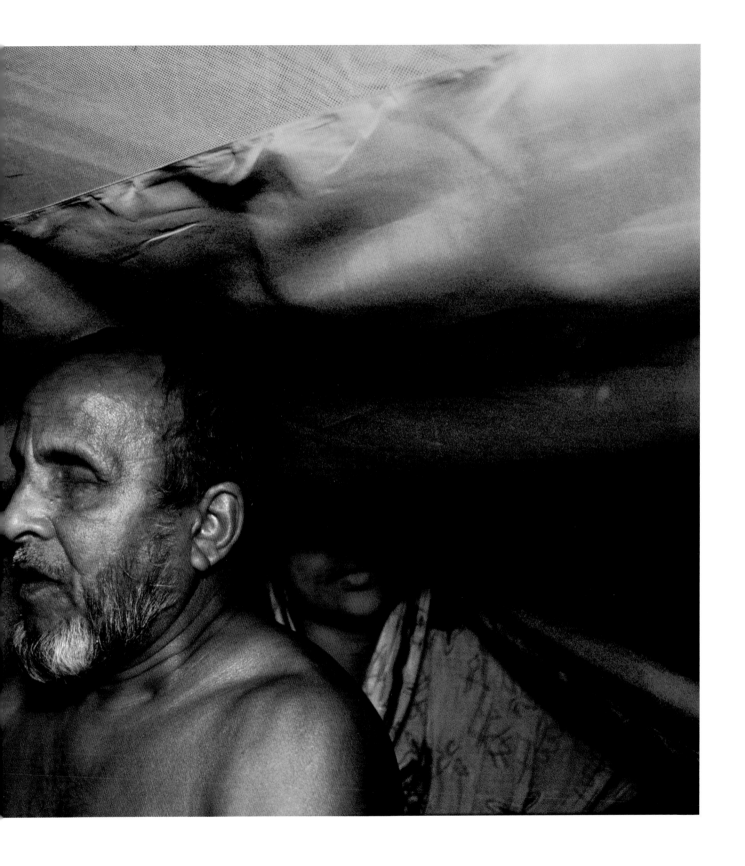

After March 25, 1971, when the Pakistani military began their campaign of violence against the East Pakistan people, all the students of my district started enlisting. I joined on the 26th. The thing is, being female, I was not allowed to fight. I just couldn't accept that. I thought: the only obstacle is the dress. If I change my clothes, I can join my team.

My brother and I had very similar features, so I cut my hair and put on my brother's shirt and pants. Dressed like this, I asked my auntie if I looked like a boy or a girl. She said nobody could tell that I was a girl. After I joined the group, I heard the other members say, "Mitil's brother is with us."

I always wore the same clothes, even when I slept. I would only change every fifteen days. I didn't take baths. I had two cousins who were with me, and at night I slept with one of them. He gave me protection and support.

I didn't mind taking a life. At that time the Pakistanis killed Bengali people like animals. We must fight back, I thought. We are not killing people, we are killing the enemy — that was my feeling. It was self-defense. Using a gun gave me the patriotic feeling that I was doing something for my country.

Dhaka, Bangladesh 2.1998

Shirin Banu Mitil at home in Dhaka holding a photograph of herself taken during the war.

1910 1920 1930 1940 1950

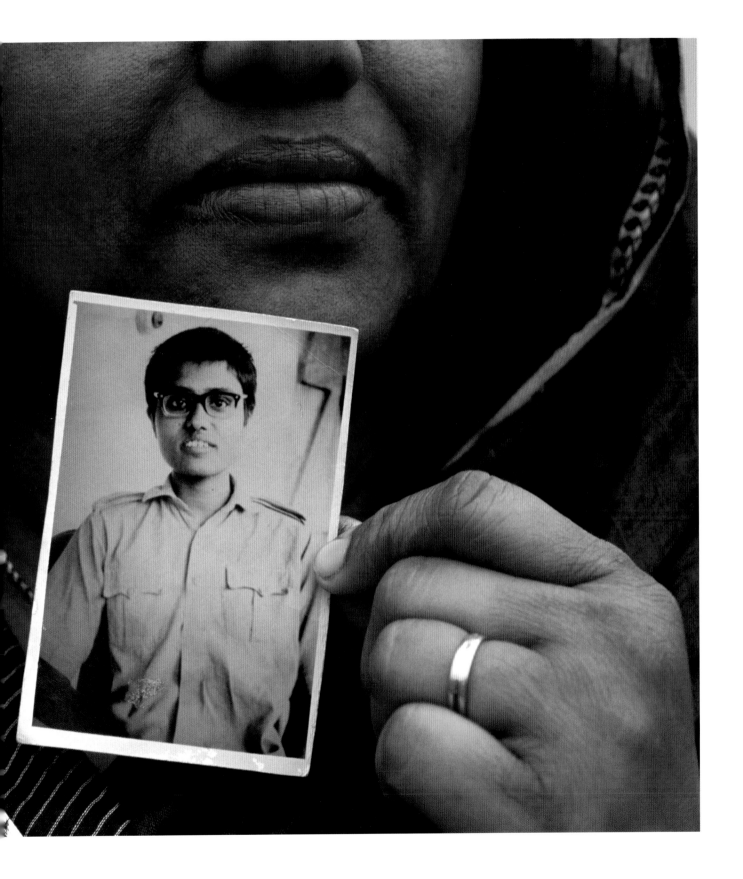

MALAYSIA _{1962 to 1966}

1910 1920 1930 1940 1950

In order to unload its burdensome colonies, in 1961 Britain proposed the creation of a Malaysian federation to include Singapore, Malay, and its colonies in northern Borneo. Bordering Indonesia, however, led by president-for-life Sukarno, called it a "colonial plot" and launched operations against the proposed federation, including Brunei, part of Borneo, on December 8, 1962. When Brunei's Sultan sought British protection, the UK dispatched British and Gurkha troops — fighters from Nepal who had fought for the British army since 1814. The Federation of Malaysia was officially proclaimed in September 1963. War raged until September 1965, when Sukarno, threatened by a Communist coup attempt at home, decreased involvement. After his resignation the following year, the two governments declared the conflict over.

NAME:
Indonesian Confrontation,
Britain's Small Wars
TYPE:
Territorial dispute
CASUALTIES:
45,000-300,000 killed

1960 1970 1980 1990 2000

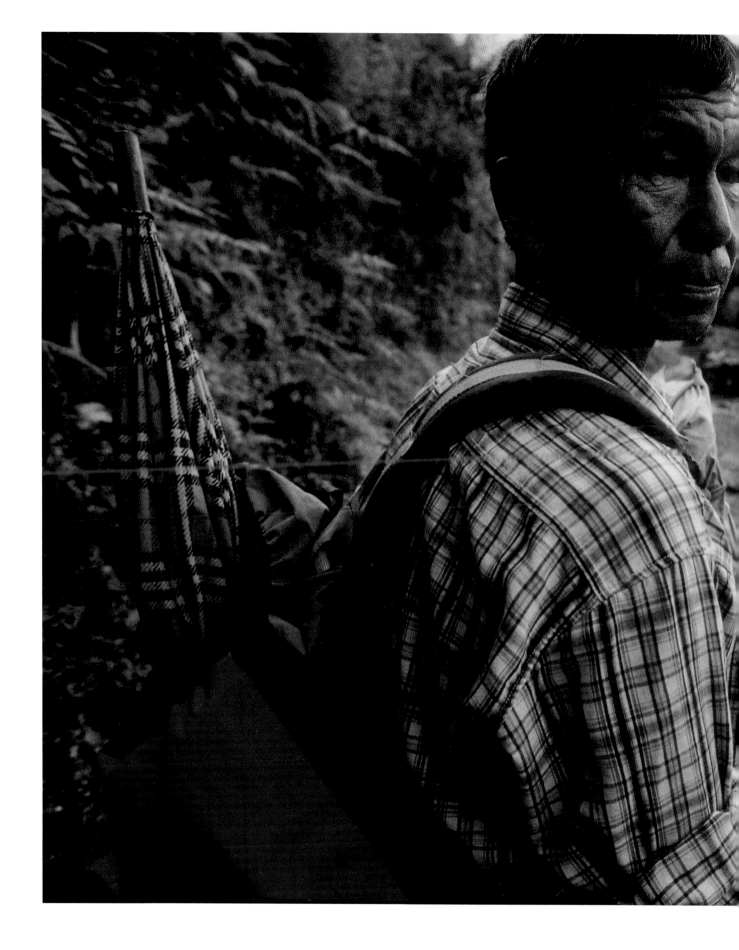

AFTERWAR : Lori Grinker MALAYSIA : 1962 . 1966

Dressed in civilian clothes, their officers came to our village to ask young people if they wanted to join the British Army. They said, "If you join us, you'll get good clothes to wear, good money for you and your family." That was the main reason I signed up, for the stomach — because we didn't have anything to eat.

About thirty-five of us from the village joined.

I had one year of training before being sent off to Brunei. I was there for three years. The war had to do with petrol, with a piece of land and petrol. The Indonesians were coming to Brunei to take the petrol. It had nothing to do with my country, Nepal. We represented the British Army in Malaysia. Some of us didn't even speak English. So whatever instructions they gave, with hand gestures or what have you, we had no choice but to obey as if we were deaf and dumb.

Because we live in the hills and in the jungles, we could march much better than the British. The way we can go up and down so easily, others can't do it. We also crossed rivers easier. Westerners couldn't cross certain rivers, but we were always able to do it. Well, we had walked with the British soldiers, and we knew the difference; it took them three hours to climb a hill that we climbed in an hour. We were always faster.

When I first joined the army I thought war was okay, no big deal. We ran around in the jungle, lived in tents — but then I saw people lose their lives. Once, when my friends were ahead of me, one of them stepped on a landmine. Then fighting started, Three of them were killed.

After that, it really affected my mind, I feared for my life and I began to think a lot about the Hindu gods and goddesses I used to hear about as a child. At home we had a family god who always protected us, so I wrote to my parents and asked them to do a special puja for me. I began to pray a lot. I prayed to God to save me.

When the war ended in 1968, the British government sent 10,000 of us back to Nepal. We had fought for them, fought for their territories, their commonwealth, went and earned our right — but they had reduced the petrol line and they didn't want to keep us on. We were sent back with 185 pounds sterling, and not a penny after.

Danda Gaon, Nepal 9.1999

Caption to picture on page : 160. 161
Dil Gurung during a three-day walk to Danda Gaon to visit other British Gurkha veterans.

Medals of a veteran at a rally for British Gurkha rights in Kathmandu, Nepal.

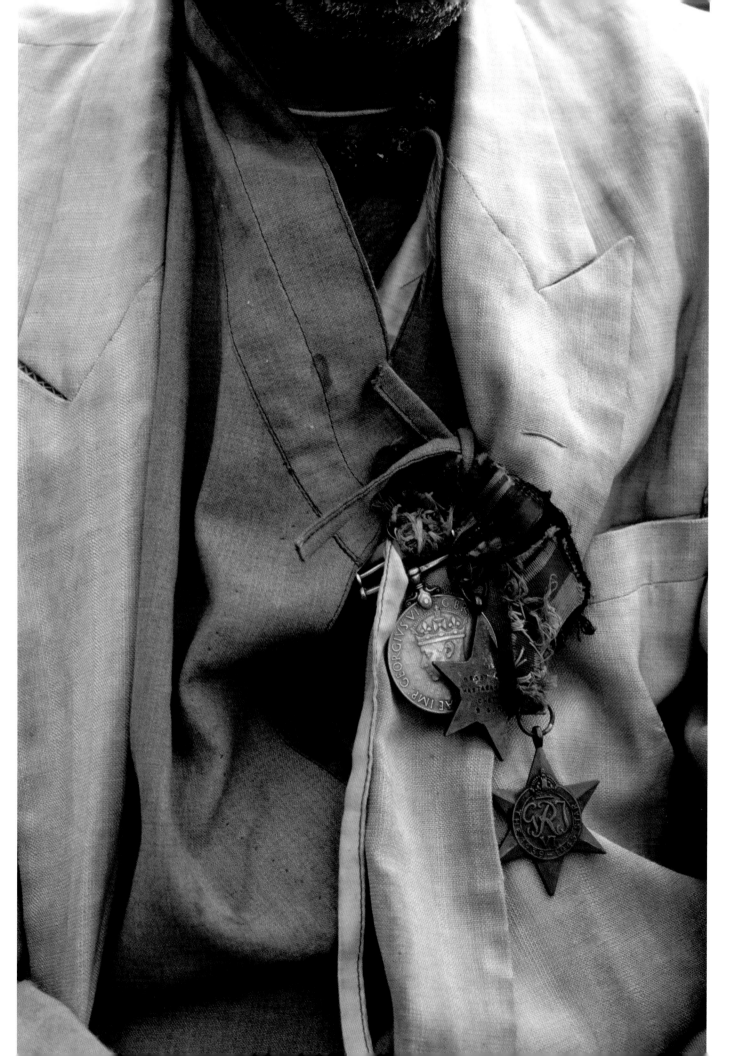

ALGERIA 1954 to 1962

1910 1920 1930 1940 1950

French involvement in Algeria stretched back to the early nineteenth century, but the nationalist sentiment of the Algerian population grew increasingly radicalized after the two world wars. Abandoning peaceful means, the newly-formed National Liberation Front (FLN) launched a campaign of guerilla war on November 1, 1954. Though the FLN did not initially enjoy the full support of the population, French reprisals against attacks, such as one that killed 123 people near Phillipeville in 1955, were so brutal, they soon united the cause. In 1959, President Charles de Gaulle abruptly reversed French policy and promised Algerians the right to determine their own future. In a public referendum held in June of 1962, some six million Algerians chose independence.

NAME:
The Algerian War of Independence
TYPE:
War of decolonization
CASUALTIES:
230,000-1.2 million killed

1960 1970 1980 1990 2000

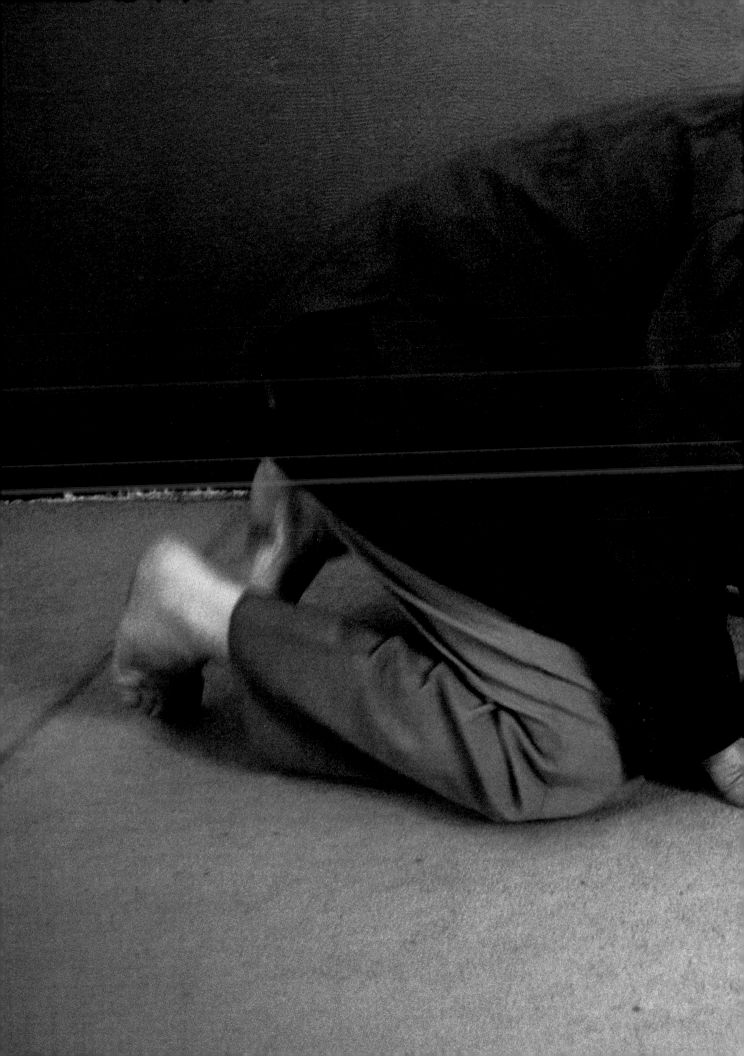

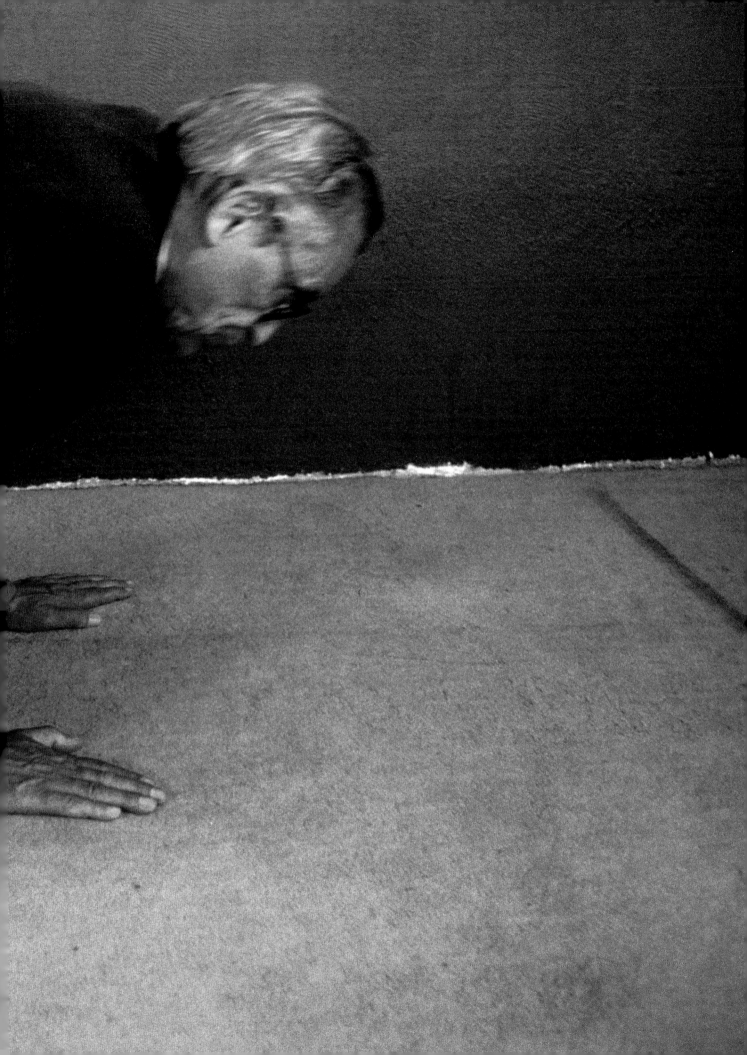

I was raised in a very poor region in southeast Algeria, a town called El Oued. There was no modern life — no electricity, no radio, no periodicals. It was very traditional.

I took courses in the Koranic school, and later on in the French school, but the only subject I excelled in at the French school was math. I had absolutely no knowledge of colonialism, no fixed ideas ...

The only work in our village was the cultivation of dates, palm trees, so at the end of 1945, I went to live with my grandmother in Aün Fakroun, a real colonial village, and got a job in a modern grocery store owned by my cousin. The store also sold newspapers, and although I couldn't read French, the paper *Depeche de Constantine* peeked my curiosity. But what really awakened my consciousness was BBC Arab radio from London. It gave me images of the world. I didn't know the world. For me, all that existed was the place where I was raised.

All through World War II, the French and the Americans made promises to the heads of the PPA [Algerian Popular Party] that after the victory there would be new reforms to help bring Algeria towards independence — but on May 8, 1945, the Algerians demonstrated in Setif with an Algerian flag. The French demanded the flag be lowered and the Algerians refused. Then the massacres began.

I became a PPA sympathizer and joined as a militant in 1948. A boiling of ideas, an interior revolt, was going on inside me. I learned the Koran, which speaks of Jesus and his mission of justice and freedom, and couldn't understand how believers in Jesus could oppress others and make them suffer such injustice. The PPA [renamed the Movement for the Triumph of Democratic Liberties (MTLD) in 1945] had a very powerful branch in France and sent many lawyers to defend the militants. Some of the lawyers were Christians. This seemed like a contradiction to me and I questioned my superior, who was bilingual. From my questions, he saw I that had a very limited view of the world so for about six months he took me under his wing. Every week he would sit me down and explain a subject to me. One day he brought me to a town called Souk Ahras, the birthplace of St. Augustine, where I met three Christian priests, who were French but spoke Arabic very well. We had a theological discussion that helped me differentiate between political power, economic power, and spiritual power. I understood class struggle without being a Marxist, as a Muslim.

In eight years, the Party completely changed me. I literally transformed from primitivism to modernism. I clandestinely distributed propaganda. I presided over meetings, sent telegrams out against oppression. I collected dues.

Then, in 1952, the police kidnapped Messali Hadj, our leader, and deported him to France. At this point, the Party directors handed out little stickers that said, "Free Messali" and I did something stupid. I gave the stickers to members of the Party's youth wing. One worked for a French colonel and put the sticker on the colonel's wall. This created an uproar and I was arrested.

In 1952 the French expelled me from Aün Fakroun and sent me to Tebessa, close to the Tunisian border. There was no threat to my family, they simply told my grandmother I had to go. After the first of November, however, when they arrested militants, they made their families suffer. That's what really helped create the FLN: the French colonialists' oppression of militants' families helped mobilize the Arab people — because whether you were militant or not, they arrested you, so you might as well work with the Party.

Less than a year after the revolution began in November 1954, I was arrested, freed, then arrested again. They brought me to Djorf camp in Msila where I stayed for sixteen months. There the FLN secretly taught us to read, write, play sports; we had conferences, theatre, and talked about the news. There were 1,300 of us. The French had meant to isolate all the Algerians who could mobilize the nation. In reality, they helped create an FLN university.

I was liberated on December 20,

1910 1920 1930 1940 1950

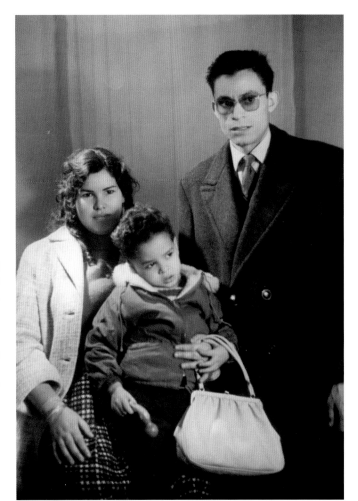

1956. In February they expelled me from Algeria.

I came to Paris. There were 340,000 Algerian workers in France. They arrested 40,000 of us, but that never slowed us down. The FLN had nine levels. Even if you shut down an entire level, militants from the level below would take their place — so the French police had a huge task.

In 1958 I took over the level called "Group," then another known as "Kamsa," then the one called "Region," then "Zone," then the "Super Zone," this one in Lyon, though, not in Paris. I also worked in a paint factory, then in a factory that made train parts. But at the end, when I was in those last three levels, I was paid by the FLN.

When I think of my life now, when I run the film of my life, I find it extraordinary what the Party gave me. I'm the child of peasants from the south, and I became a member of the central committee of the FLN. I was the director for all of Europe from April 1964 to 1969. I traveled. I met Nasser, I met Kruschev, I met Che Guevera ...

When the French judge asked me what role I played in the FLN, I told him that I helped the Algerian people commit their lives. I did it politically; we didn't achieve everything due to the army. It was thanks to the injustice of the French

— and the mountains. It was impossible for the enemy to penetrate the mountains of Algeria.

Gennevilliers, France 6.2003

Caption to picture on page : 166.167
Saad Abssi observing the afternoon prayer in Gennevilliers, near Paris.

Saad Abssi with his wife and son in France in 1959.

MOUHOUB NAIT MAOUCHE

born 1940 **served** 1956-62 National Liberation Front [FLN], National Army of Liberation [ALN]

On October 13, 1955, the French colonial army took forty-seven people from my village and killed them for no reason. They chose men in good shape, just average citizens, and killed them near the village. I was a witness. I helped bury them. I was fifteen years old. This was a year after the war had begun.

I felt a duty towards the resistance — we had to respond, to liberate the country. There was such injustice, it was unbearable. In Algeria, the French acted like kings while the Algerians lived in poverty.

At sixteen I joined the FLN and was sent to work underground in France. I was in charge of collecting dues, thirty francs from each Algerian immigrant to support the struggle of the FLN. For my cover, I had a job as an unskilled workman for the French railway, SNCF, hitching train cars.

In 1958, the police arrested a man, who, under pressure, gave me up. Learning that I had been denounced, the FLN smuggled me out to Bonn, Germany. I stayed there for three months, just long enough to get papers for a Moroccan passport.

In Morocco I joined with the ALN on the Algerian border. At this time, one part of the resistance was inside the territories and the other part based along the Moroccan and Tunisian borders. The Moroccans helped us; they let us organize and train. The ALN was not a clandestine group; we wore military uniforms. We were well-armed and ambushed the French troops. We were in open combat. At the time I was still wanted by the French police. They went to my father in Algeria and asked him to tell them where I was. He did not know, so they tortured him to death.

After independence, the military took power and outlawed Algerians their freedom of expression — there was only one political party. After 1963, we created a party called Front des Forces Socialistes [FFS] to restore democracy. For belonging to this group, I was imprisoned for one year; I was part of an organization that considered the Algerian government illegal; so after I was released on December 24, 1965, I sought refuge in France.

We freed our country, but Algeria is still a place of injustices, fanaticism, social inequalities, people who have everything and people who have nothing at all. It's just as dangerous as it was. In 1983, one of my daughters went to Algeria for winter vacation. Because she was my daughter, they confiscated her passport at the airport and kept her for a year. She was thirteen years old, and terrified. In countries like mine, when one wants to attack someone, they attack their family.

Paris, France 6.2003

Mouhoub Nait Maouche at his apartment in Paris.

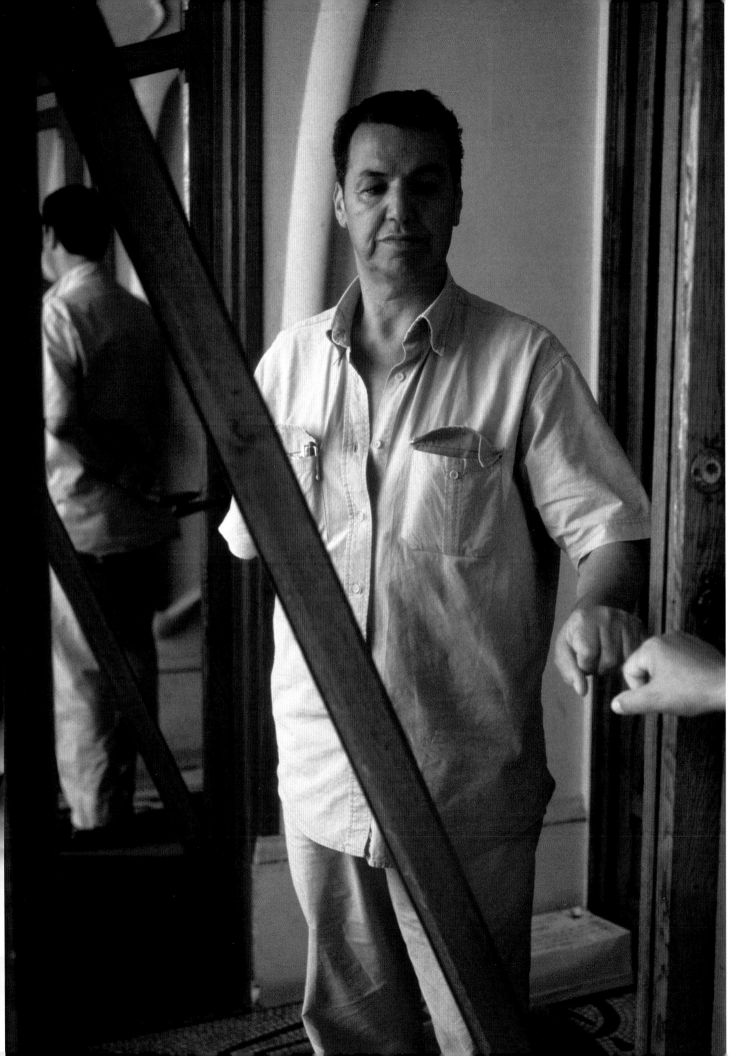

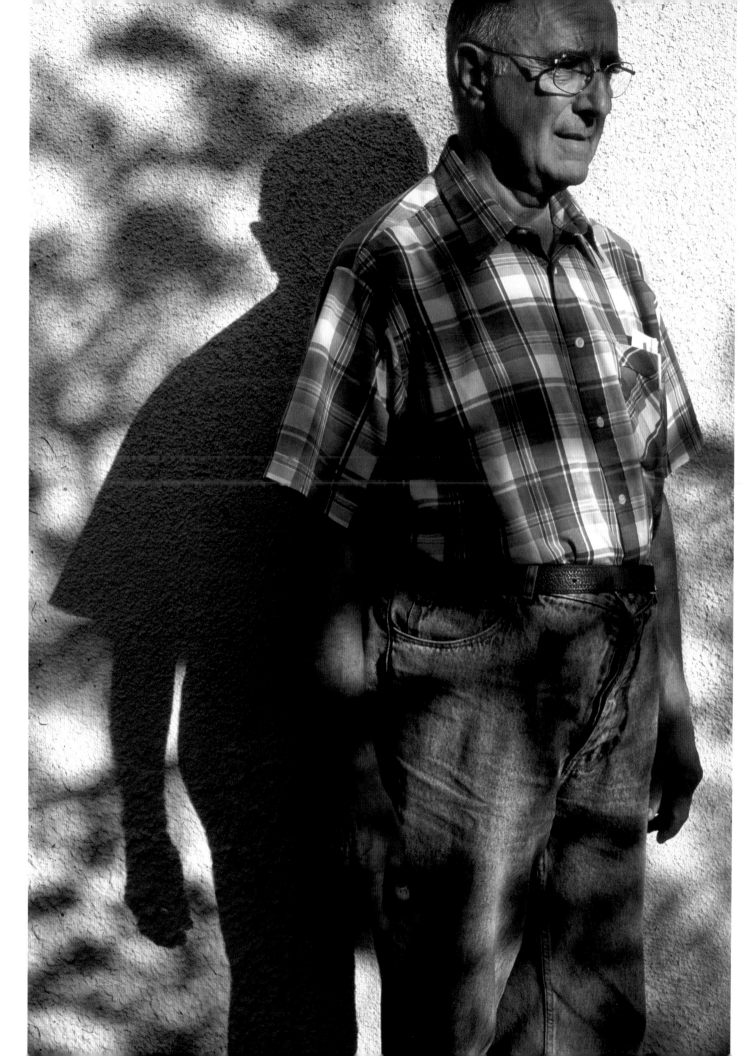

For twenty-five years I never spoke about the war.

I was with the naval paratroopers in charge of special operations [2nd RPIMA]. I went through all Algeria. We were taken from each place by helicopter and went on missions that lasted from one to several months. We were with the foreign legion. There was fighting but it was more like hunting.

This was a real war. It was not to "keep order" as it was said at the time. I had a friend, Garo, who was shot. He died in my arms. He had just enough time to give me his parents' address so that I could write them. I still have the image in my eyes.

The Algerian war was a result of 130 years of colonization. We ruined Algeria. We did nothing for them; we did nothing to help them grow, nothing to help educate the people. And we bore the consequences of that. The process of decolonization should have happened; it was about to happen, it had to happen.

I have dead people on my conscience, but I had to do it — we had orders. Their words were like a drug. They drugged us with words and speeches.' We were totally unconscious and had no contact with the outside world. They told us to kill the "fellagas." There was no frontline. When they gathered us together, we were going to hunt boar.

When one is in the army, it is a very closed world. There were a few things written, but the truth was never told. When we wrote letters home, we said we had been going to the beach or to do other things, but we never wrote the truth. There was no outside communication; no news got through. When there was an assassination attempt, the newspapers covered it as an accident in three lines.

Television did not exist.

During my seventeen months in Algeria I slept on the ground. I only had three days of rest the entire time. We were eighty people on the defensive. One day we entered an FLN hideout. There was a nurse who was about to give birth. I saw a soldier kill her. Then he opened up her belly to kill the baby. Was it just a moment, a period of craziness? When this soldier went back home and saw the birth of his children, what went through his mind?

When I killed a man, it was in self-defense. It was him or me. It happened in Le Mont du Hodna, a small town; it's called a "metcha" in Arabic. It was early in the morning; I was on the corner of a metcha. I found myself in front of a fellaga. I had an A-52 rifle. He had a Yugoslav gun. I shot.

When we came back home people did not believe us.

For fifteen years we were refused the veteran card. The reason was simple; in North Africa, there had been no war ... we were "keeping the peace."

Puycelci, Tarn, France 6.2003

Christian Grezes visiting a former Harki camp in Puycelci.

AFTERWAR : Lori Grinker ALGERIA : 1954 . 1962

When the war started, we were caught between the two armies, the FLN and the French. During the day the French troops came, and at night the FLN came down from the mountains and checked people's papers to see if they were with the French or not. When the FLN asked to see my father's papers, he showed them his veteran identity card which said that he had served in the French Army from 1939-45. They took him away. Two days later the neighbors found his body. His throat had been slit.

On one side you had the plague, on the other side you had cholera.

I hated the FLN after that, but I was not a volunteer in the French Army; I was taken during a raid. The French came to the village and rounded up all the young people. They put us in these big trucks and brought us to the base. We were given uniforms and rifles and told that we had to fight for France since we were French citizens.

I never held a rifle before, it was two meters long, it was nearly as big as I was because I was very skinny. There were a thousand of us at the base. We learned how to march. There wasn't much time to get proper training — within fifteen days we were sent away to fight.

I was just a foot soldier. I didn't fight anyone who I knew, but I did save some people. One time this civilian was accused by the French of collaborating with the FLN, and I defended him. By integrating the army, they helped us protect the civilians who had nothing to do with the FLN. On the other hand, we also helped a lot of French people. They were not on familiar terrain, it was not their climate. We helped them in the desert, we advised them. Most of us did not speak French or spoke it very badly. Usually we came to understand one another with hand gestures.

In general, the civilian population distrusted us. We were viewed as collaborators. Luckily, once the war was over and the massacres began, some very high officials, French officers, opened the doors of the barracks to protect the Harki population. These officers put their lives at risk for us — it was against the law to protect the Harkis. The Harkis who lived in the countryside were killed on their way to the barracks, or in their homes.

The worst time was not during the war, but after the war when we arrived in France. Everything began in Marseilles. In order to escape, I enlisted in the French Army. When we arrived, our military boat received an exceptional welcome. As you enter Marseilles, there is a huge boulder in the port. What we didn't know was that this boulder had big holes in it, and that there were Algerians in the holes. When we disembarked from the boat, they threw stones at us. There was a tremendous panic, the guards fired shots in the air. Then they got us onto a waiting train. When we got off the train, we were put on trucks and driven through the night to La Courtine.

I was in the 35th Company. I arrived with my family, my brother, and lots of colleagues. We slept in wooden huts. They left us for three days in the camp so we could rest, then brought us to the military base. In the morning we would leave the huts for the base, go back for lunch, return to the base for more training, and go back to the camp in the evening to sleep with our families. It was a very cold winter and we had snow up to our waists. We were living in such misery, my wife had a nervous breakdown and spent six months in the hospital. I lost a child in this camp. So many children died, our camp seemed like a cemetery.

After about a month, the colonel of the 35th Company gathered all of us as usual, but told the Harkis to stay in the courtyard after the morning call. When the other soldiers left, he said, "The trucks will come soon, you are going to go apply for your French citizenship." We looked at one another in astonishment. We thought we were French citizens. We were French soldiers, we had uniforms, we fought for them. But we were not French citizens. It was a rude awakening. The French lied to us. Dressed in our French uniforms, we looked at each other in amazement.

Gaillac, Tarn, France 7.2003

Caption to picture on page : 174.175
Ali Tebib in Gaillac.

INDOCHINA <small>1946 TO 1954</small>

1910 1920 1930 1940 1950

French involvement in Indochina began in the second half of the 19th century, treating the southeastern Asian nations, Laos, Cambodia and Vietnam first as a protectorate (1893-1939), then as outright possessions (1939- 1945). After rebel leader Ho Chi Minh declared Vietnamese independence in 1945, the French responded with arms to protect its colonial holdings. Though better equipped, France's attempt to battle an indigenous liberation movement led by the Viet Minh proved ill- fated, and after the fall of Dien Bien Phu on May 7, 1954, they sued for peace terms, which resulted in the departure of French forces and the division of the country at the 18th parallel between Communists to the north and the U.S.-supported south, setting the stage for the Vietnam War, also known as the Second Indochina War, the following decade.

NAME:
First Indochina War,
The French War
TYPE:
War of decolonization, Cold War conflict
CASUALTIES:
300,000-600,000 killed

1960 1970 1980 1990 2000

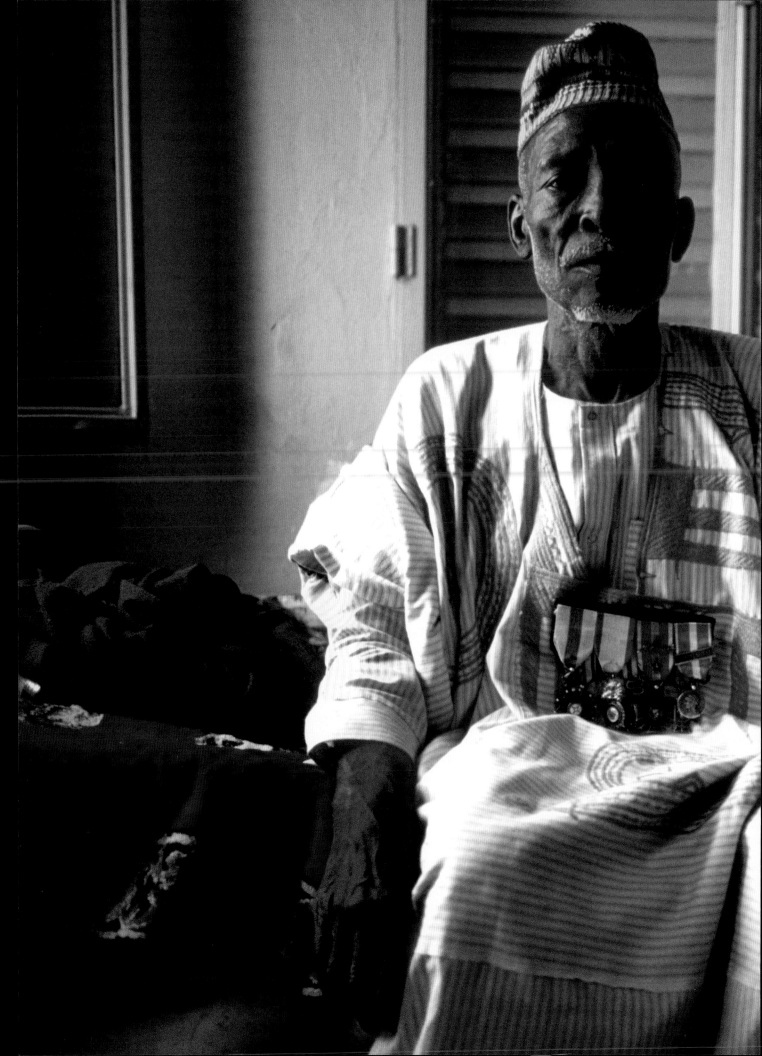

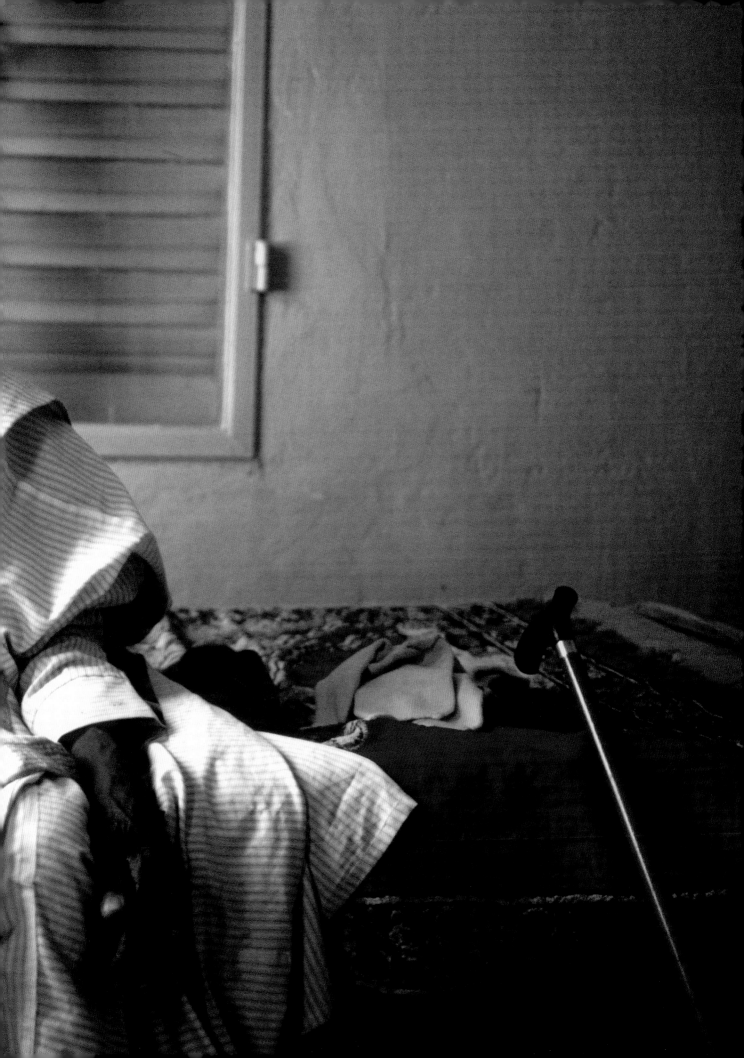

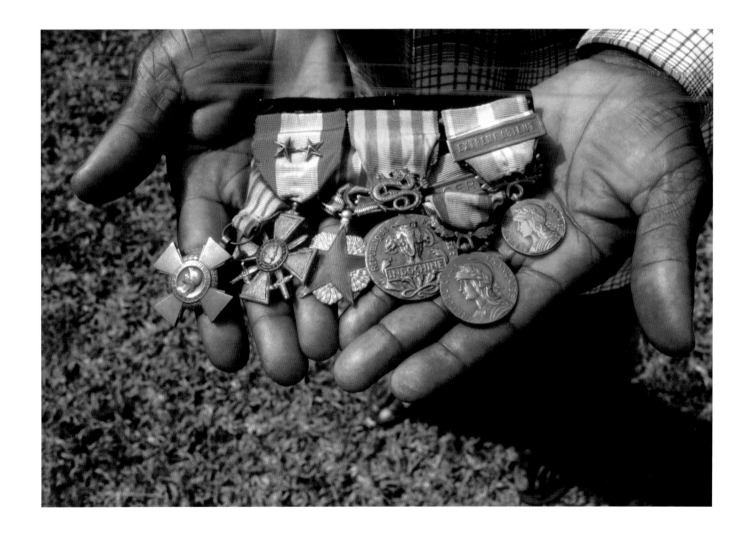

Arouna Asamou, director of the
Maison du Combattant:

Africa has always sacrificed its children, in World War I, World War II, in Indochina and Algeria. We hoped that if we fought for France they would grant independence, that was the logic. In Niamey, posters said, "Young Africans, join the army and you will be officers and junior officers."

Fighting provides a certain adrenaline rush like no other experience. The soldier is married to death. You think you are going to die any second and you see your death in a matter-of-fact way. Then you see it come to others, yet it doesn't take you; you live until the end. Any man who never had the chance to risk his life like this is not a complete man. He has not lived a full life.

A man who risked his life is humble. After war, those who survived are proud because they defended and protected our land, not because they were happy to go to war. The human part of man is ashamed that he went. Man was not made to fight. That part that has the pride is the vain part of man. The human part has the shame.

Niamey, Niger 2.1991

Caption to picture on page : 180.181
Nioma Zeinboy at the *Maison du Combattant* in Niamey.

An African war veteran with his medals. Cotonou, Benin February 1991.

1960 1970 1980 1990 2000

Before the French war, our living conditions were very bad, the French had exploited us so much — that's why I joined. Of course I need to make a distinction here between the French government and the French people. People are the same everywhere; only governments are different.

I was wounded in Dien Bien Phu, May 7, 1954. It was at night and we were running toward a hill during an offensive — that's when I hit the mine. My comrades carried me back to our base and the doctors performed three operations, each time cutting off a little more of my leg, but this didn't help so they decided to cut up to the knee. I was twenty years old.

After that, I didn't want to live anymore — my greatest fear was that I would never find a woman to marry me. But the government in 1955 was very sympathetic and they launched a propaganda campaign throughout the entire country, encouraging women to marry disabled soldiers. A lot of kind women asked us to marry them. That's how I met my wife.

Since then, I have used many types of limbs — from Germany, from Vietnam, and this American one which is very good, lighter and more useful; with the other limbs you can only step with the heel of your foot, not the whole foot. The only thing that isn't good with the American prosthesis is that the shape is a little too big for a Vietnamese — and the color must be changed; the color looks like the foot of a dead man.

Ba Vi, Vietnam 2.1989

Pha Van Kinh with his old prosthesis at the Viet Duc Center for Rehabilitation.

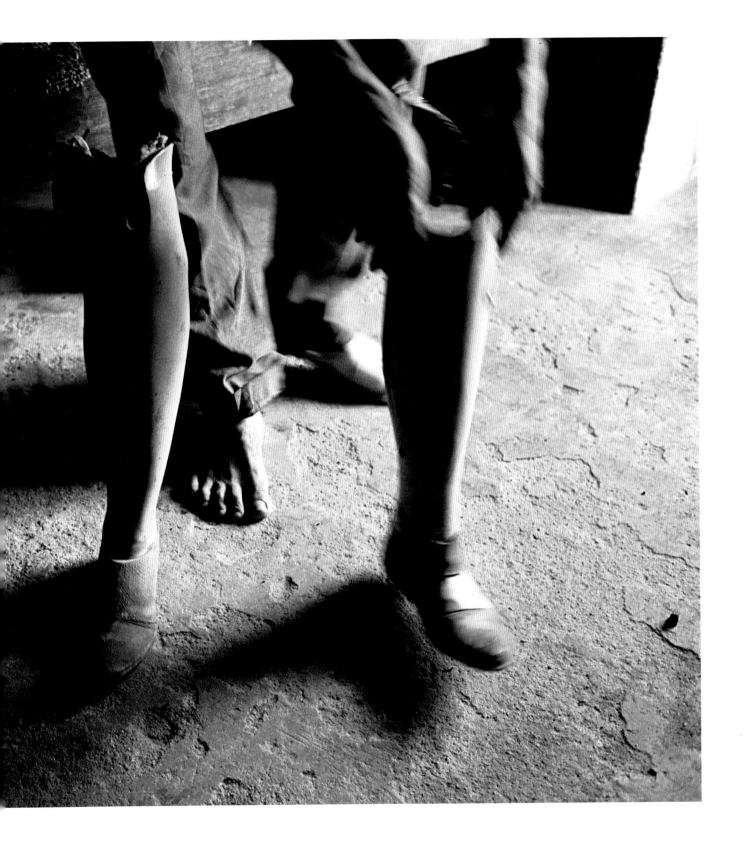

KOREA ^{1950 to 1953}

1910 1920 1930 1940 1950

After the end of World War II, the United States accepted the Japanese surrender south of the 38th parallel, while the Soviet Union accepted the surrender to the north. The result was a partitioned Korea that evolved into two separate states. With efforts at reconciliation a failure, in June 1950 North Korean forces invaded the South. The first major contest of the cold war, United Nations forces, composed mainly of American soldiers, joined on the side of the South, and despite early gains by the North, soon pressed to the China border. This sparked the entry of Chinese forces into the conflict and forced the U.S. back to the 38th parallel. After three years of fighting, with neither side having achieved anything, an armistice was declared along the same lines that existed when the war began.

NAME:
Korean War
TYPE:
Civil war, Cold War conflict
CASUALTIES:
3-4 million killed and missing, over 2 million wounded

1960 1970 1980 1990 2000

AFTERWAR : Lori Grinker KOREA : 1950 . 1953

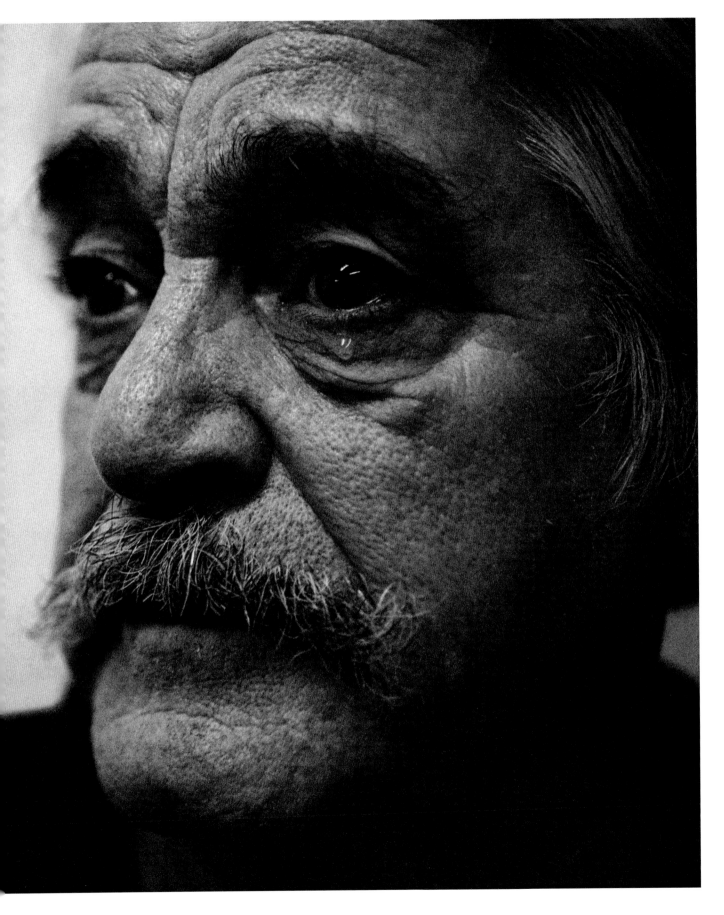

1960 1970 1980 1990 2000

The things that happened to us after we came out, well, we just took as a natural result of what we had been through. I suppose we all thought it would eventually go away — the sleepless nights, the faces — that they would die down.

But things that you saw during the war would come back, certain things would trigger them and set you off again. There are always occasions that revive the memories, you can't shut them out. You just try to suppress them for as long as you can. If you had nightmares, you'd take a couple of sleeping tablets — but you can only blunder on for so long.

We never thought that forty years on we would be in the state we're in. I don't think it ever ends. I don't believe the war can ever end.

Doncaster, England, UK 8.1998

Caption to picture on page : 188.189
Henry Green during a group therapy meeting for war veterans in Doncaster.

One memory is at the beginning of the war. We were in a cross-fire on the beach; we had a 155 Howitzer. All of sudden one of the guys shouted, "look behind!" We turned around and saw a sailor fishing out people, they were fishing bodies. Bodies were scattered all over the place. Can you imagine what it's like to look behind you on the beach and see a sailor fishing bodies out of the sea?

I knew that I was not coming back from combat, I was certain of it. It's a long story of how I became homeless. I tried after so many years, doing so many things — running away from everything. Running away from family, from my wives. I even tried different religions. I went to all kinds of groups until I found, about twenty years ago, the Rajneesh. I was based with him in Oregon. Now I am a swami in my religion — but all that time these things kept happening in my head and I made a decision that even if I loved my religion, I had to leave that place.

And, for the first time in thirty years, I began to seek help from the Veterans Administration. But I was scared to go into the system.

I started selling books on the streets of New York City, peddling by the corner of 47th and Broadway. Once in a while, I'd make good money, enough to get a

1910 1920 1930 1940 1950

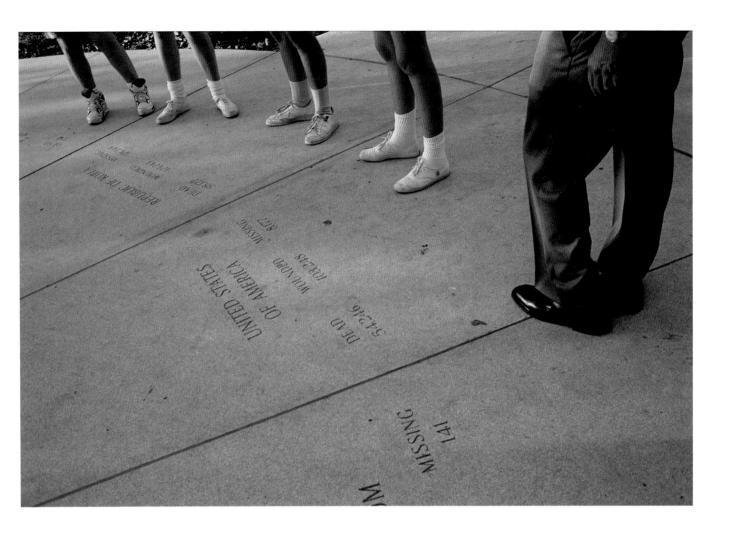

hotel. If not, I would sleep in the movie theaters, in the porno houses cause they were the cheapest theaters. But you get tired; you get crazy from those sounds, even if you don't watch the movie. I used to get out at about 4 a.m. and pick up books from the garbage. I started having trouble paying for the hotel. I always tried

to have respect for my person, to be clean and all. I just couldn't take it anymore and that's when I went into the shelter system. This was just two years ago.

In the Salvation Army shelter I found a group of guys, veterans with similar problems as myself. We organized a group that would

meet at 3 or 4 a.m. Then we found the social worker, Al Peck, and he really started to help us. He's a combat veteran, too. There are thirteen of us and we meet nearly every day. I still see things that happened in the war; I see guys standing around my bed, Korean guys, I can smell them, too — but I'm starting to feel better.

I was close to seventeen when I went to war. I got out of the service in '55, and I'm just starting to feel better.

New York, New York, USA 8.1991

Luis Ibarra Weber beside a group of tourists at the Korean War Memorial in New York City's Battery Park.

1960 1970 1980 1990 2000

CHINA 1945 to 1949

1910 1920 1930 1940 1950

The world's most populous nation, since the fall of its last dynasty, the Qing, in 1911, China had been ruled largely by warlords. By the 1930s, however, two distinct factions of power had evolved — the Kuomintang, or Nationalists, who led by Chaing Kai-shek held power, and the Communists, led by Mao Zedong whose peasant revolution had swept the Chinese countryside. The two had briefly united to fight the occupying Japanese forces during World War II, but after Japan's surrender in 1945, resumed their bitter rivalry. Although better equipped, the Nationalists had little of the resolve of the Communist guerilla forces and little support from the population, mostly a poor, exploited peasantry. Chaing was forced to flee to Taiwan in 1949, and on October 1, of that same year Mao Zedong declared the birth of the People's Republic of China.

NAME:
Chinese War of Independence,
The People's War of Liberation,
Chinese Civil War
TYPE:
Civil war, Popular uprising
CASUALTIES:
Estimate: 1-4 million killed

1960	1970	1980	1990	2000

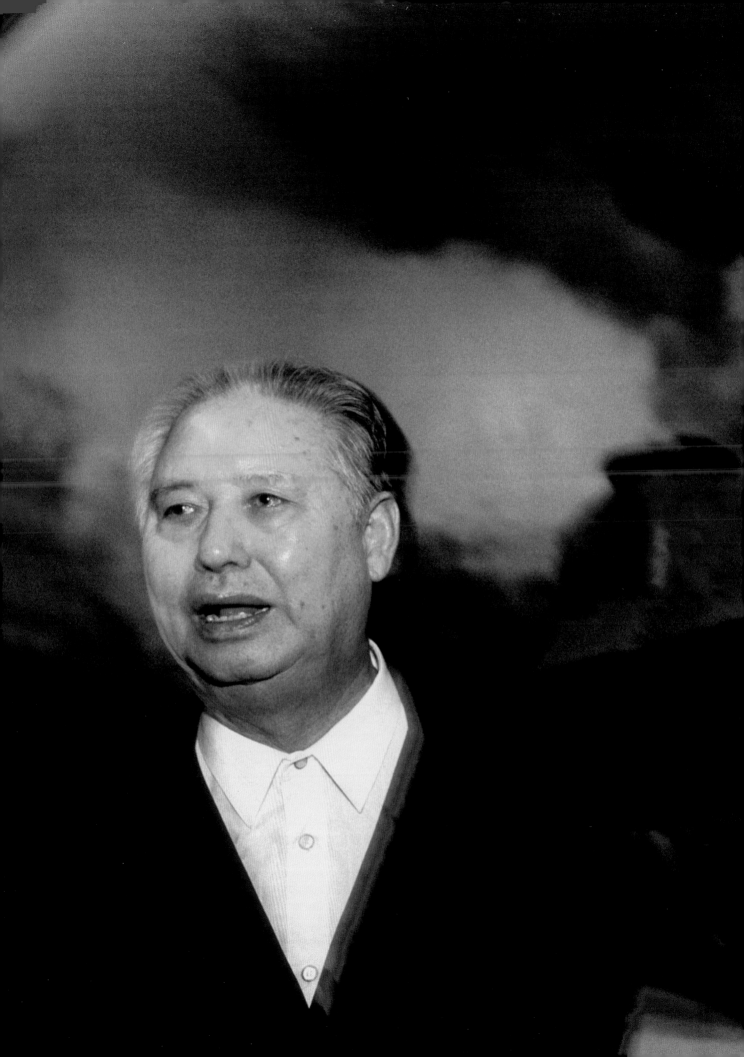

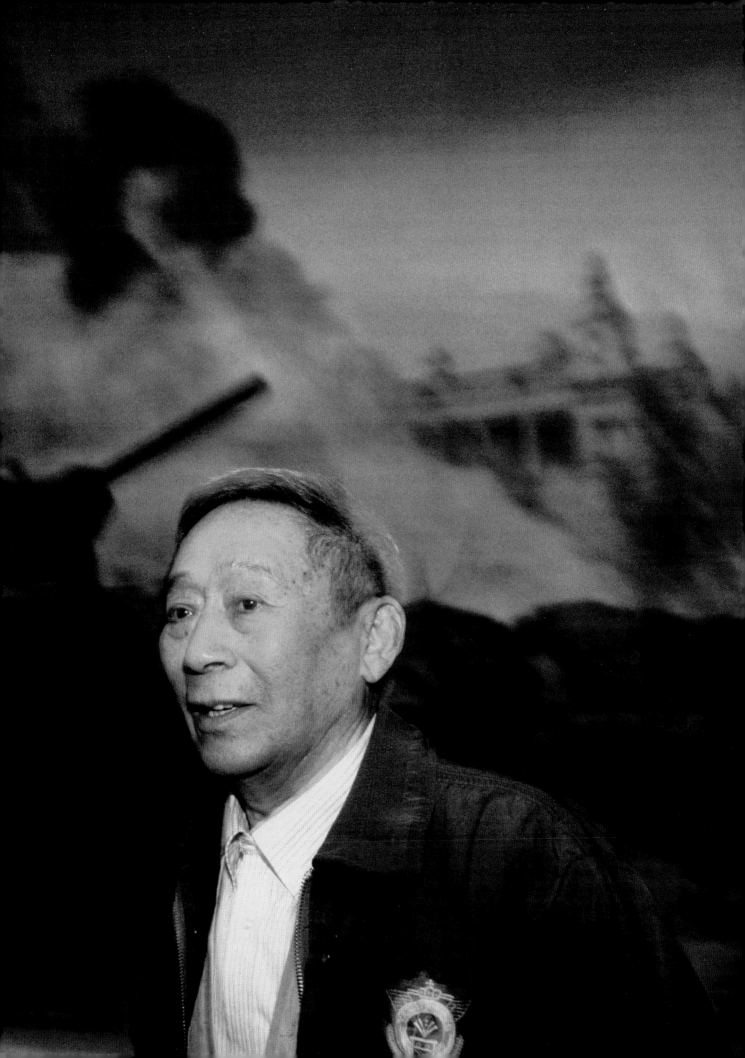

I fought on the frontlines in north-eastern China until 1949, then I was behind the front carrying weapons, or watching over the spies. Compared with soldiers who fought at the foremost front, the risk I took was small, but to say I wasn't afraid is not at all true. There were so many casualties you couldn't count. The Kuomintang army was stronger than us, better armed, and had help from developed nations. The Communist Party soldiers only had rice and simple guns.

Our army was very popular, though, very welcome by the villagers, even if they had to give up their beds. The big beds, like the *kang*, could hold six to eight people. So fourteen soldiers could sleep in two of them. Women, too. Our female comrades were brave and strong. They fought like men and shared the same ideology. They wanted to revolutionize, be rid of the landlords, and change their destiny.

Mao had a saying, "Let the villages surround the city," so we lived in the villages and in the mountains because the major cities were occupied by the Kuomintang. During the day we took a rest or studied, then at night we carried out our missions.

Nineteen of us joined together. Eighteen of us died. Seventeen in battle. The other one deserted, became a spy. We captured him and assigned him to be a prison chef.

There they reeducated him. But because it was a prison it was full of spies and he was still able to get information to the outside. I was in the Public Security Armed Forces then; it was our principle to reeducate people after they did something wrong or committed a crime. When we discovered this, we reeducated him again. We tried this several times, then we executed him.

> To execute someone is not a simple thing. I thought it was right because I was born in a very poor family and never had the chance to get an education, but his family was rich and he studied until junior high school.

If he continued in the Communist Party and made an effort to be a good soldier he would have held a high position, much better than most of us. So we felt betrayed. We hated him and felt justified.

We didn't inform the family about this killing. I have no idea how the family or friends found out in the end. I didn't care, really. It was wartime and everything was a mess. There was no law, unlike now where we have very strict laws, the court, policemen, a system to protect everyone's rights. Well this was wartime and everything was chaotic, so we didn't bother about such things as informing the family.

Beijing, China 10.2003

1910 1920 1930 1940 1950

Until 1945 I didn't wear a uniform. That was Mao's strategy. The communist soldiers were underground and couldn't stay in a village for too long. Mao's strategy was to move us from here to there, one village to another, carrying out our missions mostly at night. Whenever the Japanese attacked us, we hid in the mountains. That's why they called us "hairy monkeys." Because whenever they fought us, we ran to the countryside and disappeared like monkeys.

It was actually scariest before the battle began. After the first gunshot, you knew your enemy and you knew your aim and you were no longer scared, you just kept fighting. But before the battle you had no idea what it would be like, you didn't know where you were going to be and you couldn't make the slightest noise. You needed to be completely quiet; you couldn't cough or anything.

In 1945, we received the news that the Japanese had surrendered, and we were ordered to Jinan, the capital of Shandong province. I was familiar with the road so I led the way to a village near Jinan, a two-day walk. It was around midnight when we arrived. Everything was dark. It was raining and raining, the weather terrible.

The village was surrounded by hills. When the remaining Japanese forces realized we were entering the village they dropped a bomb on us. Only three of us survived. I had a serious injury to my leg. The weather was still very bad, my leg covered with mud. I couldn't move so the others carried me all the way. They walked for a day carrying me to a village. The villagers were kind to us, they gave us eggs and dumplings to eat, and then I started to get some treatment. Afterwards I was given 3rd rank handicap.

After the revolution I went to Beijing and drove an ambulance.

Once, in 1957, when Mao and his family went to Bei Daihe for a holiday, his daughter Lina got sick. They returned to Beijing by train and I met them to take her to the hospital. I got on the train, Mao's special train. It was such a nice train, decorated so well, carpet and sofa, everything. Then I suddenly saw Mao. I was so full of awe, I just ran away.

Beijing, China 10.2003

Caption to picture on page : 194.195
Ju Yuanxue (left) and Xie Ziyun at the Military Museum, Beijing.

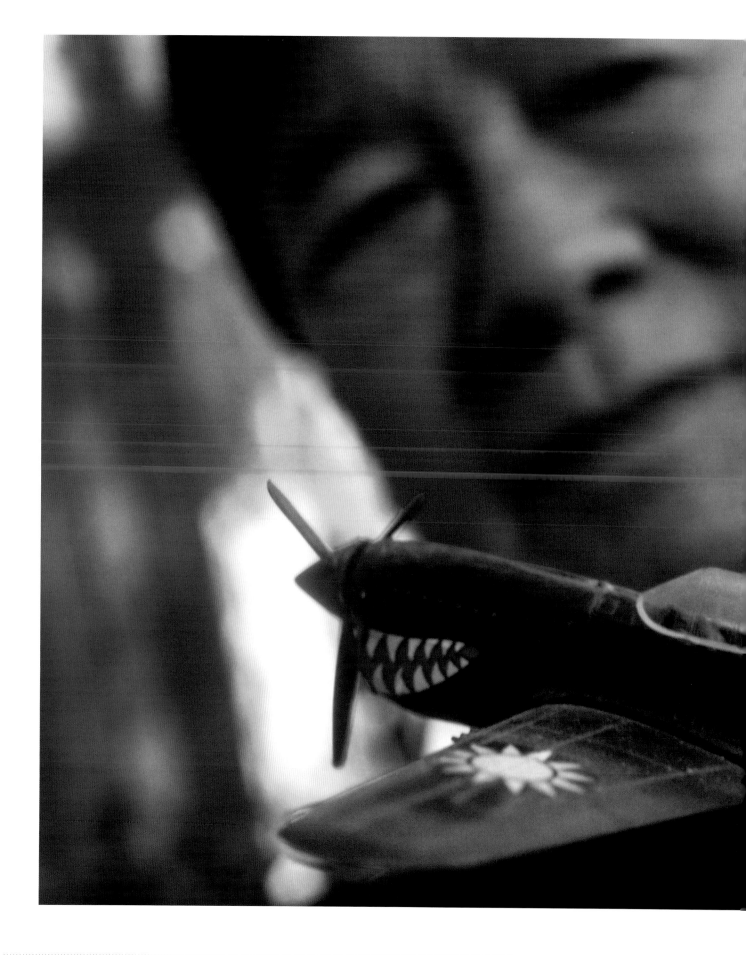

AFTERWAR : Lori Grinker CHINA : 1945 . 1949

I flew twenty missions against the Japanese and a hundred and forty-five against the Communists. Altogether one hundred and sixty-five missions. The P40 fighter, the famous Flying Tigers plane, had six machine guns. First we dropped the bombs at around three thousand feet, then we dove and used the guns to shoot the ground troops.

I was alone in the plane. I had to do everything solo. I used my feet to press the pedal, my fingers to press the button for the bombing and machine guns, and I used my mouth to communicate with the ground. There was no time to be afraid. Once, while fighting over Beijing, my arms and legs occupied, I watched a bullet whiz through the plane. Now I realize how dangerous everything was, but back then I had no fear.

I remember one particular battle against the Japanese. I was attacking with my machine gun.

The Japanese force was mounted and when we started to shoot, the horses all ran together, making it easier for us. They were jumping so high they almost touched my plane

I have no idea how many deaths I was responsible for. Hundreds. But I could not see clearly how many people I killed. I think about them now, and I wonder why I had to kill so many, especially during the Chinese Civil War. With Japan it was different. When the Japanese invaded we were eager to fight — I still hate the Japanese — but fighting against the Communists I felt differently.

They were our own people. I didn't hate them. We wouldn't refuse, we had to quell the trouble, but no one was too enthusiastic. We just hoped the war would end quickly and we would all be reunited. I hated to kill them, but I had to.

I live a quiet and decent life now. I could have retired a general at the age of fifty-two, but my daughter was graduating from college in the U.S. and I wanted to join her. Later, I opened a store around the corner from my home in Queens. A candy store. I worked there for twenty-six years.

In some respects I feel lucky, in others sorry. After all, this is not the place I was born. In China we have a tradition of returning to our hometown when we grow old. There is a saying: "the fallen leaves return to the root of the tree." Our people would like to go back to their hometowns, back to their roots.

I was born there but I cannot die there.

Queens, New York, USA 2.2004

Caption to picture on page : 198.199
Su Ching Chen at home with a model of his P40 fighter plane.

Su Ching Chen with a fellow pilot during the war.

1910 1920 1930 1940 1950

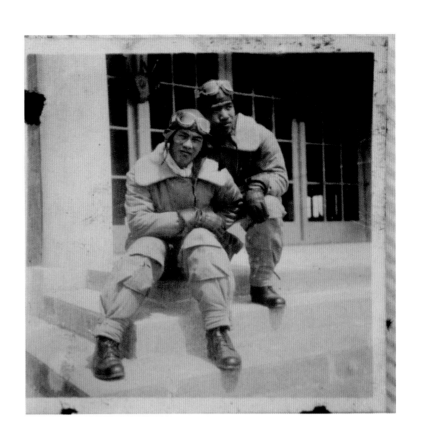

WORLD WAR II

1939 TO 1945

| 1910 | 1920 | 1930 | 1940 | 1950 |

The largest and deadliest war in history, World War II affected nearly every part of the globe, killing over 50 million people. A replay of the First World War on a larger scale, it pitted the Allied powers — mainly Britain, France, the United States, and later the Soviet Union — against the Axis powers — Germany, Italy and Japan. For soldiers and civilians alike, the war represented a new low in the history of man's inhumanity to man: the Nazi genocide against the Jews, which killed six million; the death of over 20 million in the Soviet Union; and the detonation of the world's first two atomic bombs in August 1945 on Hiroshima and Nagasaki, Japan, which killed over 150,000 people in seconds. The war also saw the rise of the two new global superpowers, the United States and the Soviet Union.

NAME:
World War II, Second World War,
The Great Patriotic War,
The 2nd Sino-Japanese War
TYPE:
Global war
CASUALTIES:
50 million killed. Over 9 million
military wounded

1960 1970 1980 1990 2000

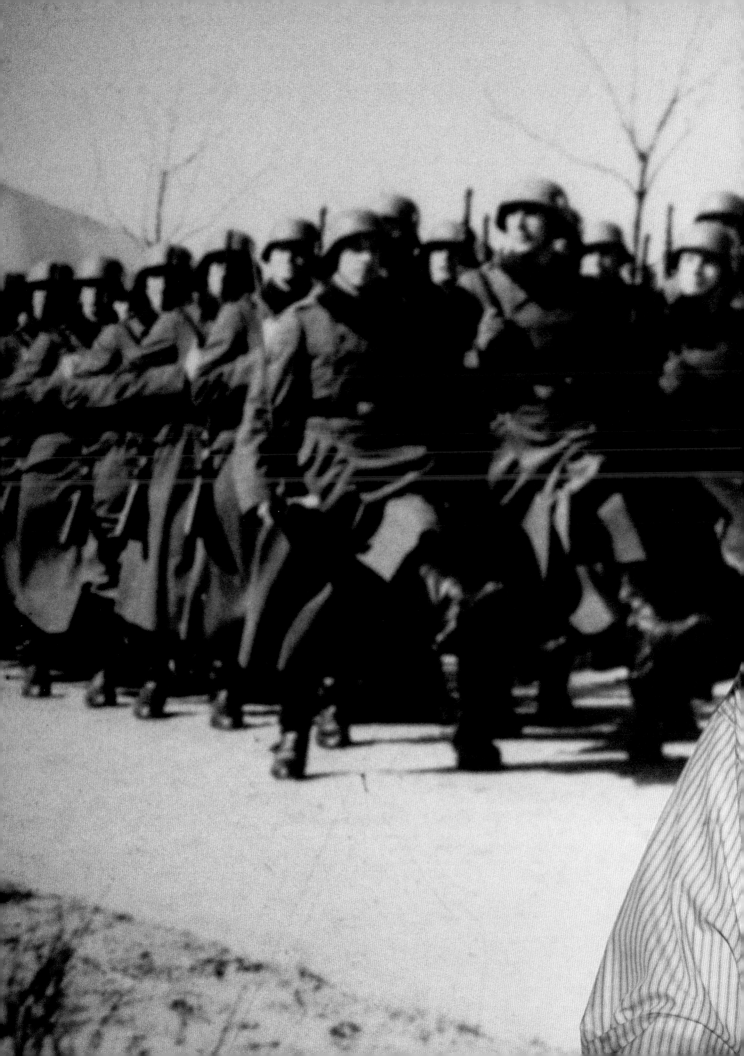

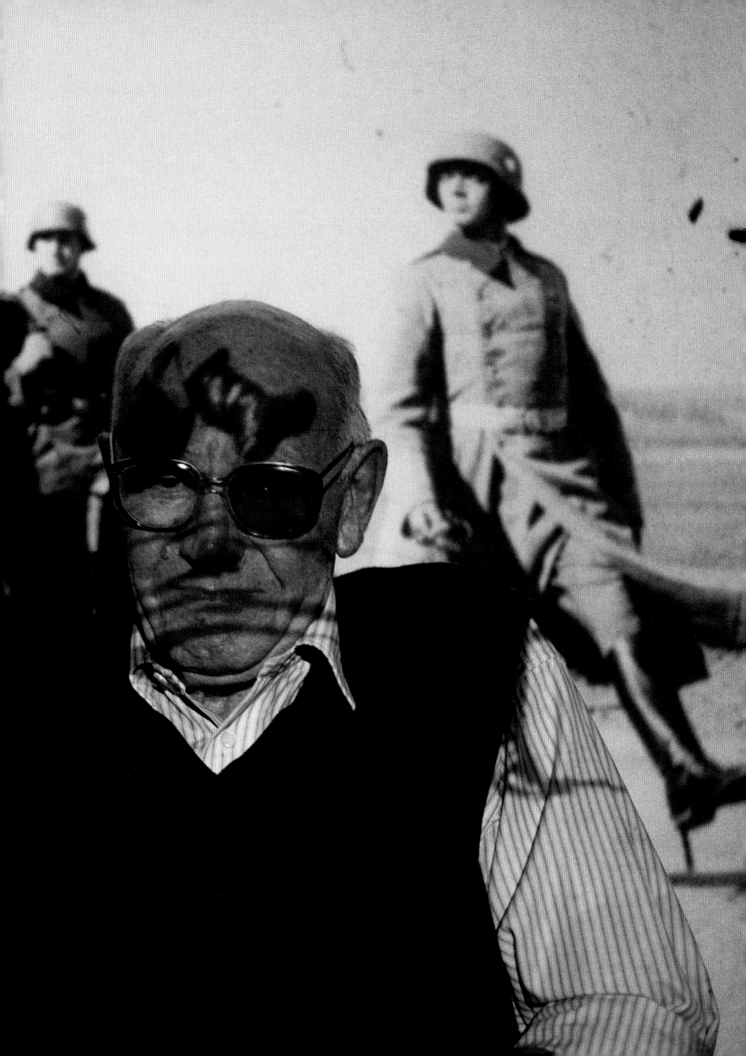

AFTERWAR : Lori Grinker WORLD WAR II : 1939 . 1945

When I was growing up in Germany, there was a law for farming families: the oldest son got the farm; the others had to find jobs. That's why I signed up for the service.

We were forced to go to war. We couldn't go back home. If you ran away you would be shot. I didn't want to leave, though — the camaraderie was so strong; you wouldn't leave your comrades, you protected each other.

During the war I was always on horseback. We rode really fast, putting in telephone lines from the frontline to the observation point, about three miles away.

By horse, I was able to move around very quickly. And from day one, until my return to Germany, I photographed everything. I served in Poland, Rhineland, Holland, Belgium, France and Russia. I was in occupied Paris for eight weeks.

On December 1, 1944, I was shot in the head. The bullet remained there until 1949. My oldest brother died in a Russian prison camp and another lost his leg; only our youngest brother came back whole.

I had so many dreams from the war, all through the years, but after I went back to visit Russia in 1993 they abated. Before my trip, my doctor prescribed special pills for my heart so I would be able to stand the strain — because the memories never leave you in peace.

That's something only a comrade really knows.

Schleswig-Holstein, Germany
10.1999

Caption to picture on page : 204.205
Willi Schneekloth at home in Schleswig-Holstein
with a projected image of his army unit.

1960 1970 1980 1990 2000

I remember in 1944 we were in the pub and one of my colleagues said, "I think we are going to lose the war." Everybody told him to quiet down, they could put you up against the wall and shoot you for saying something like that in public. It was the same thing with the Jews; you heard little things, rumors, but you couldn't discuss it or probe too deep.

In 1945 I was wounded by a British tank and captured. While I was in the hospital I received a telegram saying that my mother had died.

When I returned home nobody said a word about what had happened to her and it wasn't until a year later that my eldest brother, Bernhard, told me the truth.

Three of my brothers and I were in the war in various locations, and my mother sent a letter to my brother Rudi. In it she wrote: "Why do so many young people have to die — it's completely senseless to go on with this war," and other similar things that were considered as "destroying one's will to fight." She implied that Rudi was fighting for something that had no future, that Hitler was crazy to go on, that all morals had been completely destroyed, all values lost.

The military opened the letter and of course they read it. But, by then, Rudi had already deserted. It was just after the assassination attempt against Hitler on July 20th, 1944. The SS came to the house several times looking for him. My mother was hiding him beneath the floor of a room in our little hotel. She had cut out the wooden boards and hidden him in the basement; then she poured petroleum on the floor so the police dogs wouldn't pick up his scent. He hid like that for nine months, coming out only at night.

The SS never found him. Instead, they arrested my mother and brought her to their office in the next town, interrogating her non-stop for three days and nights. On the third night they told her that she would be taken to Lübeck in the morning, where the Gestapo would take care of her. Probably afraid she would not be able to keep her secrets, that night she hung herself with the belt from her dress.

When Bernhard went to claim her body, he found a note in her dress pocket. My mother had taken the pin out of her hair-knot and pushed little holes in a piece of paper, writing, "The honey is in room number four." Only Rudi's wife knew what it meant.

When I learned how my mother died, I saw all that had gone wrong with this war. How could they bring a woman of sixty-seven years, a mother of six children, to take her own life? Hitler used to say that every child born is a contribution to the war. My mother even received the "golden medal" for bearing so many children. She gave everything for Germany, and what had she died for?

Schleswig-Holstein, Germany
10.1999

Heinz Reshöft in the woods of Dahme, Schleswig-Holstein.

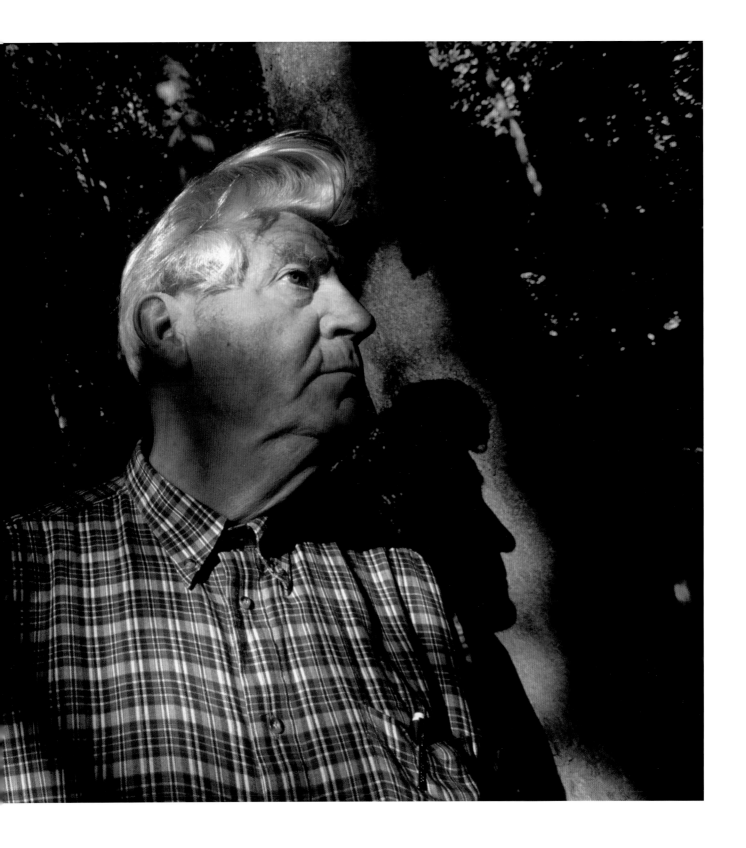

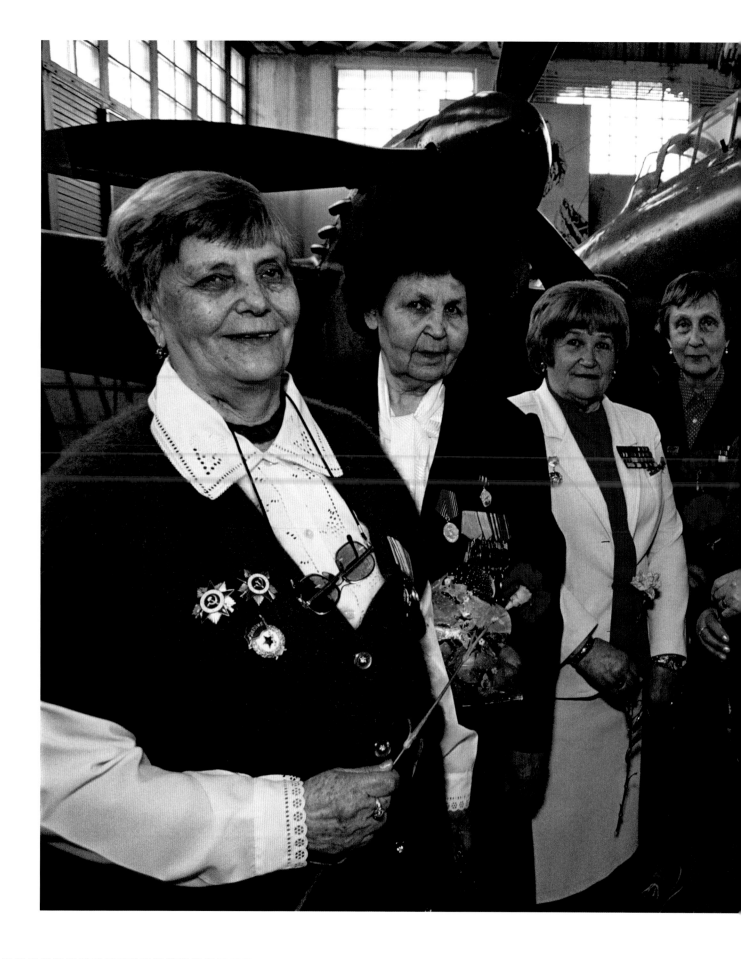

AFTERWAR : Lori Grinker WORLD WAR II : 1939 - 1945

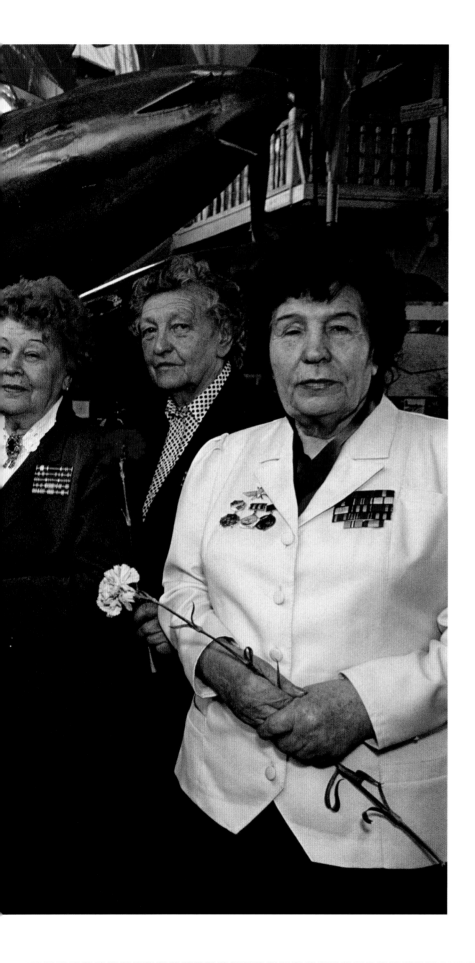

1960 1970 1980 1990 2000

pages 210 : 211

Galina Chaplingina Nikitina,
born 1920:

All young people were asked to go the front, each to do different jobs. Some dug trenches, others worked with the vegetables, and the most clever and strong were in intelligence. Different schools and classes prepared people for different jobs. We were sent to aviation school. We may have seemed small and weak, but we were strong-willed and athletic.

We were part of the dive bombers regiment. We flew the Petlayakov Pe-2, a twin engine, twin-tail dive bomber with a squadron protected by fighter planes. The bomb load was 1,000 kg, but sometimes we carried 1,200 kg. Our combat missions were flown in protective V formation. If one of us was forced to separate from the group, we became instant prey for enemy aircraft — and we couldn't land a plane before dropping an unexploded bomb. If we had to land, we faced the possibility of bombing our own troops or having our plane explode on touchdown. All of the pilots and navigators in our regiment were women.

Ludmilla Leonidovno Popova,
born 1924:

My father was in the military. In 1941 he was killed at the front. I joined up to avenge his death. In 1943 I became a navigator in the 125th. We all worked in the war effort; we were very patriotic young people. We also had responsibilities to our families at home. We always sent letters to our parents. When we got paid, we sent the money to our families. One of us left a small daughter, a three-year-old child, at home.

Antonina Bondareva Spitsina,
born 1920:

I came from a small village in the Ural region. I had five brothers.

One day a bi-plane landed and we all ran over to see what it looked like. I was so excited, my heart was beating like a hammer. In an instant I fell in love with planes. Later on, I enrolled in a nearby glider club. After graduating at sixteen, I went on to become an instructor. My father was not too happy about my choice, but mother seemed to accept it! When the war broke out, I was an instructor. In 1943, after the women's regiment had suffered many losses, I was able to join up as a reinforcement pilot.

Galina Brok Beltsova,
born 1925:

During the war we all had the same aim and purpose: to fight against the enemy. We took responsibility for our comrades; if one of us died, then we fought for her — at the same time, we developed as adults, into who we are today. The war helped us do this. We were very young girls when the war started. We learned not to lose our calm, to keep up our stamina, focus our skills.

During the war we would stick together; nothing could divide us — we had a spiritual attachment to each other. Fifteen women from our regiment, out of seventy-five, were killed. It was always hard to see your friends die, but it was even more difficult when you were in the air, in the plane, where it was impossible to give her your hand, impossible to help.

There were three women to a team, and one team for each flight. Once, a team was heading towards their target when a missile suddenly hit the engine. The pilot ordered the navigator to parachute out. She tried, but her chute got caught on the edge of the plane — she was hanging in the air. The pilot turned the plane to free her, saving the navigator's life. The next moment, the plane crashed and the pilot herself was killed.

Galina Chaplingina Nikitina
continues:

It's so sad, this story. I was the liaison pilot for the regiment, sent to bring back her body — but when I arrived, I found that the body had been buried by the locals. They dug up the body so I could fly her home. I also had to find the rest of the team, who were all dead. As I got close to the crash site, some boys ran towards me, yelling, "Look, there's a woman without a head!" — then I found the rest of the body parts. I collected everything into a bag and brought it to be buried. What an awful and sad thing.

Antonina Bondareva Spitsina
continues:

We used to talk a lot among ourselves when we were on the ground — but not during a flight. During a flight everybody had to pull themselves together, to be as serious as possible. Everybody tried to concentrate just on her specific job, the navigator/bombardier on feeding the pilot all the information, dropping the bomb; the tail gunner on firing at enemy planes; the pilot on flying. Sometimes the enemy was right behind us, shooting at us, and us at them. We could see their faces — they were that close.

Every mission was risky. We were fired at from the ground and the air. We flew the exact same missions as the men and we lived the same rugged way. Sometimes the living conditions were brutal, like when we bombed the Germans near Stalingrad and the only drinking water we had was melted snow.

People who fought together are closer to each other than anybody else, even their own family. We used to read letters together. If one girl got a letter from home,

we would all gather around and listen while she read it aloud.

After the war we remained close; we were a whole family and couldn't be divided. Today we have families of our own and live in different places, but, just the same, at our reunions we feel the same closeness we felt during the war. This closeness comes from the courage we felt as a collective spirit, when we had the same aim, the same purpose — to fight against the enemy. With this spiritual attachment to each other we went into battle.

Moscow, Russia, 5.1997

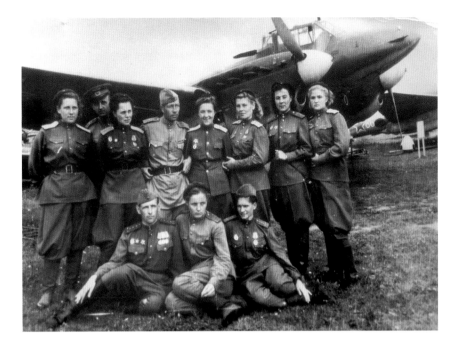

Caption to picture on page : 210.211
Members from the 125th Regiment Dive Bombers during World War II, including Antonina Bondareva Spitsina and Galina Brok Beltsova (second from right and far right).

Members of the 125th Regiment in front of the plane they flew in WWII (left to right): Ludmilla Leonidovno Popova, navigator; Daria Andreyevna Chalaya, tail gunner; Galina Brok Beltsova, navigator; Nataliya Alekseyevna Smirnova, door gunner, radio operator; Antonina Bondareva Spitsina, pilot; Mariya Ivanovna Kaloshina, tail gunner; Galina Chaplingina Nikitina, pilot.

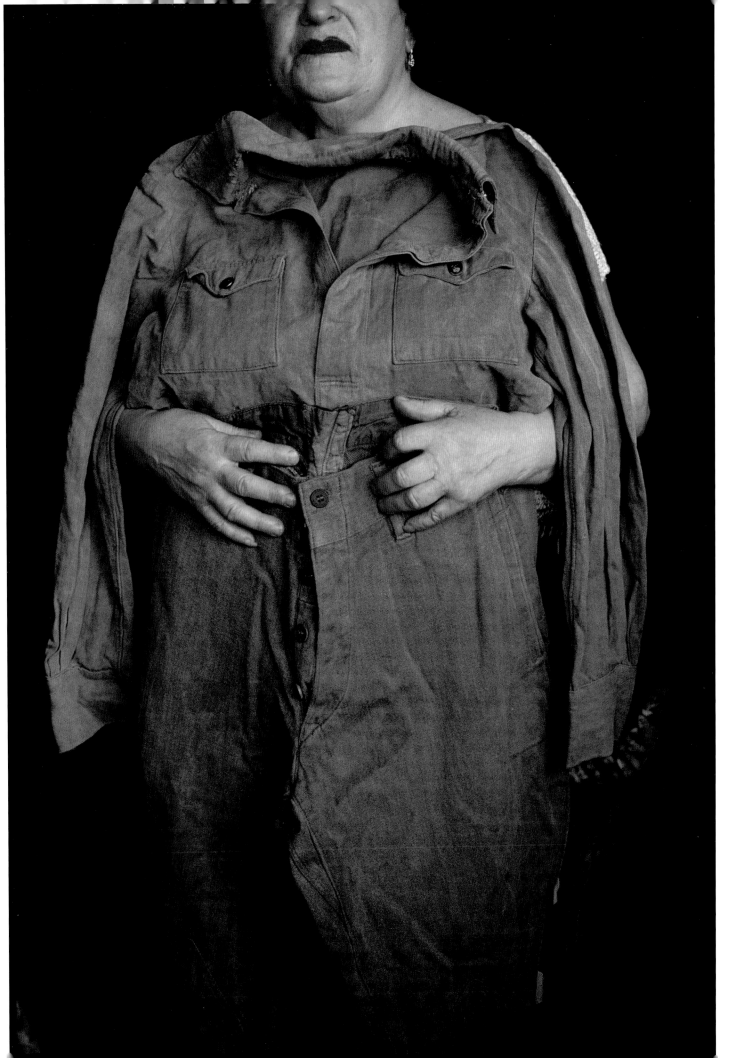

On December 15, 1937, when I was thirteen, some military people came to my house and took my father away.

They accused him of being a spy. My father was a Bolshevik revolutionary who had fought against the Mensheviks in 1923. He was a Communist and he was true to the Communist Party.

My mother wrote letters to Stalin to find out what happened to him, but nobody would explain why they took him away or where.

The next year, when I was fourteen, I applied to join Komsomol, the Communist Youth. Everybody was joining. If you didn't become a member, you would have problems all your life, problems getting into university, finding jobs, and so on.

I never lied; I told them that my father was taken to prison. They tried to keep me from joining, so I sent a letter to Krupska, Lenin's wife, who was in charge of the Communist Youth. Soon after, I was accepted, and because I was very active, I was elected as a recruiter. I also received training in parachuting and riflery.

Before the war we always heard the propaganda that we were surrounded by the enemy and had to protect our country. There was so much patriotism, it was like a wave. We believed that without our participation the war would never end — so, at seventeen, I went to the military command and asked to be sent to the front. They said, "We still haven't taken all who are of age to fight," but some boys there told me, "You look like a healthy girl ... just add a bit to your age and you'll get in." I added a year, and four days later I was sent to the Red Cross. There I gathered a team of one hundred people to be trained as a patrol group to help take the wounded off the battlefield. I was appointed to be in charge, but I still wanted to go the front, so two days later I left.

I thought that if I went to the front rather than staying behind to help the wounded, the war would end sooner. All five of my brothers fought in the war. Two were in the army; the other three volunteered to go to the front. When I saw the condition of the wounded coming in, it felt impossible to do otherwise.

Soldiers went to the front in cargo trains. When I arrived at the station, I saw a group of them standing on the platform. "Where

Moscow or we would end up captured. I didn't understand what was going on, there was so much commotion. I didn't lose control, though, I didn't become desperate. I started to assist the wounded. Some of the wounded soldiers had left their weapons behind and I took one. It didn't have any bullets, but I kept it anyway.

I don't know how many kilometers we ran, but that night we stayed in the forest. In the morning they tried to create some order. They shouted from one unit to the next. What unit was I in? Who sent me to the front? What specialty did I have?

I told them that I had started flying classes, so they took me to aviation and I became a door-gunner. That lasted until the time we were attacked and crash-landed the plane, when I received a hard blow to the head and couldn't see or hear anything for two weeks. I stayed in the hospital two months.

I held a lot of different positions throughout the years: I worked in intelligence, as the commander of a guard post, did reconnais-sance work, anti-aviation. I was hospitalized once more, a different time, when I was frozen in the forest. I was also a firefighter during the Moscow bombing. The Germans would throw lightning bombs at us. I would put them out. They would hit the ground and light up everything around, but if you could grab them quick enough you could put it out. Otherwise, it would burn up everything.

After the war, my mother and I tried to find my father and broth-ers. We learned of the first two deaths when the notifications

are you going?" I shouted. "To the front," they called back. "Take me with you," I asked, even though this was illegal and I was a little afraid they might push me off the train. "You won't throw me out along the way, will you?" I asked. "No sister," they replied, "come in."

Seeing that I needed some clothes to wear, they looked in each other's bags to see what they could find. One soldier gave me pants, another a shirt. Some of the stuff was torn. This uniform won't fit me now but it did fit me then, like a dress. I had to make it a little bit shorter because the shirt came down below my knees. I folded the bottom and sewed it up. They also gave me boots, which were huge and scraped my feet until they bled.

We got as far as Viazma when the train was bombed. That's when my hair turned gray. There were casualties everywhere. Everybody was shouting for us to go back to

were brought to my mother. The notifications just say "missing in action" so you don't know where they're buried. The other three notifications were first sent to our neighbors, then passed on to me; they didn't want to tell my mother. They also said that my father died in the war. My mother wanted to know how he could have died in the war if he had been in prison since before it started. It was fifty years before I learned the truth. On January 14, 1938, he was executed for refusing to sign a false confession. My father, my five brothers — they had all died. I alone, despite all I went through in the war, survived.

I always believed that this uniform is what saved me. When I was finally given a uniform of my own, I folded this one up. I kept it in my bag throughout the war. This was my talisman, my guardian angel.

Moscow, Russia 8.1999

Caption to picture on page : 214.215
Inna Grigorievna Kvitko in her Moscow apartment with her first uniform from the war.

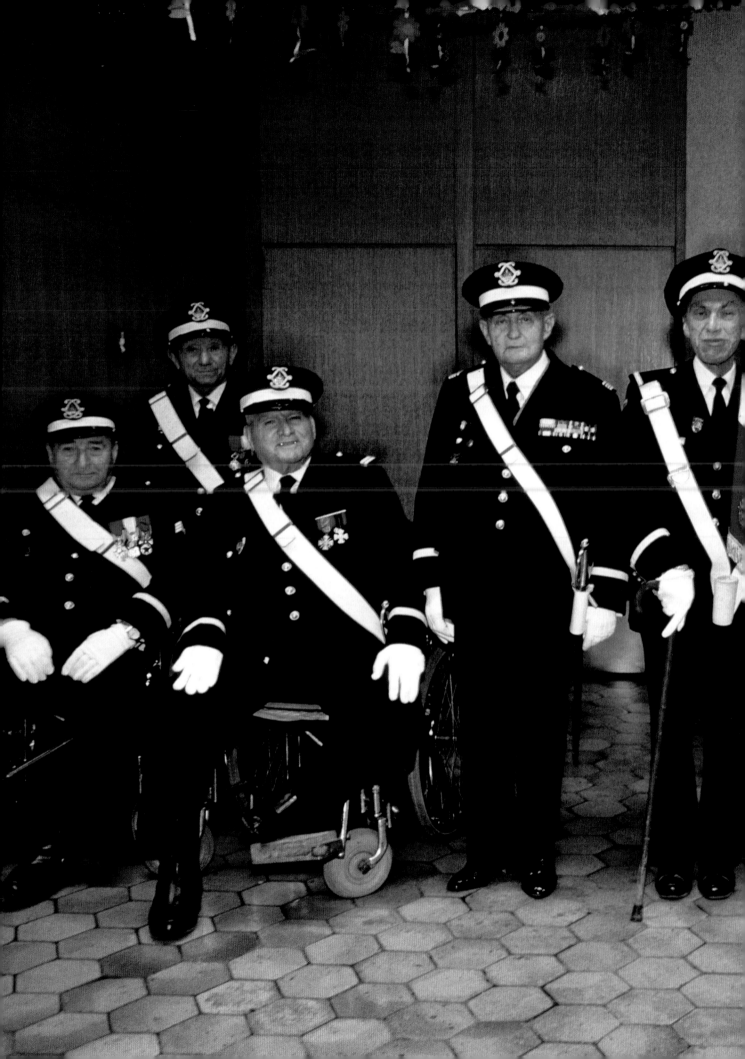

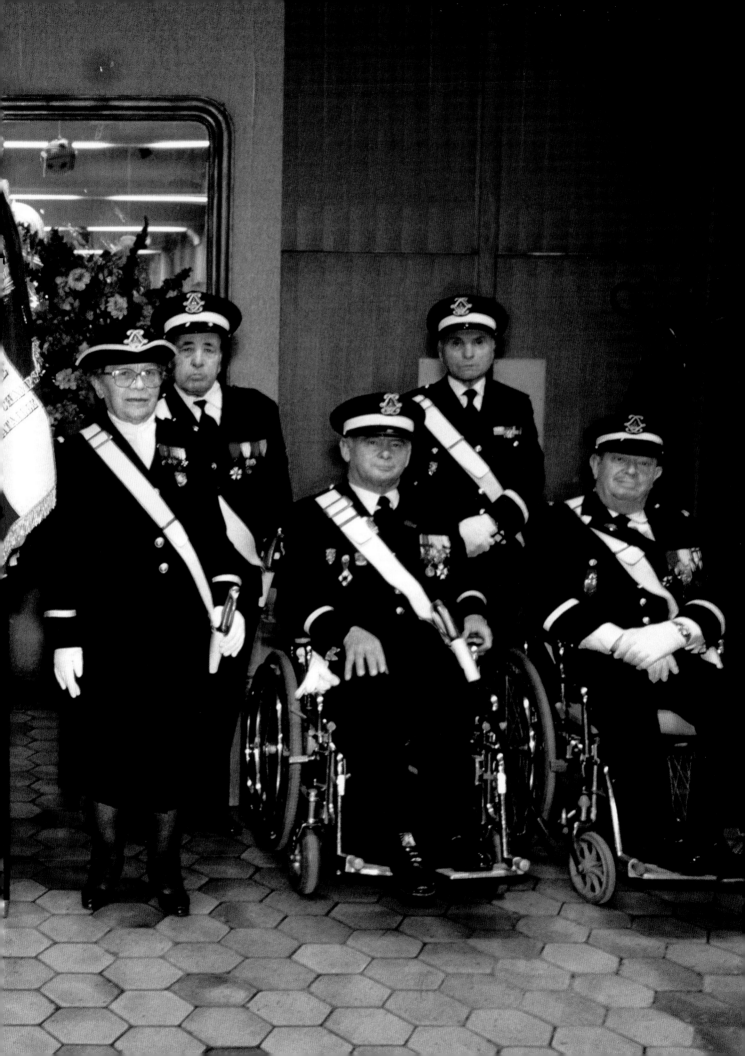

I was about twenty years old when I was conscripted. Each village had a contingent that reported to the French. They selected the most able-bodied men for service, and the rest of us were sent back to the villages.

I was conscripted for the army. They had the power to do it, and we had no choice.

I was a goat herder. I had seen the French people around, especially the commander. I knew they were building roads for their cars and that they were conscripting labor for the construction. Other than that, I had no idea what they were doing here.

I was trained a little in Bandiagara, then in Mopti, then I spent three years in Timbuktu where mostly we shot at targets. Finally they sent us up north to the desert where we fought against the Tuareg and the Gumo tribe, the "long-haired" people — a half-Arab tribe. After my first three years of service, I was released and sent back to my village. I felt like a different person when I returned, less obedient. I refused to do things. I was so tired, tired of taking orders.

When the Second World War started, the French called up all the old reserves, and everybody who had previously served was called back to duty. We all complied. To refuse, you had to pay high fees, heavy taxes. We had no money, so we went. We went by car, then train, and then, without even a single night's rest, by boat to Casablanca. From there we went to Marseilles, where the troops were based. There were so many of us Dogon there — more than you can count termites!

During the war we were paid monthly. I used the money for supplies and food, and saved part. But on our return home I didn't receive any pension. You had to serve for fifteen years to receive a pension; I had only served six. In 1941 I was released in Bordeaux, given transport to Marseilles, then to Dakar, Senegal, where they paid us a small sum and sent us back to Bamako, Mali.

If the white people who have the power want a war, they can have a war. This is their way. They profited handsomely from us.

They took a lot of grain, horses, and other things. We had to go to battle for them, and they took everything from us and brought it to Europe. We were good soldiers. We feared war, but we went anyway. I had two older brothers who were killed in the Second World War.

Before going off to war, I had no idea what the towns of the white man looked like. It was different from anything I knew. I liked it. It didn't resemble this country at all. Being a soldier in a foreign country would have been quite nice actually, if it wasn't for the war ...

Ireli, "Pays Dogon," Mali 2.1992

Caption to picture on page : 218.219
Former members of the French resistance and military forces. Hôtel des Invalides, Paris, France, February 1992.

1910 1920 1930 1940 1950

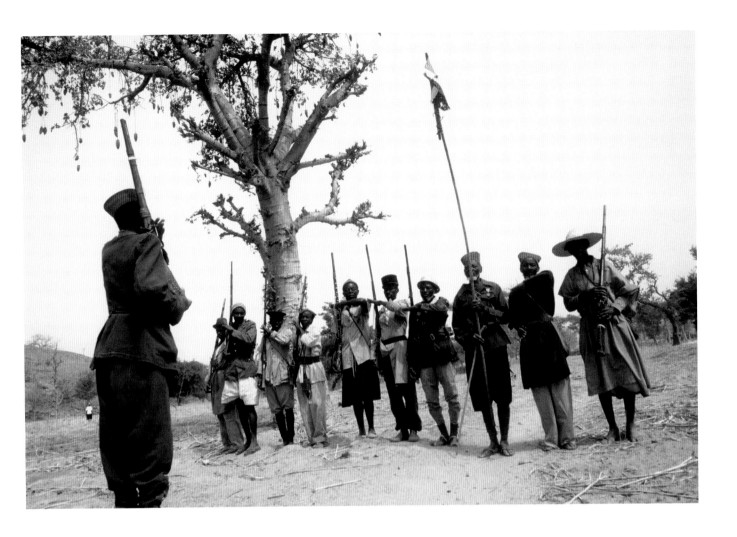

AMOMON GUINDO | born 1915 **served** 1939-1945 French Army

I never thought I would make it back to Africa. I saw so many people killed.

When a person dies it's finished for them and their body is buried right away, but the spirit of that person still lives in the house. We must send the spirit out to the cemetery, to the tomb; then, when a new baby is born, they can take the name of that spirit. In order to send the spirit out, we must do this work.

This is the funeral celebration for Maba Guindo, who served in World War II from 1939-1940, and was put in a German prison camp in France. We dress a dummy in his

uniform and put it on the roof so that everybody, even the children, will know that he was in a war; we don't have photographs to remember. After someone dies, their spirit is all that's left. Maba's spirit has learned about war. All the old veterans who are still alive will come dressed in uniform and will sing and perform a dance to imitate the war. If he had been a hunter, we would act out a hunt; if he was a builder, we would do something else.

We never share war stories with other villagers; it's too horrible — it's bad for them to know. But when an old combatant dies, we need to show the village what he

did in the war. It's an obligation to celebrate the dead. I have to teach the ceremony to the sons of the old warriors; that way, when the last one dies, they will be able to perform the Funeral of War Veterans.

Ireli, "Pays Dogon," Mali 2.1992

Amomon Guindo (holding flag) at a funeral for a war veteran in Ideli.

1960 1970 1980 1990 2000

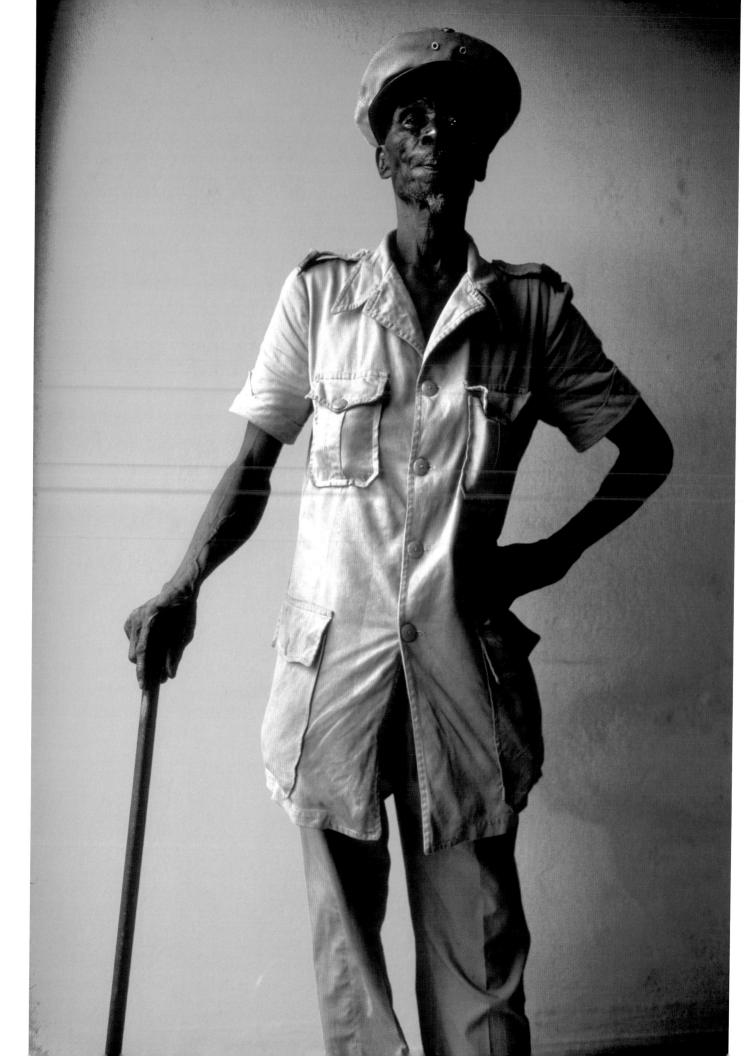

I was called up when I was twenty. The head of the village came one night, woke us up, and told my father that I was needed in the mayor's office. I was then taken, against my will, to Abomey. After twenty-four days on foot we reached Parakou, then onward to Kandi where we were trained. After training, we walked to Cotonou, and from there we were taken by ship to Morocco. Then, traveling from Morocco to Algeria by car, there was a heavy bombing. The barracks we were supposed to live in were destroyed.

We were taken in a plane to Algeria. I was the only black African among twenty-two Frenchmen. I was chosen because I was an expert marksman and a first class soldier, a corporal. Once, when I was on guard duty, I saw a goat moving and I shot the goat, and when it collapsed we saw that it was a German captain! I had to fight whether I liked it or not, so I was happy to at least be one of the best.

I was afraid, but in the army they used to have a drink, and after taking this drink, you didn't care what you did, which was quite different from your normal state. Before battle they would give it to you. It was very strong, and it excited you. They would give us a bottle and tell us when to drink it. For example: if we were about to engage in heavy fighting, they instructed us to take some, and we became stronger then ever and fought very fiercely.

Soon after we arrived in Algeria, there was a heavy bombing. We hid in the trenches, the four of us who were still alive. The three Frenchmen died later at the hospital; I was the only survivor. This happened in 1944, two years after I was conscripted. After my treatment in the hospital, I was discharged and sent back to my hometown. The war ended soon after. In 1946, I went in for rehabilitation of my leg, and in 1960, a French captain, a military doctor, decided that it should be amputated.

When I was conscripted, the French made us a promise: if you fight well and survive, we will find you a job when you return home; if you happen to die on the battlefield, we will take care of your family; and if you are wounded, you will receive treatment — so coming home, I was very happy. My mother was overjoyed to see me back and I had a little money in my pocket, mostly from the Americans, who used to give us their change after they went shopping. But, due to my injury, I couldn't work, nobody would employ me. For a while I received a small pension, but then the French denied that my injury was war-related and cut it off.

Now I have to go on the streets begging. It's a miserable life. The French come every year to give out other pensions and medical care. They take a measurement of my stump, which they send to Dakar, where the legs are manufactured. We get a new leg every five years.

Cotonou, Bénin 3.1991

Ahouatcha Mahinou at the Maison du Combattant in Cotonou.

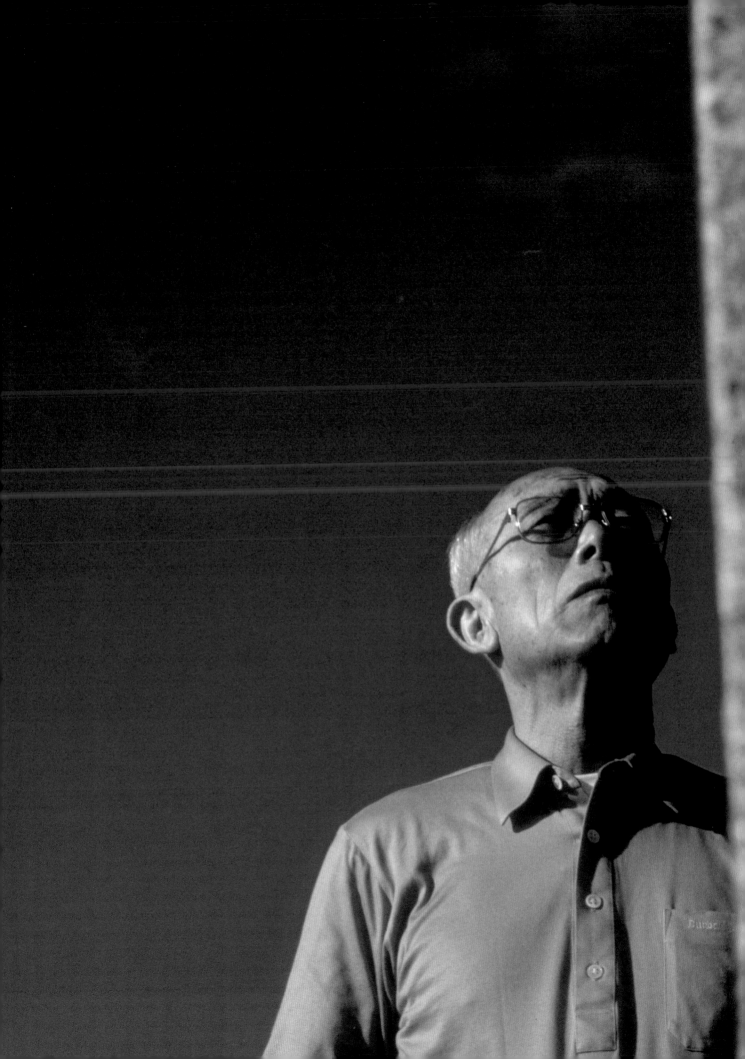

You can't imagine the deep feelings, the mixed emotions, coming to Banzai. I think about it constantly — that's why I keep coming back here three or four times a year. One year I came back forty times: a lot of my friends died here. I witnessed collective suicides of civilians and soldiers here. Of the thousand soldiers in my group, twenty of us survived.

The night before leaving for the war, I slept beside my mother. She said that I had better not die, that I had to come home alive. That night was embedded in my brain — that's why, after the final Banzai charge, I took to the bush. I hid in the jungle for a year and a half, thinking that maybe the Japanese government would come. I only came out at night. I watched the Americans secretly, I saw how they lived. I saw their bomber planes taking off. I could see the films the soldiers watched projected into the air. I smoked their cigarette butts. I ate leaves to survive.

We wouldn't surrender because we were convinced that the Americans would execute us. They even played the Emperor's surrender broadcast for us. We didn't believe it. One day I found an American magazine, I think it was *Life* magazine. There was a photograph of a black man directing traffic in Tokyo. At that point I knew it was over. There were eight of us left and for over a month we discussed the pros and cons of surrendering. On September 14, 1945, we gave up.

During this long period in hiding I was forced to come to terms with my own actions and decisions. I was twenty years old. Westerners do not understand the dishonor that comes with surrender, the shame of being taken prisoner.

It's because of my guilt over not having committed suicide that I keep coming back here — to find peace for my soul.

Banzai Cliff, Saipan 6.1994

Caption to picture on page : 224.225
Shiro Shimoda visits the memorial in Saipan for Japanese soldiers who jumped to their deaths.

1910 1920 1930 1940 1950

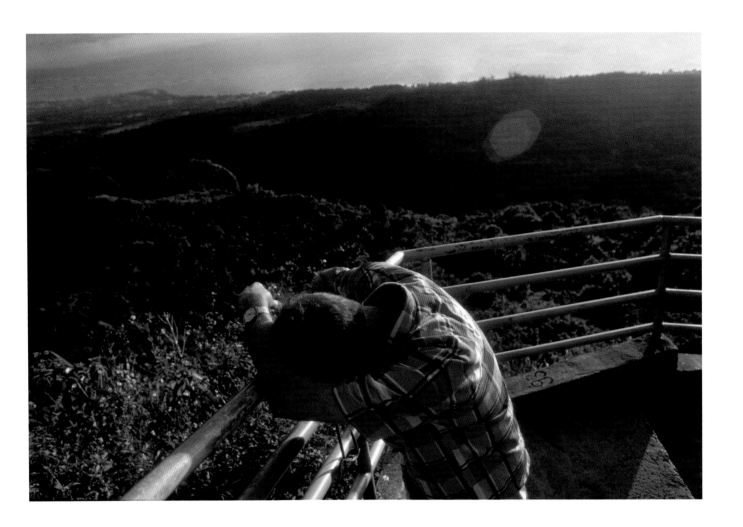

LEO KUHN | **born** early 1920s **served** 1938-1943 U.S. Army

I don't know what hit me up there;
I saw blood, Japanese and Amer-
ican flags, I saw combat — it was
all mixed up in one sequence.
Our goal was to take the mountain.
I got hit two-thirds the way up.
I'd been shot in the head. Took
seven months to recover, and then
they gave me an early discharge.

I've thought a lot about how I
never made it up there — now,
finally getting to the top of Mt.
Takpochao, I accomplished what
I was supposed to accomplish
fifty years ago.

Mt. Takpochao, Saipan 6.1994

Leo Kuhn at the top of Mt. Takpochao on the 50th
anniversary of WWII.

SPAIN 1936 to 1939

1910	1920	1930	1940	1950	

Begun in July 1936 with a well-planned right wing attack against Spain's recently-elected socialist government, the Spanish Civil War was largely a contest between Spain's working class, the Republicans, and the Nationalist members of the Spanish aristocracy. With the Nationalists, led by General Francisco Franco, receiving aid from Italy and Germany — which tried out its new tanks and planes in the conflict — and an estimated 40,000 foreigners fighting in the Republican's International Brigade, the conflict was both a prelude and testing ground for the Second World War. With France, Britain and the United States officially neutral, and the Republicans receiving no external support, the war ended in a Nationalist victory after the last Republican stronghold, Madrid, fell on March 28, 1939.

NAME:
Spanish Civil War
TYPE:
Civil war
CASUALTIES:
500,000-1,000,000 killed

1960 1970 1980 1990 2000

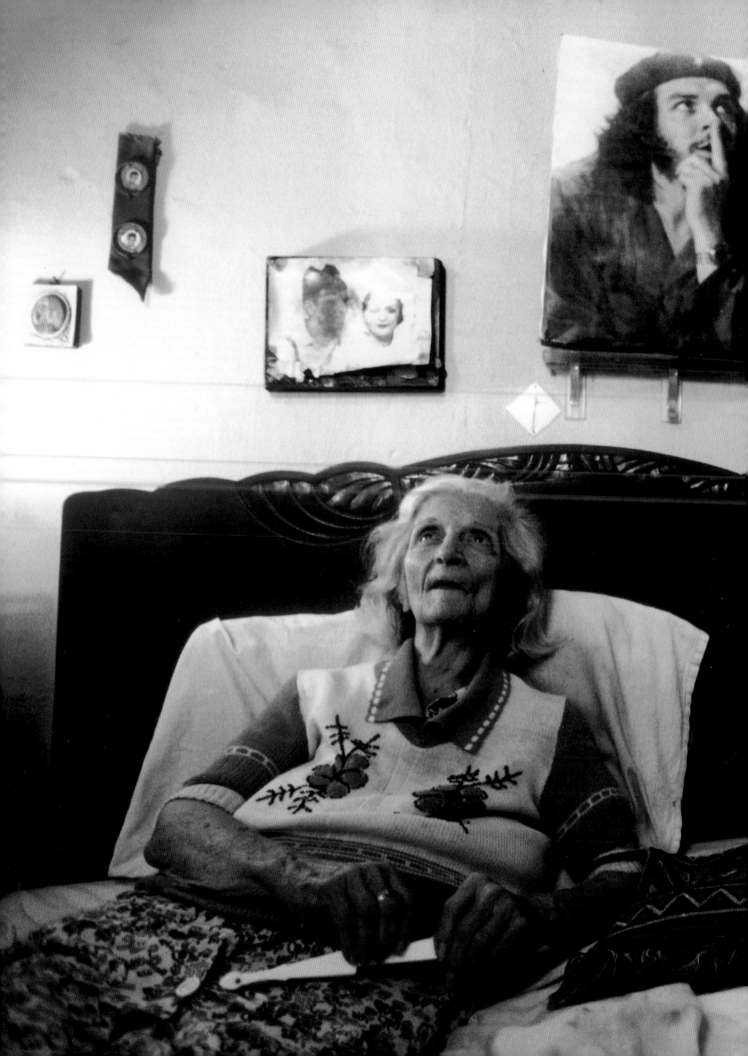

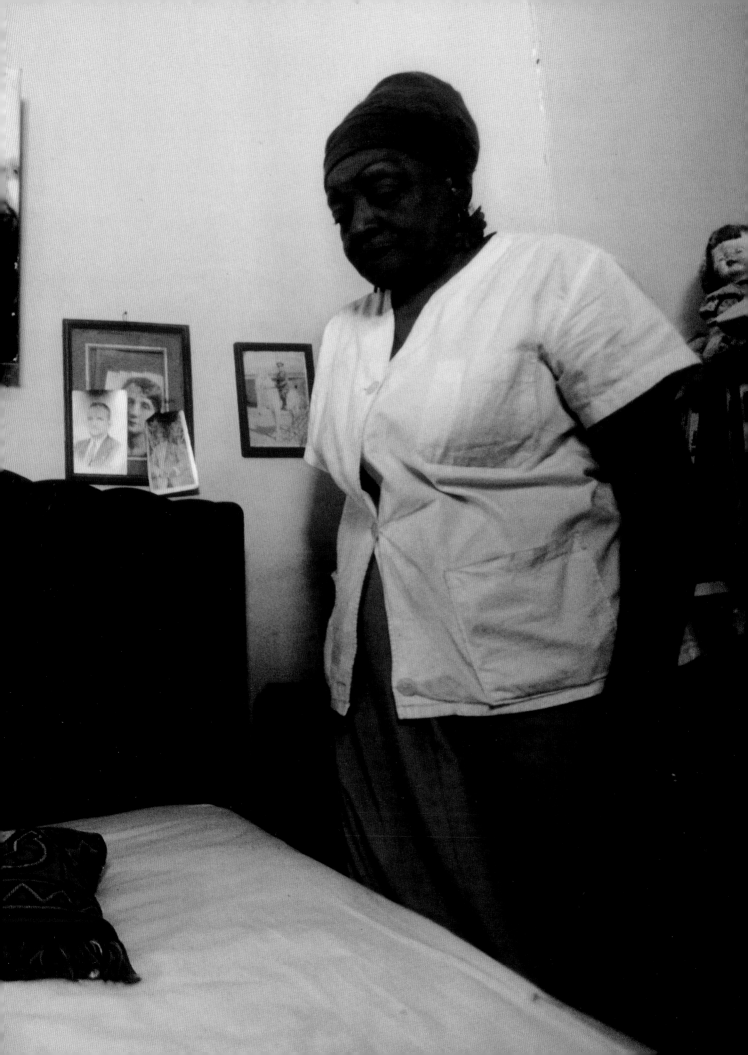

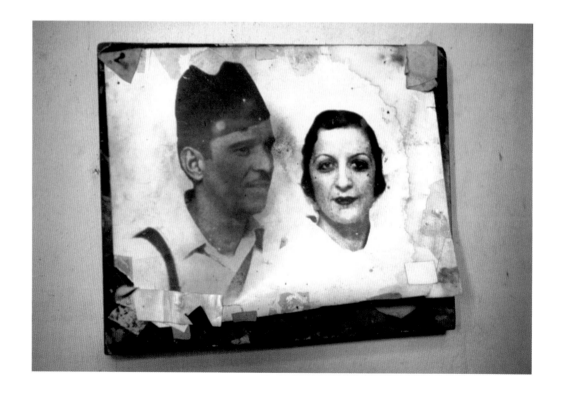

In 1935 we escaped from Cuba.

My parents were socialists, and the dictator, Gerardo Machado, had my father killed. My husband, a prominent revolutionary, was thrown in prison. After Machado fell, in 1935, my husband was sentenced to death, my mother to three years in prison, and I was given a sentence of eight years.

A British lawyer, who was also a revolutionary, helped us escape to Spain on a British ship. My mother, my husband, and my son and I left for the harbor at about seven in the morning. At about ten a.m. soldiers and marines arrived at the docks. Somebody had tipped them off. The captain of the ship was a real humanitarian, though, a valiant man. He ordered the ship to go. Two or three miles outside of the harbor we were surrounded. They wanted to board the ship and make a search, but the captain said, "No, we are outside of your borders, this is a British ship and you have no right to board."

In Spain we founded the Association of Revolutionaries and Anti-Imperialists of Cuba in March, 1935. Then, in July 1936, the Spanish civil war began. With other Cubans, we took up arms and became the first international brigade in Spain. I was in the Fifth regiment. Tina Modotti, myself, and a few other women had been working with the Red Cross as well as the peace movement.

I never thought of myself as a "woman" during the war. My only concern was for justice, for the people. We fought to defend the peace, to defend people who didn't have food, shoes, who didn't have anything. This was a duty I had to carry out, and it felt good to give my life for a just cause. Today, I am very old, blind and in bad health, but I would still fight for class equality.

Despite all the difficulties, we fought hard to win, so it was extremely painful to lose the war — so many people died, at least a million. When it was over, we escaped through France, and after traveling and traveling, found ourselves back in Cuba again.

When I arrived back at my job in Cuba, they didn't want to take me. They said that the pupils wouldn't like a professor like me, a "revolutionary lady," and I began to search for work. But whenever the police learned where I was working, they came and ordered my superior to fire me — all because we lost the war in Spain. I went on to write books about history, specifically on Cubans and other South and Central Americans who had served in the Spanish Civil War. I wrote seven books in all, but I refused to accept any money or awards for them. I made them as a contribution to the revolution. I was a revolutionary for thirty years.

In January 1961, after the Cuban revolution, Che Guevera arrived in Havana. He came to my house. He wanted to talk to me because I was a leader of the students and he was setting up a foundation for the friends of Nicaragua. Afterwards, he sent for my husband to help make contacts with people who could work in the fight for independent governance in Nicaragua, Mexico, Guatemala, El Salvador, Panama, Venezuela: all the places with a dictatorship. He seemed like a marvelous person, Che — modest and good. He knew that I liked coffee a lot and every time he came to visit, he made me some. I arrived at home about eleven o'clock one night and there he was, waiting for me with coffee. My mother offered him one, too, but he said that he never drank the stuff!

In the 1930s, when they killed my father, we lost everything —

but one thing that you cannot lose is your morals and pride. It's difficult to bring about change, experience teaches you that. You can see it in the factories today; they make a lot of money and can throw away 100,000 pesos on a party without even thinking about it, but they don't increase the workers' salaries, not even five pesos. When we put food on the plates of all the poor, then we will have social justice. And until we have social justice in the world, we will never have peace.

Havana, Cuba 2.1999

Caption to picture on page : 230.231
Maria Lusia Lafita in bed in Havana, with her attendant Emilia.

Maria Luisa Lafita and her husband, Pedro Vizcaino, in Spain, 1936.

In Segovia the military authorities agreed to join with Franco. At the time I was just beginning my career as a teacher. For the fascists, teachers were very suspicious, intellectual and left-leaning, so I decided to escape.

I talked to two others who felt the same way. One had the idea to wait until the army came to mobilize us, and then escape to the other side from the frontlines. So we went and they put us all together, about fifty of us in the plaza. They said they would take us all in a train. On the way to the station they sang fascist songs, which made me very angry. I heard one man say, "This man not singing is a communist" This group were falangistas, the officers of the army who took care of the volunteers. One of the falangistas pointed at me and said, "He is a teacher, a Communist," and hit me with his rifle butt. I lost my breath and fell. I heard them say that they would take care of me at the station.

At the station I saw all the families coming to say goodbye, and in the midst of the chaos I made my escape. I ran across the tracks, saw an empty wagon and hid inside. I heard people looking for me. Then in a moment someone connected the wagon to another one and the train began to move. I had no idea where it was going. When we stopped, we were in Valladolid and the other car was filled with mobilized soldiers. We stayed in a camp for three days. On the last day an officer announced that they didn't have enough weapons or uniforms, so those from Segovia were told to go back.

When we were leaving, I saw a close friend who was now a falangista. He was shouting, "Oh look, it's Liborio, he's been resurrected," as if I'd been dead. I was amazed and scared. He took me aside and said, " Liborio, I want to be honest

with you; I said that because I saw your name on a list of those to be executed."

Back home, I met a friend who knew about a doctor who had a hospital in a stronghold on the Republican side. So, we crossed the mountains. When we arrived at the camp I told the doctor that he didn't have enough people to hold this area, that it would be easy for the fascists to get in here and take you. Finally he saw that I wasn't a spy and invited us to join them.

I worked to prepare the Alpino battalion for winter — to stop the fascists in the mountains from getting through to Madrid. Madrid had not joined the fascists; it was full of international brigades, even Tito's. Then, when Franco launched an attack on the city, they put me in the window of a hotel behind sandbags. My first fight was against Franco's Moroccan troops. All the international brigades and all the volunteers made a huge parade through Madrid and Franco retreated.

When the fascists took Madrid as the war ended, I was up in the mountains. My commander told us to escape to Alicante. During the war I thought how small a country Spain was, and how I always met people who knew me. You never knew who was who, or which side they were on. On our way, in Valencia, I heard a woman yell to me, "Liborio, Liborio why are you here?" I knew her as a cook in places I had worked. She told me that if we reached Alicante and passed through the line of falangistas, there were three British ships that were taking refugees. We had a van with a machine gun and went, but by the time we reached the barbed wire fence of the fascists, the British ships had fled, forced off by German warships. We crossed the fence and found ourselves in this circle of

falangistas. It was like the apocalypse, people were trying to commit suicide. I saw a man jump in the water; I went in to save him. "Don't help me, don't help me, I want to die," he said. "I don't want to be taken prisoner." Then he took a large rock and climbed a mast and shouted insults at the Italians and the Germans. They shot him and he fell — but he didn't die, and injured a woman on the way down.

The next morning, after being captured, we heard one of the falangistas announce over the loud speaker that anyone who wanted to go home could go and be judged there. Some believed it and went in the trucks. Some were executed; others were immediately put in prison. We hid, but they found us and took us to Almendros Camp — the almond tree camp. We were starving. We ate the trees, literally the leaves and the wood. People with leather shoes put them in water to soften the leather so they could eat it. People from outside gave us orange rinds and skins of bananas to eat.

After a week in this camp, they put us in the Plaza del Torros in Alicante, where they have the bull fights. There, they organized a humiliating public spectacle for us where we had to climb high up a ladder and either pee or shit in a target bag they set below, and if you couldn't do it, they would just shoot you.

I was in twenty-two different prisons in the seven years between 1939 and 1946. A year after the war they put me on trial and gave me the death penalty, but some friends of mine who had been fascists helped me get a new trial and my sentenced was commuted. The last prison was in Talavera. I did hard labor working on the river to get my sentence reduced.

When I got out, I was exiled to

Albecete, where I met my wife. I lost my job, I lost my title, the right to teach; we were pariahs. I went to work as a topographer and when they learned about my past, I lost the job. The hardest thing was to get work. They always checked with the police about your background, so I looked for the most humble jobs, keeping a low profile. In the end, I got a job at a dam. I worked in maintenance, mostly oiling the machinery. My friends, the former fascists, came to visit me. We were on different sides during the war, but afterwards, it was just like before, like the flip side of a coin.

Segovia, Spain 11.1999

Liborio Lopez Gonzalez in the woods of Las Arenas, near Segovia, where he began the war.

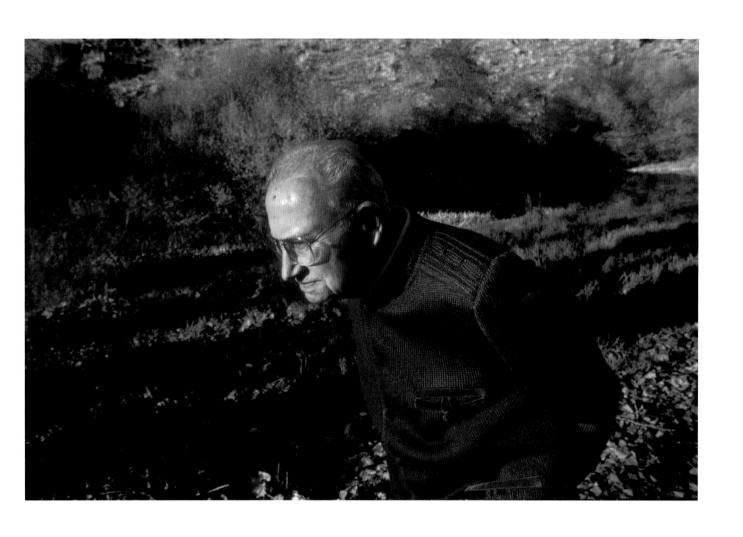

1960 1970 1980 1990 2000

I was mobilized at the beginning of the Spanish Civil War. I was twenty-four then. We knew nothing about this war, nothing about communists, fascists — we had no idea about these things. I went because I was told to go.

I spent eleven months in the trenches. I only remember the misery, the wetness, the lice. To pass the time, we had lice races on our pant legs. We would boil our clothes, but the next day our pants would be full of lice again.

After almost a year, they offered to transfer us to the department of public order. We were sent to Cartagena, in the southeast, to work in a place where they held prisoners of war. I can't talk about it. It was very sad, there were horrible things, there were these five brothers ... I cannot talk about it, executions ... it was horrible. I don't know how we survived.

What can you learn in war?

Nothing, only hate. Wars have no fundamental purpose. What did we know of this war? It was like a lie, this war, little lies. We were ignorant. We thought we would probably die, that's all. We fought, we won. If we lost it would have been just the same.

Valdevimbre, León province, Spain 9.1999

Elvigio Pellitero at home in Valevimbre next to a photo of himself in the army.

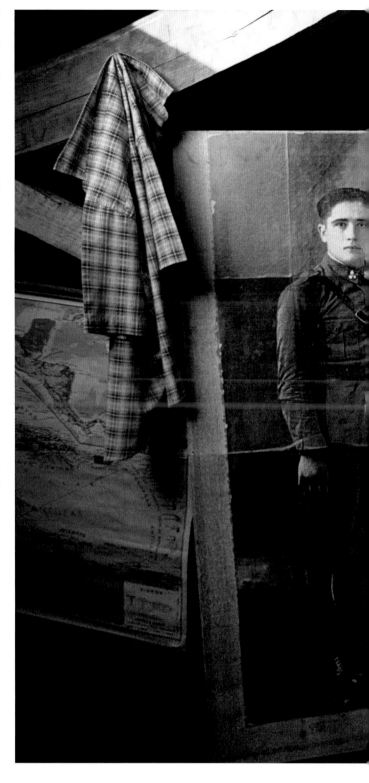

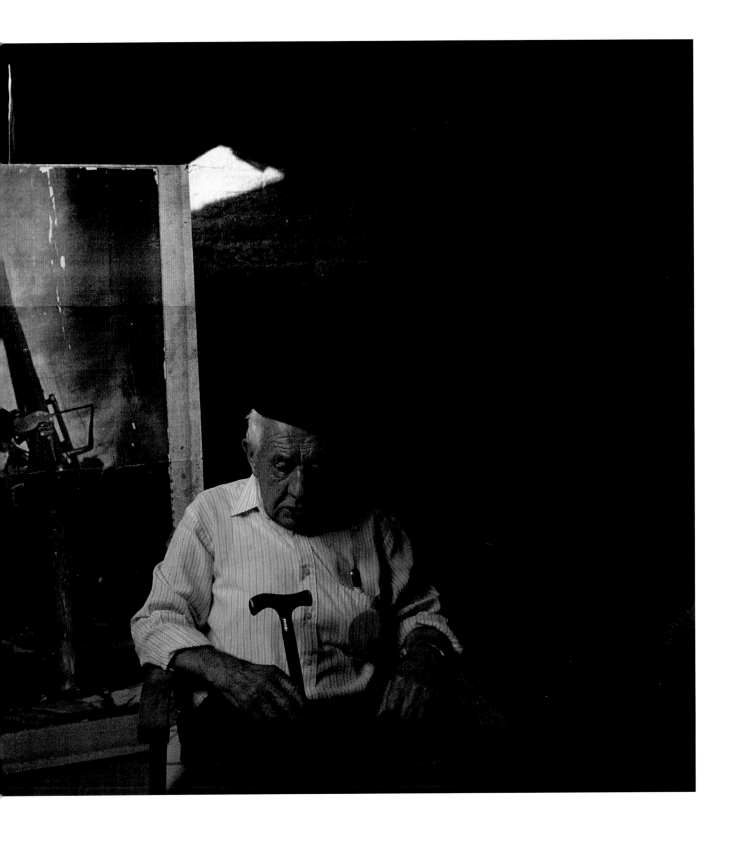

WORLD WAR I 1914 to 1918

1910 1920 1930 1940 1950

Sparked by the assassination of the Archduke Franz Ferdinand of Austria-Hungary in Sarajevo on June 24, 1914, the conflict in the Balkans soon spiraled into a global conflagration of unprecedented scope. Fought between the Central powers (mainly Germany, Austria-Hungary) and the Allies (France, Britain, and the United States), the war introduced new 20th century weaponry such as aircraft, U-boats, tanks, machine guns, and poison gas. Used in concert with 19th century fighting methods, the result was an unprecedented and useless slaughter of millions of men in trenches and on fields rocked by explosions and poisoned by mustard gas. Though the Central powers won many early victories on the Eastern front, the entry of the U.S. into the war slowly turned the tide, resulting in an armistice signed on November 11, 1918.

NAME:
The Great War, First World War
TYPE:
Global war
CASUALTIES:
9-10 million killed
1 million missing
21 million military wounded

1960 1970 1980 1990 2000

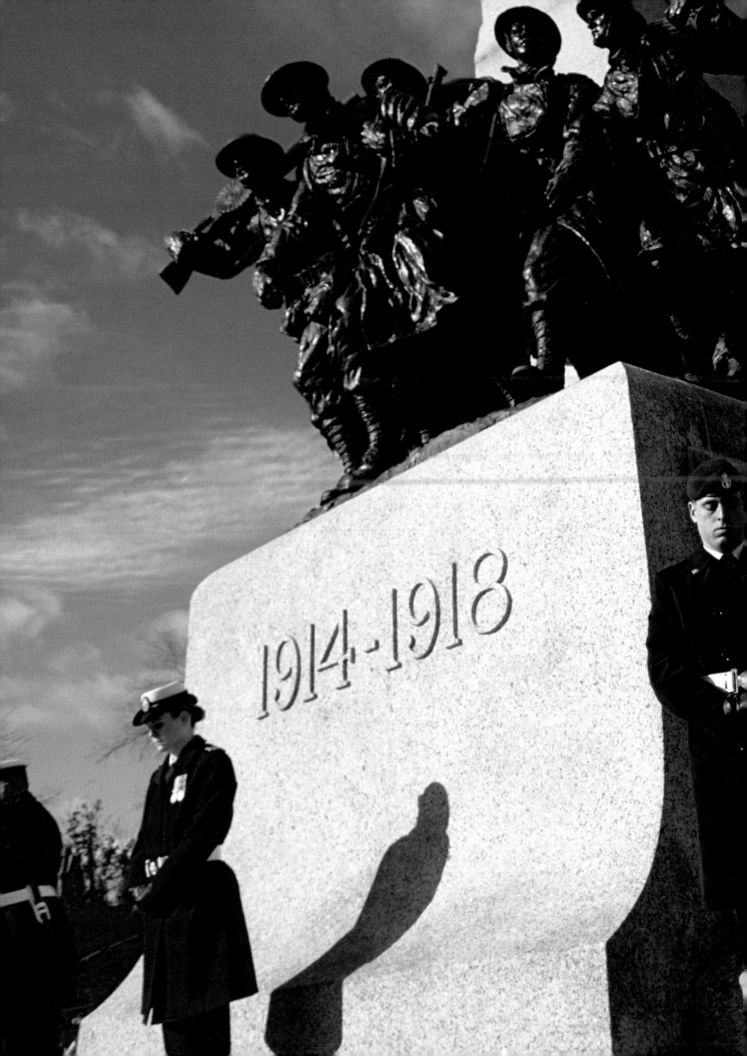

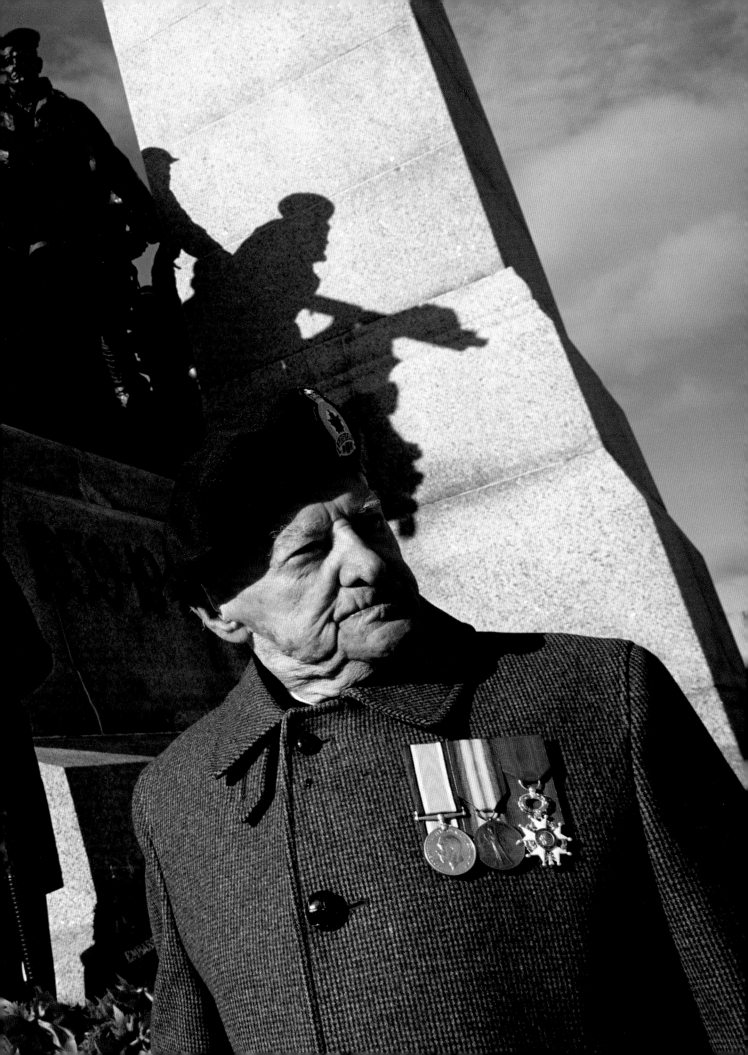

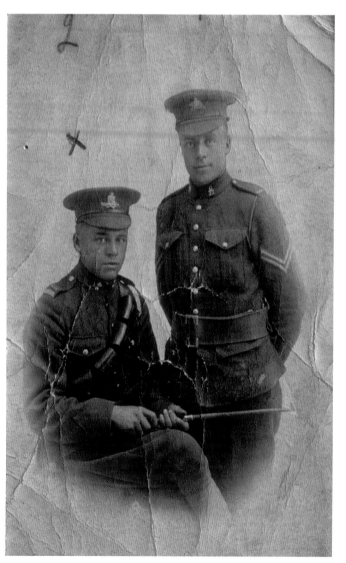

Two weeks after I started working in the shell factory, I was fired because I couldn't handle the heat. One day they put me next to the furnace and I passed out. I woke up as they were washing my face, and they told me I was fired.

The army was hungry for men by then; this was March, 1917. I enlisted in Montreal on condition that I would be sent overseas as fast as possible. I had to lie about my age, of course — I was sixteen years old — but they didn't ask for any proof; they only marked on my papers: "looks younger."

When I got home after enlisting, my mother was crying. She had just received the telegram saying my brother had been wounded in France. He was twenty-seven years old. Machine guns hit him, and he had seven big holes in his side and back. My mother said she wouldn't let me stay in the army. But I told her that if she interfered, I would just re-enlist I didn't have much political knowledge, I just knew about the history of France, and I wanted to fight for the liberation of France from the Germans.

Within three weeks of joining, we left for England to train; in July we were sent to France, close to Vimy, where the battle of Vimy Ridge took place.

I joined the artillery because I wanted to ride horses. You know, when you're young, you like cowboys. I wanted to be a cowboy, to ride in the saddle — and that's what I ended up doing. I had never ridden a horse before, but they teach you in the army. We would jump off one horse, run, catch the edge of the saddle, and jump on the next. They didn't have trucks back then. Three teams of horses would pull one gun, a small eighteen-pounder. This was done in the holes and mud, under very bad conditions. A lot of power was

needed, and the only power they had was horses. My job was to drive for whatever was needed. If they needed stone to fill a hole, and a rope, I would get on my horse and carry it over. I never had a damn thing to say about anything.

I had two horses, which I practically owned. I only had them two months because they had trouble getting over the difficult terrain; in the mud their skin dries up, it cracks and bleeds, and they are no good when they hurt like that. So they had to remove the horses and give us mules because mules can stand the mud. So I had mules. I called them Israel and Sixty-Four.

During my first eight months people were getting killed, and shelling occurred all day long. I saw companions die, fellas I knew. You get hardened to that; you get used to seeing people die. It doesn't take long till it kind of toughens you. And I had my job to do. I served eight months straight before they told me I was entitled to go on leave. I went to Paris. While I was there, the Germans started to shell the city. People were scared as hell. One night we were in the *Folies Bergeres* waiting for the show to begin, expecting a fun evening, when all of a sudden a siren goes off. Some sixty odd people were killed from the crowd rushing for the metro; hardly anyone was killed from the shelling.

At Easter time, 1918, I went back to Paris. While I was there, the Germans made a big advance and the Canadians finally stopped them near Amiens. I was sent back to my unit. That's when I saw the misery of people, people in villages running away, people carrying each other, helping those who could hardly walk.

After I arrived back at my base, it rained all night. There were over twenty of us in the tent, twenty-

1910 1920 1930 1940 1950

two men, our feet crunched up one over the other. I took off my water-soaked shoes and put them under my head, the only space available. When I woke up, they were filled with water.

You can't imagine how awful, how sickening, it was; it doesn't seem fit for human beings. Sometimes we would go a month without a shower; we lived in stables and broken-down houses, or in tents. To amuse ourselves when we had time in the bunkers, we would kill the rats. We would put the cordite in their tunnels, light it up, and blow them out. The rats would come out all dizzy and we would shoot them with our rifles. The rats were having a good time over there — look at all the flesh they could eat from the body parts lying in the mud. There was mud as far as the eye could see. I considered the mud to be my enemy more than the Germans. There were no trees, just mud, mud like porridge with too much milk. If a man was shot, but still conscious, and he fell in the mud, I'm sure he would die. A man could drown in the mud of Vimy.

Ottawa, Canada 11.2001

Caption to picture on page : 240.241
Paul Metivier in Ottawa at the 83rd anniversary of the armistice.

Paul Metivier and a friend with whom he joined the service in 1917.

PIERRE SAUNIER | **born** 1897 **served** 1915-1918 French Army

This is my first memory of the war. It was at Hôtel de Ville. All of Paris was there, and we were all naked. We were getting tested — that's why we were naked.

It was the end of 1914 or the beginning of 1915, just before I went into the army. I was eighteen years old.

In May 1916 my eardrum was perforated in a gas attack in Champagne. The following year I fought in the fierce battles of the Somme and the Chemin des Dames. When the German offensive in Picardie began on March 21, 1918, I was in the 19th infantry division, the first to arrive as the Germans moved in. The front was completely demolished and the Germans were coming in fast. We found a chateau nearby, and about fifty soldiers hid out there for protection. The chateau had a piano, and a French soldier was playing it during the battle.

This was the battle *Chateau de Grivesnes*. On the last day of the offensive, April 6, we arrived to reinforce the 29th infantry division at Mailly-Raineval. Just across the way, a German soldier was shooting at us. I was shooting at a different German, and got hit by the first's machine-gun fire. I knew right away that my arm was messed up, there was so much blood. I was running, looking for the medic, carrying it in my hand. Four days later they cut it off.

They'd talked about the war in school, and I liked the idea of going. I didn't see it the same way afterwards. Three of my friends were killed there.

Two of my brothers were killed, one in 1914, and the other in 1918 — the same year I lost my arm.

The war was the worst thing that ever happened to me.

Paris, France, 2.1991

Caption to picture on page : 244.245
Pierre Saunier at Les Invalides in Paris with a photograph, circa 1937, of the changing of the guard at the Schinkelwach Building Memorial for Unknown Soldiers in Berlin.

1960 1970 1980 1990 2000

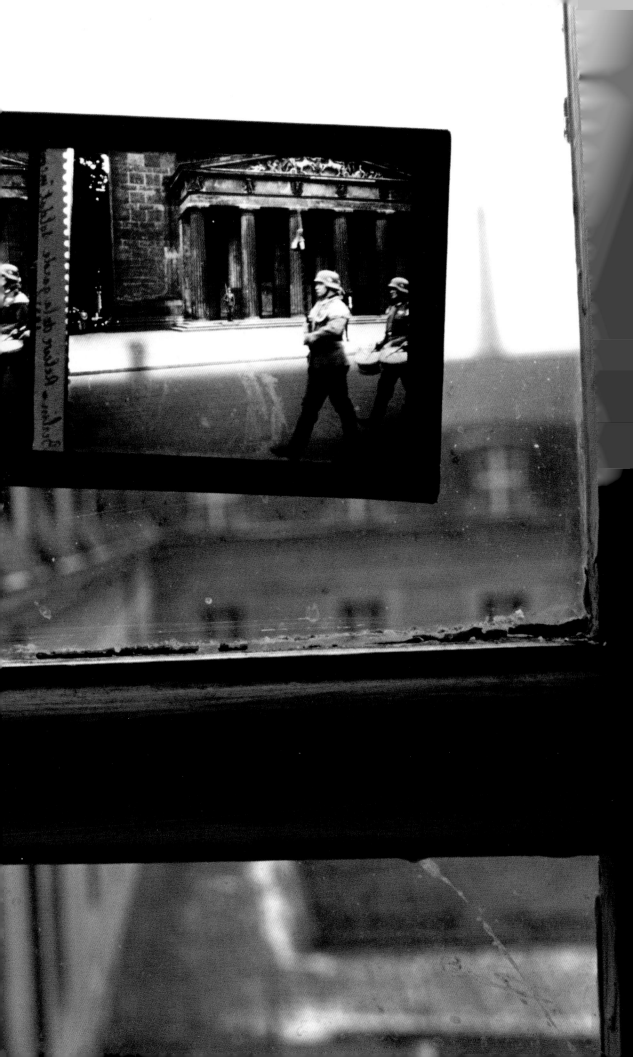

1 : ARGENTINA
2 : CANADA
3 : CUBA

4 : EL SALVADOR
5 : FALKLAND ISLANDS (UK)
6 : UNITED STATES OF AMERICA

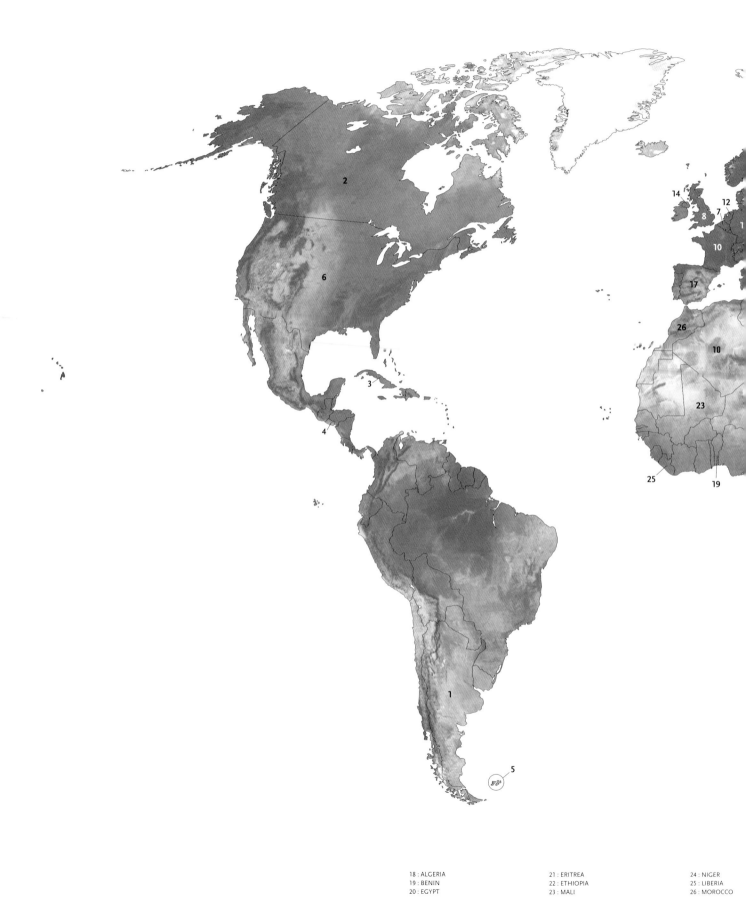

18 : ALGERIA
19 : BENIN
20 : EGYPT

21 : ERITREA
22 : ETHIOPIA
23 : MALI

24 : NIGER
25 : LIBERIA
26 : MOROCCO

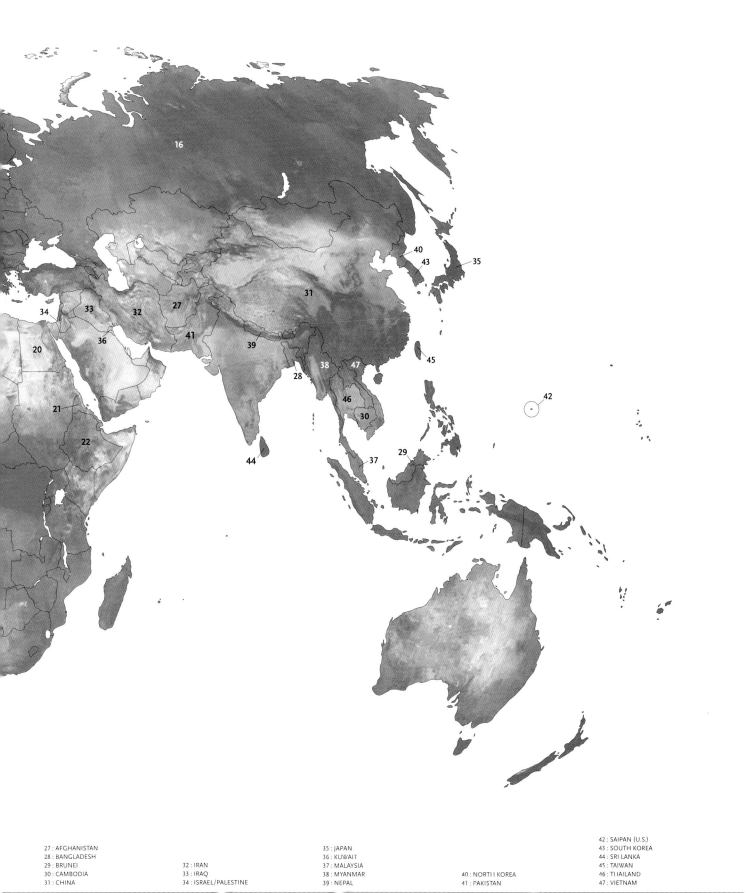

CREATIVE DIRECTOR AND BOOK DESIGN:
GIORGIO BARAVALLE . de.MO

GRAPHIC DESIGN:
MILLIE ROSSMAN KIDD AND SANDRA VAN AALSTEDE

PHOTO EDITORS:
LORI GRINKER AND ROBERT PLEDGE

PRINTED AND BOUND IN ITALY BY GRAFICHE MILANI
SEGRATE MILANO ITALY

AFTERWAR: PUBLISHED IN 2004 BY de.MO
DESIGN.METHOD OF OPERATION LTD.
123 NINE PARTNERS LANE MILLBROOK NEW YORK 12545

WWW.DE-MO.ORG

Acknowledgments

During the past fifteen years hundreds of people have assisted me with this book, whether with a sofa to sleep on, a bit of advice, a contact, help with filing or fundraising, translating or "fixing." My apologies if some of their names do not appear below. I am beholden to all.

My deepest gratitude goes to the veterans for welcoming me into their lives and allowing me to make very personal photographs, and for sharing stories rarely discussed. I hope the work reflects all that I have learned from them.

When I first had the idea to pursue this subject in 1989, I was immediately encouraged by Robert Pledge, president of Contact Press Images. I only had a few photographs from related work done in Israel in 1986, and an idea. It was his push that helped me follow my instincts, and I cannot thank him enough for his words of wisdom, years of reflective and tireless editing, and for helping to shape the images and texts into a book.

Special thanks goes to all at Contact Press Images (past and present) who continually helped me secure assignments in areas where I needed to work and tolerantly endured the many highs and lows: Jeffrey Smith for his endless support and patience, Dominique Deshavanne for her boundless, 24/7 energy, and Tim Mapp for guiding me through the printing process. In New York: Samantha Box, Audrey Jones, Alain Jullien, Bernice Koch, Fiona McCaskie, Catherine Pledge, Greg Sauter, Aaron Schindler, Mark Rykoff. In Paris: Behnam Attar, Jean-Jacques Mandel, Frank Seguin. To Contact's photographers who have always been there to lend a hand, give a name, or share a story, and David Burnett for many a favor.

I am grateful to Chris Hedges for writing such a profound introduction, and to Jacques Menasche for weaving his magic into the words and helping me stay true to the veterans' voices.

Many thanks to my publishers Giorgio and Lisa Baravalle for being true to their word from day one; for taking the chance on this book; and of course to Giorgio for the beautiful design.

Bill and Judith Moyers believed in this project from the beginning and their encouragement has helped me throughout the years. I want to thank Peter Howe for the first assignment at Life that got me started in Vietnam in 1989, and Karen Mullarky and Hillary Raskin, then at Newsweek for the next assignments. Many thanks to Fred Ritchin for championing the work since the first photos from Vietnam and all the way through, and Mark Bussell for years of lending his very talented eye. To Carol Squiers for putting together an early feature at American Photo, and Debra Willis Kennedy for the first exhibition and her wonderful words. To David Friend and Sydney Schanberg for invaluable help. To all the editors whose assignments enabled me to continue the project. I am lucky to have such wonderful overseas agents who made contacts for me, secured assignments, and at times housed and fed me: Margot Klinksporn and all at Focus, Grazia Neri, Miguel Gonzalez and Ana Gomez-Acevedo at Contacto, and Neil Burgess of nb pictures.

To my friends and family who put up with years of my coming in and out of their lives, especially: Jacki Ochs for always lending her ear and always getting it; Mark Bobrow, Erin Cramer and David Sternbach for reading and critiquing my early interview edits, and to David for continued legal advice; Ed Kashi for his constant generosity, Keri Pickett for listening and looking. To my dad, Charles Grinker for reading through texts and proposals, for giving me a sense of history, for his influence. To my mom, Audrey Grinker, for always being there. My gratitude to Carlos León for his artistic influence, and help on many trips. To Martha Burgess and Kathleen McCarthy for their creative input; to Richard Dreyfuss for his time and hospitality, and Phil Robinson for the same; Anne Thacher and Sheryl Mendez for their time and efforts; Adelaide Camillo and Ron Gross for keeping Marc in the picture; to Clem Taylor for helping to copy edit; and Hilary Rosenthal, Tracy Dembicer

and Jeff Doctorow for, among many other things, providing me a place to rest my head.

To Steve Broady at Beth Schiffer Fine Photographic Arts for doing a wonderful job with the digital imaging and photographic printing.

Afterwar could not have been completed without the financial support from the following grants, foundations, and individuals: Ernst Haas Award, Hasselblad Foundation, Mosaïque Programme, W. Eugene Smith Fellowship Award, Marty Forsher Grant for Humanistic Photography, New York Foundation for the Arts Catalog Project, Santa Fe Center For Photography Project Grant, Florence and John Schumann Foundation, Warren V. Muster Foundation, Heathcote Art Foundation, the Puffin Foundation, Ed Asner, Michael Blake, Mike Farrell, Jack Field, Carol Bernstein Ferry, Arthur J. Kobacker, Norman Lear, Michael and Sherry Lindner, Robin Lloyd, Mathew Maslow, Dr. Bertram Schaffner, Rose Underberg, Haskell Wexler, Cis Wilson, and my "guardian angels": Daniel M. Berley and Joan Morgenstern who offered more support than I could have hoped for.

This list of thanks continues around the world: **Argentina:** Cesar Trejo. **Bangladesh:** Abir Abdullah, Shahidul Alam, Rahnuma Ahmed. **Benin:** Jean Francois Lanteri, Danielle Valabregue, Dr. Verschoore. **Bosnia:** Dr. Kasim Brijic and son, Ruth Fremson, Perkieć Milenko. **Canada:** William Badets. **Cambodia:** Mrs. Sun Saphoen, Princess Sihanouk. **China:** Li Zhengsheng, Li Shi, Zhang Junwei. **Cuba:** Adita and Sophie Bravet, Rodolfo Gil. **Egypt:** Nermine Nizar, General Moustafa Eid. **El Salvador:** Cindy Karp, Marcelino Castillo Abarca, Rafael Gonzalez Herrero, Mario Velásquez. **Eritrea:** Askalu Menkarious, Veronica Duntmeesters. **Ethiopia:** Ursula Koechlin, Mario Martelli, Gian Pietro Testolin. **France:** Julie Graziti, Deborah Copaken-Kogan, Ann Cuisnet, Mohammed Halbi, Oury Matero, Cara Scouten, Berenice Debras, Zohra Mokhtari. **Germany:** Elisabeth Biondi, Heidrun Reshöft. **India:** Devica and Renu Daulat, Ajay Paliwal. **Israel and West Bank:** Donna Bojarsky, Yudi and Yael Dotan, Sharon and Merav Grinker, Ghassan Khatib, Gail Pressburg. **Liberia:** Lois Bruthus, Tom and Carol Jeffrey, Susuku, General G. Yerks, Robert Yerks, Father Joe Brown. **Mali:** Dr. & Mrs. Larry Hill, Linda Karpell, Walter Van Beck, Caroline. **Morocco:** Daniel Rousselot, Phillip Schuyler. **Nepal:** Nigel Fisher, Bikas Rauniar. **Niger:** Ephraim. **Pakistan:** Nick Danziger, Belquis Ahmadi. **Persian Gulf:** Ed Austin LCDR, Debbie Bondulic, Dr. Marilyn Gates, Dr. Jeff Hedrick, Dr. Jeffrey T. Lenert. **Russia:** Valeri Churashov, Tatiana Krayko, Konstantin Leifer, Edward Luniov, Anne Noggle, Marguerita Ponomaryova, Irina Tonkikh. **Saipan:** Serge Viallet. **Spain:** Ana Lopez, Jose Sevillano, Amalia Sanz-Hernandez. **Sri Lanka:** Eileen Cohen, Colin Glenny, Chamari Rodrigo. **England:** Tim and Jackie Lynch, Haider Ahmed, Linda Jamil, Nev Mountford, Robert J. Orner, Michael Urdang. **Northern Ireland:** Neil Jarmin, Roisin McGlone, Kathy Radford. **United States:** Gini Barrett, Paul Berman, Jean Caslin, Gary Chassman, Nina Chaudhuri, Zoe Chen, Anne Cronin, Yolanda Cuomo, Bob Dalton, Dr. Keith Druley, Tod Ensign, Dr. Sylvia Formenti, Alice Rose George, Vicki Goldberg, Barbara Goodbody, Hilary Grinker, Ira. J Hamburg, Ed Hanlon, Ron Haviv, Ed Henry, Abigail Heyman, Mac Holbert, Richelle Huff, Linda Ferrar, Jackie Jacoboson, Amy Janello, Bethany Jones, Brennon Jones, Judith Jorrisch, Stephanie Keith, Peggy Kerry, Verlyn Klinkenborg, Barbara Kopple, Dr. Bart Kummer, Pamela Lach, Mark Leepson, Li Xiaobing, Dr. Robert Jay Lifton, Veronica Matushaj, Ann Michelle Meehan, Shad Meshad, Connie McCauley, Susan Meiselas, Dr. Tibor Moskovits, Donald Moss, Jim Nachtwey, Alfred J. Peck, Steven Petrow, Mel Rosenthal, Stanley Rosenthal, Rita & Barry Shwartz, Jan Scruggs, Dr. Charles Strozier, Bruce Stutz, Marge Tabankin, Suzanne Tobias, Edward Wood Jr., Charles Wen. **Vietnam:** David A. Boone, C.P, Do Cong Minh, Hai Son, Mai Hong, Minh Ha. **Organizations:** Handicap International, Human Rights Watch, ICRC, Open Society Institute, UNICEF and numerous veterans' organizations around the world.

Afterwar is sponsored by the Human Arts Association, a non-profit organization based in New York.